INDYTAKER

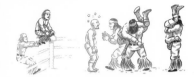

1 Hold your opponent upside down in Tombstone position, while your tag team partner stands on the apron.

2 Tag team pa... springs high into the air.

3 Tag team partner helps drive opponent's head into the mat with force.

MELTZER DRIVER

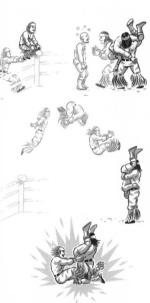

1 Hold your opponent upside down in Tombstone position, while your tag team partner stands on the apron.

2 Tag team partner springs into the air, and does a front flip.

3 Tag team partner helps drive opponent's head into mat with extra force. Meltzer then rates match 5 stars!

MORE BANG FOR YOUR BUCK

1 As tag team partner is perched on top rope, do a forward roll off of opponent's body.

2 Tag team partner connects with 450 Splash on lying opponent.

3 Spring to top rope and connect Moonsault on lying opponent.

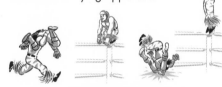

SUPERKICK

1 Mock your dazed opponent.

2 Gain perfect footing, and aim at your target.

3 Connect foot to opponent's face with impact. Your opponent has now been cordially invited to a Superkick Party!

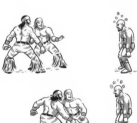

YOUNG BUCKS POSE

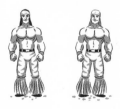

1 Stand tall with your tag team partner.

2 Flex your biceps, and tilt body opposite of your tag team partner.

3 Embrace your inner Young Buck. Party time!

DEY ST.
An Imprint of WILLIAM MORROW

YOUNG BUCKS

BUCKS

Killing the BUSINESS from BACKYARDS to the BIG LEAGUES

matt jackson
and
nick jackson

DEY ST.

HarperCollins books may be purchased for educational, business, or sales promotional use. For information, please email the Special Markets Department at SPsales@harpercollins.com.

FIRST EDITION

Designed by Paula Russell Szafranski
Illustrations for interior and endpapers created by Bill Main
Chapter opener lightning bolt art © VoodooDot/Shutterstock

Library of Congress Cataloging-in-Publication Data

Names: Jackson, Matt, 1985- author. | Jackson, Nick, 1989- author.
Title: Young Bucks : killing the business from backyards to the big leagues / Matt Jackson and Nick Jackson.
Description: First Hardcover Edition. | New York : Dey Street Books, an imprint of William Morrow, 2020. | Summary: "A memoir co-written by The Young Bucks, the most electric and daring tag team in all of wrestling, highlighting their inspirational coming-of-age story as two undersized, ambitious amateur wrestlers in Southern California to becoming one of the most popular showcases in popular sports"— Provided by publisher.
Identifiers: LCCN 2020029079 (print) | LCCN 2020029080 (ebook) | ISBN 9780062937834 (Hardcover) | ISBN 9780062937858 (Paperback) | ISBN 9780062937841 (eBook) | ISBN 9780063033467 (audio)
Subjects: LCSH: Jackson, Matt, 1985- | Jackson, Nick, 1989- | Wrestlers—United States—Biography. | Wrestling—United States—History.
Classification: LCC GV1196.A1 J34 2020 (print) | LCC GV1196.A1 (ebook) | DDC 796.812092 [B]—dc23
LC record available at https://lccn.loc.gov/2020029079
LC ebook record available at https://lccn.loc.gov/2020029080

ISBN 978-0-06-293783-4

20 21 22 23 24 LSC 10 9 8 7 6 5 4 3 2 1

To Dana, Zachary, and Kourtney.

Everything I do, is for you.

Mom, Dad, look. I wrote a book!

—MATT

To Ellen, Alison, Gregory, and Michael.

Thanks for being you.

You're my world. I love you.

—NICK

CONTENTS

PROLOGUE

BY MATT JACKSON

Me and my brother Nick, together, the most sought-out tag team in professional wrestling along with arguably the greatest wrestler in the world, Kenny Omega, all had contracts that were set to expire. We sat quietly in a hotel room, surrounding an iPhone placed on a coffee table, waiting for it to ring. We had back-to-back phone calls scheduled with two major players: Tony Khan, entrepreneur and co-owner of the Jacksonville Jaguars, and eager to get into the wrestling business; and Triple H, an executive representing World Wrestling Entertainment, the largest wrestling organization in the world. Both were vying for one thing: our commitment to work with them. Our next move would largely impact the future of the wrestling business. (Seriously, not an exaggeration.) Finally, the phone lit up, and vibrated on the table. I looked at my two Elite comrades and

said, "Well. Here we go!" before pressing the green accept-call button . . .

We had been preparing for this moment our entire lives, but, sitting in that paisley room and realizing that our worlds were about to change forever, my brother and I were thinking the same question: how in the world did we get here anyway?

Growing Up Young Bucks

MATT

"Code Blue! Code Blue!"

This was what blared over the hospital intercom at Beverly Hospital in Montebello, California, as a team of doctors ran toward the room where my mother lay in bed in the tenth hour of agonizing labor with her second child. "Code Blue" means a patient is having cardiopulmonary arrest and needs immediate resuscitation; what it meant to my mother was that the umbilical cord was wrapped around the baby's neck. My mom's doctor, Dr. Lee, told her that this was now going to turn into an emergency cesarean section delivery, and he and his team promptly stuck paperwork in my mom's face, asking her to make a choice in case something were to go wrong during surgery: Whose life is the priority to save? The baby's or her own?

My mom chose the baby. The surgery team quickly wheeled my mom into the operating room to prepare her. My dad was hysterical and prayed to God to spare both his wife and baby

son. He held my mom's hand and recited, "Lord. You're the giver of life! You're the giver of life!"

Dr. Lee made an incision, but the positioning of the baby made this difficult, and his arm was sliced as a result. My mom fell unconscious. Finally, the doctors pulled the newborn out and unwrapped the umbilical cord from his neck.

The baby boy's face was blue and he was not breathing. Immediately, the doctors put a breathing mask on him and began chest compressions. Soon they used a defibrillator, which sent doses of current to his heart. His chest began to move up and down, and his breaths increased, shallow but steadily. But the work wasn't over yet. The medical staff had to clear fluid from the baby's lungs, and after forty-five minutes of intense work, the operating room was finally filled with the productive sound of crying.

That baby was me. I was born Matthew Ronjon Massie on March 13, 1985. To this day, my mom and I have matching scars from the initial incision made by Dr. Lee—mine on my right arm's bicep, hers on her midsection. My scar is a lot more visible during the winter when I don't have a bronze tan. But they aren't just scars, either: they're matching reminders of what we went through that day, of how close we came to death.

I know the story of my birth in such detail because my dad, also named Matthew, tells it to me each year on my birthday. Growing up, I recall him telling it to anyone and everyone we'd meet. We'd ride ten floors down in an elevator, and by the time the elevator doors opened to a new floor, every stranger on that elevator knew I was a "Code Blue Baby." It became such a reoccurring story in our household that every member of the household would scatter as soon as he began telling it.

My mom and dad are the definition of "Couples Goals." They met at a church outing at Bullwinkle's Family Fun Center when they were only thirteen years old. My dad, ever the

charmer, approached my mom and told her how beautiful her voice was. They were dating not long after that, and by age sixteen he asked my mom's father for permission to propose, which was swiftly denied. So, he waited until he was eighteen to ask again, at which time permission from her family was granted. They haven't looked back since: for the thirty-nine years they've been married, they have probably spent a total of five nights away from each other. They hold hands wherever they go, attend church together every Sunday, sing together in the car, and pretty much make all other married couples look weak in comparison.

My mom, Joyce, comes from a large family of eight and was born and raised in Chino Hills, California. She is a little thing: five foot three inches and one hundred pounds and not a lot of change. She's blond-haired and pale and is the most soft-spoken woman you'll ever meet. My dad, Matthew, comes from a family of eleven and was born and raised in La Puente, California. He's six feet tall, has long jet-black hair, tanned skin, and is handsome and gregarious. When I was growing up, it would take fifteen minutes to check out of the grocery store line because he would strike up a conversation with the cashier. Half of my childhood involved me grabbing my dad by his hand in an attempt to pull him away from a pleasant conversation with a stranger.

My father's openness compared to my mother's shyness seemed stark, but both of my parents had one thing in common: they were both super-Christians. Or, as I like to refer to them: "Jesus Freaks." I mean absolute fanatics. Naturally, that devotion became part of the home I grew up in. Before every meal, even if we were at a restaurant, we'd link hands and say a prayer. During every car ride, Mom and Dad would sing praise and worship music, encouraging us to join along.

My older sister, Donajoi, (pronounced "Donna-Joy") or DJ

for short, and I were best buddies. She's about three and a half years older than me, and always babysat me in those early years. She was a wonderful playmate who taught me how to use my imagination whenever we sang, danced, and tumbled in the living room. I remember she and I would hold our ears to cups and press them against our parents' door in order to listen in on their conversations. We didn't know what was going on in that room, but we knew the moans and groans coming from the other side of the wall sounded silly. Luckily, we had the wherewithal not to investigate them further.

My sister and I had so many toys between us that my parents would store them all in a giant gray Rubbermaid trash bin. Every day we would play a game called "Barbies and Hulk" where she'd use her Barbies and I'd use my collection of World Wrestling Federation LJN figures. These toy figures aren't like today's figures: they were rubber, heavy, and the paint chipped from them as soon as you touched them. The body parts didn't move. Oh, and if you had a pet, the fingers and arms of the figures would be chewed off almost instantly. My very first wrestling figure was Jesse "the Body" Ventura, which I still have to this day. Some figures were not so lucky as to survive my youth, though. When I was two years old, my family went on a trip to Hawaii. While at the ocean with my favorite Hulk Hogan figure, a big wave came and launched the toy from my hand. My Hulk was lost forever, and I was devastated. For years after, whenever my parents would ask me where my Hulk figure went, I would look out into the distance and dramatically say, "Hulk went bye-bye in the ocean."

I spent the first few months of my life in Whittier, California, until we moved and settled into a small three-bedroom, one-bathroom home in Rancho Cucamonga, California. Yes, Rancho Cucamonga is a real place. And yes, it's the same Rancho

Cucamonga referenced in Looney Tunes cartoons, the *Friday* movies, and the television show *Workaholics*. It's a small city located thirty-seven miles east of downtown Los Angeles and is sunny pretty much every day. I'm not kidding, it's sunny on average 287 days per year.

That was where my brother Nick entered the picture. Like my delivery, it wasn't easy. Prior to this pregnancy, my dad told my mom he didn't want to have any more children. He didn't want to relive what they had already gone through with my birth, and he planned to get a vasectomy. But my mom wouldn't sign off on it. Literally. Back then, the spouse would also have to sign off on vasectomies. Despite Dr. Lee recommending to my mom that she not have any more children due to the high probability of a miscarriage, she wanted to try. Eventually, she became pregnant again, but at two months into the new pregnancy the house became filled with my mother's screaming. I remember racing into the bathroom because it sounded like she was in trouble. The door was cracked, and when I let myself in, I found her hunched on the floor crying hysterically. Next to her was my dad, who was scooping something out of the toilet. I couldn't see what it was until he turned around: in his cupped hands was a red, fleshy, transparent fetus of a little baby girl. I remember being able to identify a small semblance of a face and thinking how it looked like a little alien. Soon after, wiping tears from their eyes, my parents sat my sister and me down and explained what a miscarriage was. The house felt dark for a while, to say the very least. I was young and confused, not quite able to grasp what had exactly happened, but I think I learned a small lesson about mortality.

Two months later, my mom complained of feeling weak and ill. She thought she was having spasms, and my dad feared she might've developed an infection from the miscarriage, so she

was rushed to the hospital. As my dad sat in the waiting room, my mom was wheeled out wearing the biggest smile. Apparently, she was four months pregnant with a baby girl. *How could this be possible?* The miscarriage from two months back was a fraternal twin, Dr. Lee explained. My parents went back home and painted the nursery pink in preparation for their girl to arrive. However, my sister DJ told my parents they weren't having a girl. She said she had had a dream that my mom would have a boy and that they would name him Nicholas.

What compelled DJ to say this to my parents I'll never know, but nevertheless it proved prophetic. Nicholas Lee Massie was born on July 28, 1989 (in Greek, *Nicholas* means "victory"). While I was born with dark brown hair, brown eyes, and darker skin, Nick came out with light blond hair, blue eyes, and pale skin. We like to say that I got my dad's features and Nick got my mom's.

So now you know, if you didn't already, that Nick and I aren't twins like many people think. Even today, when we're traveling, TSA agents will look at us side by side, with our matching Elite backpacks and clothes, and say, "Twins?" Sometimes we get tired of correcting them and just smile politely.

I adapted to the big brother role nicely. I enjoyed not being "Baby Matt" anymore, which everyone in our extended family annoyingly called me. The house might have been louder, full of Nick's crying, but I appreciated the company.

Then, in unexpected fashion, my mom found out she was going to have a fourth child. Don't worry, nothing dramatic happened this time—well, aside from the tears from DJ, who cried, "No! Not another boy!" Sure enough, after keeping the gender secret for the duration of the pregnancy, our dad came back to report the news of the birth of another baby boy, our youngest brother, Malachi. DJ might have been bummed, but it was only temporary. (Later in life, she ended up having three

beautiful daughters of her own: Makayla, Rebecca, and Natalie). As a baby, Malachi was up most nights screaming in pain. My parents were absolute zombies around this time, constantly complaining about their lack of sleep, though I'd argue that *sleep* and *parenting* are antonyms as stark as night and day. I know that now because I'm a parent, too.

On my first day of elementary school, I stood in my front yard on one of the busiest streets in Rancho Cucamonga, Arrow Route, where two huge pine trees shrouded me from the traffic. The street we lived on was so busy the windows in my bedroom would shake violently when cars drove by. But outside on that day, all felt still and serene. I was wearing a white Teenage Mutant Ninja Turtles T-shirt, and a giant name tag attached to a necklace.

Say cheese. I smiled for a picture for my mom and dad.

We lived so close to Bear Gulch Elementary School that my parents walked me there. The mascot for the school was a bear, and in the front of the school was a giant plaster statue of a bear hugging a pole. There were bear tracks all along the sidewalks that led to the classes. I thought that was really cool, and it made me feel like I was visiting somewhere fun, like a theme park, as opposed to a school. My parents showed me into my class, met my teacher Mrs. Robertson, a sweet older lady probably in her sixties, and then cried their eyes out before saying good-bye. The tears mostly came from my father, who is the most emotional man I've ever met. I settled in and met another quiet boy who was all alone, playing on the carpet. He wore glasses and seemed anxious, just as I was. His name was Michael. He was my first friend.

My siblings and I went to Bear Gulch Elementary from

kindergarten through fifth grade. By third grade, I was deemed responsible enough to wake myself up in the morning, get dressed, pour myself cereal, kiss my parents who were still in bed, and then walk to class by myself. Times have changed, haven't they? Around this time, I also started to realize that everyone else in class was taller than I was. As we would all stand in a single file line by the door after the bell rang, I'd walk into the classroom on my tiptoes so I could blend in with the rest of the students. My size difference compared to the rest of the class would become more apparent as I got older. As all of my friends grew taller, it felt like I stayed the same height. I was bullied for being so small, and while these taunts were mostly verbal, I was still hurt by them. On Fridays I'd stare at the classroom clock, counting the seconds until the final bell rang so I could finally go home to a place where I was one of the biggest kids.

Every weekend home was a marathon. Our house was always filled with family members and friends. Uncles, aunts, cousins, and neighbors would stay over until early morning, and everybody seemed to either sing or play a musical instrument. I remember trying to sleep late at night and hearing someone playing the drums or bass guitar so loud that my body vibrated. My dad was an aspiring Christian rock musician and had turned our garage into a music studio. In the living room and on car rides, bands like Chicago, Styx, Queen, Boston, and Stryper played constantly, and if they weren't playing, it was because someone was singing their songs a cappella. Every Sunday morning was spent at church with the same family, and without exaggeration, the service would go on for hours. I would fall asleep in the car on the way to church and hope my parents would just leave me in there during the service. I thought it was the most mind-numbing, boring thing in the world. Don't get me wrong, I considered myself a Christian, but

I would've much rather been at home watching Michael Jordan and the Chicago Bulls. Plus, after the anguish of church, we'd go out to eat and eventually end up back at someone's house and stay until the wee hours of the night, where the family would sing and debate about the Bible. *A marathon.* By the time Monday came around every week, we kids were exhausted. I credit my parent's ceaseless behavior for the reason I'm always on the go or am constantly anxious to leave the house and do something, to this day.

During most of my childhood, my dad worked as a house painter. Since the life of an independent contractor didn't guarantee full-time work, he'd work his butt off all day and often pull into the driveway late at night, stepping from his truck exhausted and his shirt splashed with a rainbow of color. At night, I'd hear him and my mom stressing out about when the next job might come. Still, my parents always somehow managed to spoil us. They would save up money and buy us name-brand clothes in the clearance sections at outlet stores before school started every year, or buy us secondhand toys at the swap meet to make sure we had presents underneath the tree for Christmas. My mom stayed at home with us and kept the house in neat order. Not only did she physically look young (she still does!), but she also had a childlike spirit and spent hours playing with us on the floor. Many times, throughout my childhood, people thought she was my older sister, and as I got older, people thought she was my girlfriend. *Gasp.*

The buoyancy inside the house was put to the test when I was eight and my dad's father, my Grandpa John, became seriously ill with colon cancer. Suddenly, dread permeated my family. We all went on a health kick and fed him carrot juice among other homemade recipes, but as the days dragged on, we could feel we were losing him. One afternoon in March, we visited him at his home where he was being treated by hospice care. I

watched as my teary-eyed dad massaged his back and spoke to his father in hushed tones. I felt hopeless, and, unsure of what else to do, I began massaging my grandpa's feet, which seemed to soothe him. Later that night, when my family and I were back at home, I heard my mom scream when she picked up the telephone; I knew Grandpa's time had come, but I wasn't told how. I found out later that Grandpa must not have been able to take much more pain because, with the last of his strength, he took the gun he kept in the house and shot himself in the heart. It ripped a hole in our family that still hasn't been fully healed. That night, my mom told me that if I felt sad or if things in my life felt out of control, God would always listen to me. Before this tragedy, praying was just something I did prior to dinner and bed. But after Grandpa John's suicide, I experienced loss on a whole other scale, and I believed that God could help me brave future storms to come. On the day of the funeral, as I passed my grandpa's open casket while holding my dad's hand, I prayed my first real prayer. I said it with conviction.

It seemed like I was destined to be involved in wrestling from the day I was born. The very first T-shirt I wore read, "World Champion." There's a picture of me, a couple days old, wearing this T-shirt with my hands raised in the air. To this very day, whenever my arms are raised in victory after a successful wrestling match, my dad still screams, "World Champion!"

My earliest memory of professional wrestling is at age two. I was in San Francisco at my aunt and uncle's house, where my mom left me while she went with her sister and her nephew to watch *WrestleMania 3* on closed-circuit television. I didn't get to attend because I was too young, but I noticed how happy they were when they returned. Their joy seemed contagious.

The way my cousin described what he had seen must've captured my imagination because I kept asking my parents questions about the colorful world of wrestling.

This memory formed the basis of my interests, and as my brothers got older, I introduced them to wrestling as well, letting them watch along with me and look at my *Pro Wrestling Illustrated* magazine collection. My dad would take us all to Blockbuster Video, and we would rent every World Wrestling Federation videotape on the shelf. Like me, my brothers gravitated to the lively, muscular, bald-headed Hulk Hogan. Before my parents knew it, we had the Hulk Hogan stuffed animals, bedsheets, mugs, lunch pails, and even hand grippers. We were full-blown Hulkamaniacs. We'd run home from Blockbuster, push the VHS tape into the VCR, and all of us would wait for it to kick into action as we would mimic the sound of a ring bell—ding, ding, ding!—and copy the moves on-screen. As Nick and I would nail Malachi with a perfectly synchronized double Superkick, Marty Jannetty and Shawn Michaels (the Rockers) would play in the background. (For you fans newer to wrestling or who didn't grow up in the '80s or '90s, a Superkick is a sidekick once used as a finishing maneuver but that is now used sporadically in wrestling matches.) It wasn't even known as a Superkick yet, so we'd just yell, "Double Kick!" Then we'd create the sound of a roaring audience with our mouths. I was the biggest of the three boys but unselfish, and I let my brothers clothesline me and trade off giving me jumping leg drops. I was selling their moves before I even knew what that meant. These nights would usually end with Malachi crying from one of us slamming him down too hard onto the makeshift pillow wrestling ring, and my parents rushing into the room to shut down shop. On one of these nights, I jumped off the top rope (meaning the couch) and landed right on poor Malachi's arm. The crack was so loud that my parents heard it from across the

house. After crying for an hour, Malachi convinced our parents he was fine. A few weeks later, my mom noticed Malachi favoring his arm, so she took him to the hospital for an X-ray. Turns out, the tough kid was walking around in school with a broken arm. Wrestling was banned in our household for a while after that.

But while walking past our local comic book shop a few months later, my brothers and I saw a poster for a WWF live event taking place on June 30, 1994, at our minor-league baseball team's stadium. My eyes lit up when I saw Diesel and Razor Ramon on the poster, and I couldn't fathom they would be coming to our tiny hometown. Nick and I begged our parents to get tickets, and lucky for us we were headed to the Rancho Cucamonga Quakes' stadium, which was known as "the Epicenter," for some WWF action! As we walked up from the concourse, my eyes fixating on the wrestling ring, I wondered how the ring mat felt, how bouncy the ring ropes were. As each wrestler came out, I stood silently and studied their every move. I didn't boo the bad guys or cheer the good guys. I just watched in blissful awe.

A year later, on July 28, 1995, Nick's sixth birthday, WWF came back to the Epicenter, and we were even more excited and prepared this time around: we chose sides. I brought a sign dedicated to Kama "the Supreme Fighting Machine" that read, "Kama the Supreme Losing Machine!" I thought it was genius, though I'm sure Kama did not (he probably never even saw it, however). Things kicked off in the second match when 1-2-3 Kid flew around the ring, dazzling me and the rest of the audience. We sat right by the entrance where the wrestlers entered and exited, and after 1-2-3 Kid's loss to Waylon Mercy he walked toward the exit holding his neck. He spat at the wall, launching a stream of blood. Kids at school would tease me about wrestling being fake, but this was all the evidence I

needed to bring back to them. As the show progressed, the tensions rising high with each subsequent wrestler, I couldn't look away from the bloody spit. My attention would soon turn back to the show when Shawn Michaels reached out and gave me a high five. He did the same for DJ, who looked down at her hand and said, "I'm never washing this ever again!" At one point later in the night, the black curtain was flung open and I saw a smiling Paul Bearer sharing a laugh with Yokozuna. During the matches, Paul Bearer played a creepy, boisterous character who carried around an urn while Yokozuna was portrayed as a giant, immovable sumo wrestler. I knew at the time that this was a moment I wasn't supposed to have seen. A good guy and a bad guy, together, laughing? It didn't add up. I looked back at the blood-stained wall and smiled.

The Undertaker would eventually stuff Kama into a casket and slam the door shut, winning that evening's Main Event Casket Match and ending the show on a high note. As my family and I exited the building, I saw a giant line forming to meet several of the wrestlers. I pulled on my dad's arm and pleaded with him to let us meet Razor Ramon, whose gold necklace lit up the entire room. "We've gotta beat the traffic. Sorry, Matty," my dad said.

For those who grew up in California, traffic is as natural as the sunshine. So, when we weren't glued to a television watching wrestling, our family would drive three hours to the California-Nevada state line for weekend trips to escape the bustle of the city. We usually stayed at a family fun casino resort called Buffalo Bills, which had a roller coaster adjacent to it and even an indoor log ride. I recall many summers spent in the arcade and in their giant buffalo-shaped swimming pool. One time, I was left upstairs in the hotel room to watch Nick and Malachi while my parents went downstairs to play slot machines. Within minutes of their leaving, Nick picked up a

hairbrush, and I surprised him with a beautiful Superkick. We would do this all the time as a cruel sort of game: find each other at inopportune moments and greet each other with a Superkick. When I performed this kick, however, the brush was inadvertently slammed directly into Nick's face. His hands immediately covered his mouth, and his eyes began to well up. I asked him if he was okay, and rather than replying he uncovered his mouth to reveal that one of his front teeth was gone. It took Nick a second to realize this fact, but as soon as he did, he cried and chased me around the room. A few hours later, I sat at the edge of the bed staring at a cup of milk, which Nick's front tooth now sat at the bottom of, as my parents scolded me. Once again, wrestling was banned in our household.

I wouldn't attend another wrestling event until October 29, 2000, at the MGM Grand Garden Arena where World Championship Wrestling was hosting an event called *Halloween Havoc*. The night before the event, my friend from school, Casey Newsome, and her mom, drove us into Las Vegas. In the lobby, I noticed camera lights flashing and saw a crowd of people hollering because a bunch of the wrestlers had arrived at the hotel. Casey and I joined the crowd to see if we could meet anyone.

Disco Inferno stopped to chat, and Billy Kidman took pictures. I stuck my hand out to high-five Booker T, but he zoomed passed everyone with his roller bag, in a hurry. Finally, I looked and saw one of my favorite wrestlers, Rey Mysterio Jr. In my eyes, Rey was the closest you could come to a real-life superhero. Throughout most of his career he wore a colorful mask and outrageously decorated costumes. He jumped off of the ropes in the ring so effortlessly that he resembled a beefier Spider-Man. I joined the line forming in front of him in order to get my chance to meet him. As the person in front of me moved out of the way, to my surprise, I was now face-to-face

with one of my heroes. Still very self-conscious of my five-three height at age fifteen, I noticed that I was the very the same height as the best high-flying wrestler in the world. I told Rey I wanted to be a wrestler just like him, and he encouraged me by throwing out a bunch of phrases I could barely comprehend because I was so awestruck. Really, he didn't have to say anything at all. He'd already done enough to inspire me.

The *Halloween Havoc* show itself ended up being a whole lot of fun, although World Championship Wrestling was dwindling in popularity by the minute. WCW was a company owned by billionaire Ted Turner, and it had defeated World Wrestling Federation in television ratings for more than a year and a half. But due to bad story lines and office politics, business declined. The attendance wasn't that large and the match card not so strong. Still, I remember being mesmerized by the matches as I watched Jeff Jarrett smash a guitar over Sting's head. Plus, the show gave me lots of ideas.

Remember how my parents forbade wrestling not once but two times? Well, once again, that didn't last long. After the *Halloween Havoc* show, Malachi, Nick, and I would sneak a soggy mattress into our backyard that had been sitting out for days in our back alley. We'd practice wrestling moves on each other until we'd hear a fist pounding on the window through the curtain. My mom would give us a look, and we knew it was a wrap. We'd drag the old mattress back to where we found it and walk back into the house with our heads low. But that was only temporary, because once my parents were gone and the coast was clear, we'd call our friends over to wrestle. One time, as one of my friends leaped off our stucco wall onto my head, which was stuffed inside of a trash can, my dad pulled up in his truck and took in the entire thing. He told everyone to go home immediately. He didn't care that we were in the middle of a classic match; he had seen enough violence. Making his

decision easier was his observation that my nose was bleeding profusely.

So we'd take the show on the road to a friend's house, in which we launched from his fence and cars in the driveway and onto each other, until his parents would shut us down as well. Finally, one day, with nowhere to wrestle, we found a gold mine in no other than the back parking lot of an old furniture store called Vision's Furniture. There were multiple mattresses, couches, and an abandoned furniture truck with spiderwebs on the tires. I know it doesn't sound glorious, but we made a makeshift arena from these finds and wrestled there every day one summer, having twenty-minute matches that we nicknamed classics. Better yet, we didn't have to worry about one of our parents trying to shut us down.

One afternoon, though, as we raced there to prepare for another day of wrestling, we found that our entire makeshift arena was nothing but a pile of ash. There had been a massive fire behind the furniture store the night before. As we watched the debris, someone who must've been the owner of the store rushed outside and yelled, "You guys are the ones who did this! I've seen you back here for months. I'm calling the cops!"

We jumped the chain-link fence and sprinted home. If only he had known how special that place was to us, he never would've blamed us. We had lost our favorite spot, and once again we had nowhere to go.

A Wrestling Ring in My Backyard

NICK

I looked down at my leg, which had a giant gash in it, and screamed. Blood was everywhere. Despite my cries of pain, my dad remained calm as he asked my sister, Donajoi, to go find the remaining skin that was somewhere hidden in the grass. Here is what had happened: I was climbing the top of the gate in our front yard how a tightrope walker does, pretending it was the rope on a wrestling ring. Me and my brothers, Matt and Malachi, along with our next-door neighbors, Jesus and Adolfo, were having a competition to see who had the best balance and who could climb the farthest across the gate. As I scaled it (and set yet another new record!), I lost my balance and fell directly onto a sharp edge, which gouged a giant hole in my calf. The cut required close to seventy-five stitches to close the wound. As it healed, it looked like a mouth, and to make my friends laugh while recovering, I'd draw two eyes near it so it looked like a big smiley face.

The injury ended my city league basketball season prematurely, and my team lost every game without me, but that wasn't what made me most upset. What did was having to sit out while my brothers and friends played and enjoyed themselves at the park. Looking back, my childhood is filled with stories like this, so there's no wonder my parents wanted to take precaution with my brothers and me.

It was true that my parents couldn't prevent every slip and fall, but they vowed they would try their best. This reached a new meaning when, a few months prior to Matt's birthday, my dad promised he would build us a wrestling ring in our backyard. He gave himself the deadline of March 13, 2001, what was to be Matt's sixteenth birthday. By this time, Dad had gained his general contractors license and expanded his business from not only painting houses but to building them as well. Ultimately, my dad's decision to build the ring would be my parent's way of regulating what we had been doing for years elsewhere under no supervision. They could monitor who was at the house and which wrestling moves we were practicing, and they could have the peace of mind of knowing we would be performing in a soft, safe wrestling ring as opposed to the grass, or on a moldy mattress. We just had to promise them that we wouldn't do anything *dangerous*, which included using weapons like glass, fire, thumbtacks, or any other object that could puncture an eye (which, at that time, almost every backyard "company" used). But we were more interested in the athletic side of wrestling than the barbaric side and simply wanted a place to try out the high spots we saw on TV.

There was only one catch to having our very own wrestling ring: we'd have to come up with half of the money ourselves, and then we'd have to assist our dad in building the ring as well.

This was where we kids first learned the value of the dollar

and how hard we had to work for it. Every day after school, we'd help paint houses, build fences, rooftops, and put up doors and windows. We did a little bit of everything. After several months of saving every penny we earned, and with some help from our parents, we had enough to buy all the supplies for the ring. Going to the local hardware stores became routine. In the early 2000s there weren't details on the internet on how to build a wrestling ring—you couldn't exactly Google "Blueprints for a wrestling ring"—so my dad did his own research and came up with his own plan.

Once we secured the money, the first thing we did was dig four huge holes three feet into the ground. Then we installed four black poles that we had special-ordered and cemented them in. From there, we bolted 4×4 wood planks across from the poles, which gave us the frame of the ring. Every twelve inches we nailed in more wood to provide the ring with more strength. We also had concrete blocks to hold up the frame. The ring needed to have some give for when one jumped and fell on the mat, so my dad's idea was to stretch chain-link fence across the beams. That plan failed miserably, as the fence didn't hold any weight, so we abandoned that and replaced the chain-link with plywood, which seemed to be sturdier. To make the ring soft, we went to various local carpet stores and grabbed the leftover carpet and carpet padding they had decided to throw away. The carpet would help soften the landing when we fell on the ring, or, as we say in wrestling, "bump" the landing. We worked tirelessly, but the real hero was my dad, who after working full days as a contractor would race home, brew a cup of coffee, and meet us in the backyard to work with us until bedtime.

So, when Matt's sixteenth birthday arrived, the only thing left to do was hang the ropes. Matt, who was unfortunately sick with the flu on his birthday, had to rest in bed while my dad

and I worked for hours trying to figure out how to get the ropes to work. We used actual rope for the ring ropes but didn't know anything about turnbuckles, so the ropes were loose. And we didn't have a proper ring canvas just yet, so we tossed a blue vinyl tarp over the carpet padding and tied it down. But we didn't care: the ring was complete and my dad had kept his promise. We went into Matt's room to tell him the news and he jumped out of bed and ran outside. It was as if his symptoms had flown from his body, and Matt stayed in the ring with us through the rest of the night. It was the best birthday present he could have asked for.

From that day on, my brothers and I counted the hours down in the classroom, waiting for the final bell to chime so we could run back home and practice the moves that we saw on TV or on tape each week. Before we had a wrestling ring in our backyard, our matches were hosted by our self-made company, KBYWA, which stood for Kid's Backyard Wrestling Association. It was an idea of a wrestling company the way most kids fantasize going to space. News spread quickly at our school that we had a wrestling ring in the backyard, and I remember becoming quite popular in a matter of weeks. To solidify this popularity, Matt and I decided to rename our backyard company the Backyard Wrestling Association (BYWA). We didn't feel like kids anymore, and plus, we now had a reputation to uphold!

Graduating to the next level, we also felt like some of the stunts needed to be bigger. My dad always had extra drywall lying around from jobs he'd previously finished, so we'd sneak them under the ring, hiding them to be used for big matches. We'd either set up two chairs or trash cans and put the drywall on top, in between, acting like it was a real table. Every time we crashed through one, it would make a massive sound and explode into many pieces, but it never hurt and always

looked spectacular. We were into the tables and ladder matches that were going on during this time with the Dudley Boyz, the Hardys, and Edge & Christian, and we wanted to be just like them.

Recruiting friends to come over and wrestle with us was easy. One of my closer friends from school at the time, Jeremy King, was very athletic and jumped right away at my invitation. His wrestling name would be "Fusion." My younger brother Malachi recruited his friend Nolan Staten, whom we called "Dr. Dare," which didn't really make any sense because Nolan was a lanky, redheaded, and freckled kid, who usually wasn't the type to take risks. One of our best friends who happened to live two doors down, Adolfo, would be named "Krazy Bone," which was a bad choice for a wrestling name because the fans looking at him would yell "Krazy Boner!" (he played a bad guy). I should take a second to note that those "fans" happened to be us, since we didn't have a big crew, or actual fans yet. Although Donajoi, and Mom and Dad would sometimes take a seat out back and cheer us on, we still had a lot to learn about putting on shows by ourselves. For one thing, we had to teach ourselves how to perform most of the moves correctly. We would watch and rewatch videos of our favorite wrestlers and emulate what they were doing, down to every technicality. Once we got good enough to string a series of moves together in the new ring, we memorized long sequences and eventually felt confident enough to put on matches. But in order to put on a wrestling show, you had to do more than just wrestle. You had to have the characteristics of a Renaissance Man and be willing to wear more than one hat.

Each of us played multiple roles during the shows, trading off being the referee, cameraman, music DJ, and other characters; and some wrestlers like myself had to play two different gimmicks as well. My bad guy wrestling persona was "Slick

Nick," which I gave myself simply because I thought it was a cool rhyme (I didn't even realize Ric Flair used the similar moniker of "Slick Ric"). My second gimmick I called "Caution," because I would wrap caution tape all over my body and would come out for my entrance with a caution sign in my hand (I know, it was very "on the nose"). I would set up the sign that read "Caution Wet Floor," and then slip and fall as I passed it by, sending my body flailing in a bunch of different directions. We all thought it was hysterical at the time. Malachi's wrestling name was "the Comedian Killer," and he made his entrance holding a ventriloquist doll dressed up just like him in flannel while a creepy Halloween soundtrack played in the background. In the worst ventriloquist impression ever, he would make the doll say, "I eat little children." It made little sense at the time and still doesn't. Malachi was the smallest of all of us but always the loudest and boldest. He gave orders to all the wrestlers, and because he had Matt and me as his big brothers, he thought we'd fight his fights for him, and truthfully, we would. Matt, of course, was Mr. BYWA, which was a take on Rob Van Dam's "Mr. Monday Night" gimmick. Rob was an athletic wrestler who pioneered a new style of striking and flying. Matt would wet his hair and walk slowly and dramatically to the ring with a red, two-sizes-too-small MLB Cardinals jersey, which he would pull up to reveal his abs.

Since Matt was in high school at the time, the roster started to fill up with some of his friends. One of them was an African-American guy he played basketball with named Wendell White. He entered the ring to Nelly's "Ride Wit Me" and based his entire gimmick off of that song, naming his wrestling persona "Alley Wendelly." He had the most beautiful Senton Bomb I'd ever seen. He'd gracefully jump off the top rope and front-flip, tucking his head at the last second before landing on top of his opponents. Every backyard wrestler compared themselves to

Wendell and his Senton Bomb. Then there was Daniel Grubbs, Matt's best friend, who wasn't a natural athlete but who had a big heart. He played two different gimmicks: one was "Johnny Rotten," who spoke with an English accent, wore a tie, and naturally came out to the Sex Pistols' song "Anarchy in the U.K." His other persona was "The Annihilator," an energetic, sports-jersey-wearing guy fanatic entered the ring with a song from the *Hulk Hogan and the Wrestling Boot Band* album that all my friends and I bought from the 99-cent store. At the time, I thought for sure that Daniel would stick with wrestling and get to where we'd eventually be, since he was by far the most passionate out of everyone.

Songs fueled our collective passions. My dad was huge into the band Kansas, and we had a lot of their albums at home. Naturally, I picked out one of their songs, "Not Man Big," to make my entrance to, performing air guitar with a replica WWF title belt like my favorite wrestler at the time, "Hollywood" Hulk Hogan, did. The funny thing is, Matt loved the song so much that he ended up using the ending of the song as his entrance as well. The song is a staggering eight minutes and forty seconds, so no wonder it stretched across both our walk-out entrances.

If you're into wrestling (and I hope you are), you will know that every wrestling company has an annual show. These shows are usually the culmination of all of the biggest story lines throughout the year, climaxing at the big event. It is treated like a season finale of a television show. We called ours "Highway 2 Hell" and put it on every July. The first one took place in July 2001, around the time that we met Dustin and Brandon Bogle. Dustin was Matt's age and Brandon, mine. They were two tall, quiet guys with short hair who looked nothing alike at the time, and it wasn't until six months after meeting them that we learned they were brothers. For our show, Dustin wore an

old Kmart hooded Halloween costume and called himself Diablo. Brandon, the younger, slimmer brother, got around everywhere by skateboard and was called Skater #1—no big surprise there. The Bogle Brothers would eventually be known as the Cutler Brothers and would have their big break years later at a Southern California wrestling promotion called Pro Wrestling Guerrilla, or PWG for short, which is still the biggest independent wrestling company on the west coast (we'll be talking about PWG a lot in this story). But before all that, they came to *Highway 2 Hell* as our first official paid fans to watch the show. Prior to 2001, admission had always been free. But this time, Matt charged the Bogle Brothers each $1 admission and told them to enter the backyard through the alley once their tickets were purchased. At that show, Matt had come up with the idea to bring Dustin and Brandon into the ring to test them and see if they'd be tough enough to get into wrestling. We ran a story line where we would invite the "fans" (the Bogles) into the ring, and then beat them up. It was a savage way to recruit them, I realize now. Matt gave Dustin multiple 450 Splashes from the top rope—a move where you do a full front flip and then rotate all the way to your belly before crashing onto a prone wrestler. Both Dustin and Brandon wanted more, and they came to our house after school every day after that. Nearly twenty years later, we're still best friends.

At this point in our burgeoning wrestling careers, sharing videos on the internet was still a relatively new, difficult, and timely task. It took hours to download a thirty-second video clip on our dial-up internet modem at home, but eventually Matt learned how to build a website where he uploaded various clips of our best moves. He also began to look up other backyard wrestlers on AOL Instant Messenger and became part of a large community of people with common goals and interests. Backyard wrestlers in the area started taking notice and asked

to collaborate. A guy named Vince who ran a company from the Anaheim area called SCWA (SoCal Wrestling Association) reached out to Matt and tried to convince him that he was a big-time wrestling promoter and that he could be the key to unlocking all of our success. Vince was thirty, significantly older than us, and talked a huge game. Our parents monitored all of our online communications and would put anyone we'd meet online through the wringer before finally inviting them over, then they'd never leave our side (I'd have a hard time imagining something like this happening these days). Vince's claim to fame was telling other backyard wrestlers that he used to book Chris Masters on his backyard shows. Chris Masters would eventually find success years later in WWE.

It was Vince who introduced us to the very popular wrestling venue in Anaheim called the Anaheim Marketplace, a big flea market that hosted wrestling shows in the back. WPW (World Power Wrestling) was run by promoter and wrestler Martin Marin, and it was in his ring where we made our *real* wrestling debut. I remember being blown away the first time I saw the original padding on the outside with flames on it from the early *WCW Monday Nitro* television show. When WCW folded, Martin was fortunate enough to buy one of the old WCW rings. He also had bleachers, guardrails, and an actual entrance set up with a real backstage. Vince rented the arena from Martin for a special show that would include multiple backyard companies joining together, and we had to pay $20 or $30 each to have a match on the event—a small fee for such a grand opportunity. For my match, I competed against my brother Malachi, who was probably all of ten years old at the time. We stole the show: the highlight was Malachi hip-tossing me off the apron onto the small floor mats that covered the concrete. You could hear a massive thud and the fans gasp as the air was knocked right out of me. I remember getting into that

real ring before the show started for the first time and think-
ing it was the hardest thing I'd ever felt in my life; the ring at
home was covered in soft carpet padding, but this one had only
one little foam mat that separated it from the boards and metal
framing. But I thought that if Hulk Hogan and all of my favor-
ite WCW wrestlers could take bumps in this very ring, then I
could, too! After the match ended, the promoter Martin came
up to me and Malachi and asked if we'd ever be interested in
training with him. I denied him on the spot: twelve-year-old
me thought that I didn't need training. To prove I was wrong,
Martin asked me to tie up with him, or "lock up," which is usu-
ally the very first thing wrestlers do to start a match. I didn't
have a clue how to do a proper lock up, and he called me out
on it. "You don't know as much as you think," he said. I was
offended by that at first, but I soon realized he was probably
right. I had no clue about the basics of wrestling.

Still, our group of friends—whether we knew a lot or very
little—became a club. I'm sure people assumed we were a
bunch of loud, rebellious teenagers who were constantly seen
roaming the town on foot, but we were actually just a bunch of
kids who dreamed big and milked every second out of child-
hood. We spent almost every waking hour together, walking
to school in the early mornings and meeting at the local pizza
restaurant's arcade in the afternoons. We spoke a certain lingo,
employing terminology that only superfans of wrestling would
understand. And every conversation was full of inside jokes
that only we had the keys to. We dressed the same, which typi-
cally meant cargo shorts, tank tops, and flip-flops year-round.
We worked out together at the apartment complex community
gym and the recreational center. We grew our hair long so we
looked more like wrestlers. We practiced in the ring all day,
ranging from tumbling and stretching to landing on crash pads
from the top rope, and helped each other along. When we were

in school, as we'd pass each other in the halls, we'd give each other a knowing look, like we were saying with our eyes, "See you in the ring after the school bell." Every weekend, we would pull the camera out and host a four- or five-match wrestling card in the blistering sun. As I ran the ropes and rolled around the ring, I'll never forget the smell of the ring canvas, like the scent of a burning leather jacket. It was the smell of innocence and boundless ambition.

Little did we know our whole life would soon change. It was July 22, 2002, on a hot summer evening, when an ambulance raced passed our house on Arrow Route. Whenever my mom heard sirens in our neighborhood, she quietly said a prayer. This time was no different. The second after she spoke her piece to God, the phone rang, and my dad answered it. It was me on the other line.

"Hi, Dad," I muttered. "Come to Mobil gas station as soon as you can. Mal has gotten into an accident. He got hit by a car."

Nice to Meet You, My Name Is Mr. BYWA

MATT

Out of breath, Brandon Bogle sprinted to the gate behind which his brother Dustin and I were relaxing in his apartment complex's Jacuzzi. Just a few minutes earlier, Nick, Mal, and our friend Nolan (Dr. Dare) went on a bike ride to the local gas station for snacks.

"Mal got hit by a car while he was on his bike!" Brandon shouted.

"What! Is he alive?" I yelled, jumping out of the hot Jacuzzi.

"He's alive. He's okay, but the ambulance is there. I think his leg is broken."

Brandon had walked over to the gas station by himself, and upon spotting an ambulance went over to investigate. Soaking wet, Dustin and I bolted barefoot toward the Mobil on Arrow Route and Hellman Avenue, only a couple blocks from where we were.

We learned after the fact that Mal was crossing the cross-

walk on a red light, when a driver who wasn't looking made a right turn and hit him, knocking the bike over with him on it and then dragging both of them another eight feet. In shock, Mal went to stand up, but Nick shouted at him to stay down. The tire had run over Mal's right leg, causing a compound fracture, which is when the bone breaks through the skin. Nick still compares the way Mal's leg looked to the famous viral video of Sid Vicious snapping his leg famously at a WCW pay-per-view in 2001. Meanwhile, Mal crawled away from underneath the car, where his bike lay, broken and twisted. Nolan tried to calm him. By the time the Bogles and I had gotten to the scene, Mal had already been taken away by the ambulance, with my mom inside. It was that quick. As I approached, I heard a police officer questioning Nick and Nolan aggressively, as if they had done something wrong. The officer yelled at them for riding bicycles without helmets on. My dad, who had stayed behind after the ambulance left, paced around nervously and took photos of the incident. When he overheard the police officer giving grief to his traumatized son and friend, he asked the officer to shut his mouth.

Eleven-year-old Malachi was rushed to the hospital on a gurney where doctors reset his tibia bone and then performed surgery the following morning, putting four long screws and a plate in his tibia. The doctors also placed a giant metal external fixator on his leg, which he would have to wear for four months and which would help keep the bones stabilized. I remember the entire backyard wrestling roster coming to visit Mal in the hospital. If one of our guys was down, it meant that we were all down.

Six days later, we got to take Mal home, and the entire wrestling team decorated my house with "Welcome Home" and "Get Well" banners and posters. Mal would have to get around in a wheelchair for the next several months, then use a

walker, and finally teach himself how to walk again unassisted. Of course, the doctors would tell him his future wrestling career was in jeopardy. This was such a mentally draining time for the family. My parent's biggest fear had always been seeing one of us get hurt while wrestling, but they never expected something bad to happen this way. We all tried to stay strong, but I had moments of weakness. When I saw how much my brother was struggling, I privately asked my parents whether he would ever be able to walk again. They always had faith he would end up being okay. Our lifestyle as a family changed, too, as we all pulled together and took turns taking care of Mal, helping to feed him, dress him, and make him comfortable. We hardly left the house, as getting Mal in and out of cars proved to be quite difficult, so family events were held in the roomy living room, where Mal was temporarily camped.

Meanwhile, I was a junior at Alta Loma High School, and uninterested in all things educational. I just remember feeling so checked out, daydreaming about being back home with my family. Mal was starting the school year out with independent study at home, and I felt guilty not being there for him. The incident with Mal had really put things into perspective for me. Life is fragile and you should be with the ones you love, doing the things you enjoy, and the thing I enjoyed most was being out in my backyard. Not many other kids in the world could say that they had their very own wrestling ring.

As if I wasn't distracted enough about Mal, I was absolutely infatuated with wrestling. During history class, I remember jotting down ideas for wrestling moves and creating fantasy cards for upcoming shows. In science class, instead of following along as the teacher read the textbook, I would secretly read professional wrestler Mick Foley's autobiography *Have a Nice Day*. It felt like everything being taught to me at school seemed so irrelevant. *Why do I need to learn about this stuff? I am*

*going to be a professional wrestler, when would I ever need to use al-
gebra?* I decided I was going to wrestle professionally, and noth-
ing else mattered. Every day, I would come home from school
and complain to my parents about how pointless school was.
I'd beg them to let me finish my remaining time at homeschool.
And it wasn't like I was a bad student, either. I was the type of
student who wouldn't pay attention to anything all week, but
then study really hard the day before a test and somehow ace
it. It was simply that wrestling was calling to something deep
within my soul. It got to the point where I became extremely
depressed and showed up to class with my hood on, isolating
myself from everyone else. The only excitement I experienced
was when I'd pass Dustin Bogle or Daniel Grubbs, my fellow
wrestling buddies, in the school hallway. They were the only
ones who understood, and they were likely going through a
similar crisis.

One day in my HTML computer class, my teacher ap-
proached me and told me that I needed to go to the office.
Shortly after, I opened the office door, and there was my mom
waiting for me. "I'm getting you out of here," she said. It was
like she was rescuing me. On the drive home, she told me I'd
be homeschooled from now on, but she was stern and listed her
numerous expectations of me. I was expected to not only stay
on target with my curriculum but to be *ahead* of my class. While
she was very hands-on with teaching math, the subject that gave
me the most trouble, she was lax about all other subjects that
came easily to me. This, in turn, made me feel self-reliant and
independent, like an adult should. I promised my mom that I
would overdeliver, and I stuck to my word, finishing all of my
work six months early and graduating with all As and Bs.

Mal would slowly heal and eventually win a lawsuit against
the lady that hit him with her car, but he wouldn't see any
money from it until he was eighteen years old. Because of his

injury, my parents had no choice but to homeschool him as well. And since DJ had graduated high school in 2000, Nick didn't want to be the only Massie kid who had to go to "real school," and so my parents let him enter homeschool too. Every day my brothers and I would sit together at the table and rush to get our schoolwork done. I remember times when I'd be out back in the ring, lying on my stomach with my feet in the air, finishing my classwork, and my friends would walk into my backyard and rage with envy upon seeing me.

By this point, everybody in the neighborhood had heard about BYWA. We were drawing crowds of thirty to fifty kids every show, and we were getting good because of all the practice we were doing. Mal would watch for months on the sidelines, dying to get back into the ring. In fact, as soon as the external fixator came off his leg, and he was relearning how to walk, we'd sneak him into the ring whenever my parents left the house. "Get up there and do a Moonsault before you begin to fear it," I would say to him. And he did, fear being the last thing on his mind. Technically, Mal was doing backflips off the top rope and landing on his belly before he learned how to properly walk again.

Our group of wrestlers was changing. Daniel Grubbs, one of my best friends and one of our core wrestlers, had decided he no longer wanted to be a wrestler. He'd always treated it as a hobby, and I think he just simply lost interest. It felt like I had broken up with a girlfriend the moment he told me. When Daniel left, a muscular Italian kid named Darrin DeMasi, who was Nick's age, started coming around. Right off the bat, he stood out from a lot of the guys because of how high he jumped and of how easy everything came to him. He became a main fixture in our group.

Through a connection I made while participating in another backyard wrestling show at the Anaheim Marketplace,

Dustin Bogle and I were invited to come to a professional wrestling school because, of our group, we were the only ones old enough to attend. Well, that wouldn't matter because what we thought was a *school* turned out to be someone's house, and that someone was Ron Rivera, "the American Wildchild." Ron was a short, stocky guy with bleached-blond, shaggy hair and was best known as a WCW jobber, or someone who would lose to the superstars in the big leagues. But at this point in his career, he trained people at Rudos Dojo and ran an independent wrestling company called Revolution Pro. Revolution Pro was heavily influenced by the Mexican style of wrestling, known as Lucha Libre (when most people hear Lucha Libre, they think of the Jack Black movie *Nacho Libre*, which satirizes much of the Mexican wrestling culture). Rudos Dojo sounds fancy, but it was just a ring in Ron's backyard located in La Mirada, about an hour's drive from Rancho Cucamonga.

Dustin and I arrived late on our first day and found everyone else in the ring warming up. Next to the ring, a few feet away, were cages full of chickens who were clucking so loud you could hardly hear the person in front of you. A couple of chickens were even loose out back, liberally pooping wherever they wanted, including in the ring. That didn't deter us. We signed waivers, paid the $10 fee, put on our knee pads, and laced up our Asics wrestling shoes. Dustin entered the ring first and appropriately shook all eight or nine of the wrestler's hands as he introduced himself. I did not. I was MR. BYWA and, as such, had developed a big ego and didn't want anything to do with wrestlers from other clubs, especially when it meant being courteous to them. I was the best wrestler out of our crew and had gained a small following from the video clips I uploaded online. I was also physically developing into quite a young man. My hair had grown long past my shoulders, and all the time I had spent in the gym awarded me scoped arms and ripped abs.

This was beneficial outside of the ring, too, as whenever we'd go to the mall on Friday nights, I began to get more attention from ladies. I liked that. Between my success as a backyard wrestler and my new looks, I thought of myself as a big deal.

After Dustin finished properly meeting everyone, I stepped onto the apron and began climbing the ropes until I ended up on the top rope. I stood there perched and gestured for everyone to please move back. Everyone returned my order with shocked looks. With the space that I needed now available, I jumped straight into the air and did a Shooting Star Press—which is a forward-moving backflip—and stuck the landing perfectly. Then, and only then, did I stick my hand out and introduce myself to every person in the ring. "Nice to meet you, my name is Mr. BYWA," I said.

One by one, every guy I met shook my hand and peered at me with death eyes. Except for one, a handsome African-American man in his early twenties who greeted me with a warm smile. That guy, Scorpio Sky, would end up being one of my best friends in the wrestling business. Sky taught me how to properly lock up for the very first time as soon as training began that day. I remember him being so patient with me. But eventually, I would have to work spots with the other wrestlers, running through a series of movements with them and ending when one of us finally bumped the other. That was when things got rough for me. I didn't realize at the time that I had a target on my back. Since I hadn't properly introduced myself to everyone, the wrestlers began chopping me, more times than the spot called for, and forearming me right in the face. If the drill called for a move, I'd be on the other end of it being stiffed purposely. For three hours, I basically got my ass kicked. Dustin, being taller and bigger and not so egotistic, didn't get it that bad.

Driving home that day, I was surprisingly humbled. My body ached and my head felt like it had weights stacked atop it, but I didn't mind. I'd had a blast. But as you might have guessed from having read this far, my parents freaked out upon seeing my bruised body. My dad told me I couldn't go back. I insisted it was nothing, and a week later, Dustin and I returned to Rudos Dojo. I came home that day with a small black eye and busted lip from a stiff forearm. Seeing this new slight, my dad said he was going to call the cops and charge Rudos for assault and battery. I insisted that I was being initiated, that every wrestler went through this sort of thing. Dustin and I went back. Every week after driving back home from wrestling school, we'd meet the rest of our crew who were waiting for us in my backyard, and then go over everything we'd learned earlier that day. Eventually, the more Dustin and I kept showing up to Rudos Dojo, the more everyone started to like and respect us. Ron Rivera clearly saw something in me, and always chose me to work with or to use in demonstrations to the rest of the class. By this time, we had been able to train and learn from Southern California wrestlers who also attended the training, like Quicksilver, Ronin, Johnny Paradise, Disco Machine, Human Tornado, King Faviano, Black Metal, and eventually, Super Dragon. Of all the wrestlers in Southern California, Super Dragon was by far the most popular, discussed frequently among us boys and on the internet as well. He wore a black mask that looked like the head of a dragon and a full bodysuit, and he had a bad reputation for the way he stiffed and bullied wrestlers in the ring; the mere mention of his name would divide a room. That didn't matter so much because, at the end of the day, he was booked all over the northeast, and he even had a couple tours of Japan under his belt, which was unheard of for a Southern California wrestler at the time. So, when people

in the class started whispering that Super Dragon would be hosting a training session one afternoon, I anxiously recoiled. *Will this guy drop me on my head today?* I thought.

That afternoon, as we stretched in the ring, I heard a voice say, "Okay guys, let's get started." I looked up and saw a skinny, white guy standing there. He *was not* Super Dragon. The white guy, whom everyone referred to as Danny, was as nonthreatening as anyone could be and courteously shook hands with everyone in the ring. But then, one of his fellow wrestlers who was also going to train that day, climbed into the ring and approached him. "What's up, Dragon?" the man said. My mind was blown. *Wait. That's Super Dragon?* I thought.

That was when I learned a lesson that I take with me all these years later: looks can be very, very deceiving. So deceiving, in fact, that at that moment I could feel a little bit of that MR. BYWA supreme confidence coming back to reclaim its throne. As the training session began, Super Dragon called for a drill where we would send our opponent into the corner and deliver a basic clothesline. It was my turn, and when I sent my opponent into the corner, instead of performing a clothesline I ran up off his chest and did a backflip. I beamed, thinking that I had impressed Super Dragon. Not quite. Super Dragon pulled me aside and said, "If I tell you to do a clothesline, do a clothesline." I didn't listen, since I was still convinced that he'd realize how good I was if I kept proving my athleticism. The next drill Super Dragon wanted was another basic one: lock up, body slam, hit the ropes, and drop an elbow on the opponent. When I locked up with my opponent, I body-slammed him and then hit the ropes as I was told. But instead of dropping a simple elbow, I decided to do a running Shooting Star Press, which I also nailed perfectly. I looked to Super Dragon for approval, but he wouldn't even return my glance. In fact, it felt like he ignored me the rest of the session. About a year later,

Super Dragon would end up opening Pro Wrestling Guerrilla, and years later he'd refuse to book myself or my brother on his shows because of the way I acted that day. Super Dragon might be small in real life, but Super Dragon never forgets.

Back at home in our backyard, we were still running our BYWA events, and through the education Dustin and I were gaining through Rudos Dojo, our whole crew had a basic understanding of the fundamentals of wrestling: how to properly roll, bump, lock up, hit the ropes, and give basic maneuvers. All of the hard stuff, like the acrobats and stunts, we had mastered ages ago. But now, we knew the all-important basics. At this point, Nick had started to separate himself from everyone in the group. It was clear that he was naturally gifted and learned faster than anyone else. Only thirteen years old, he was doing things in the ring nobody had ever seen, like adding an extra twist or flip to a dive from the top rope. Often, we'd play games of "Can you top this?" where you would have to repeat whatever trick someone did before you. Nick couldn't be beat.

Meanwhile, Mal finally made a full recovery and was out with us every day in the ring, just like before. One day, our parents sat all four of us down, including DJ, who felt so much older, and somberly broke some news. "We're putting the house up for sale and moving to Hesperia," my dad said.

"What?" Nick shouted. I was speechless.

"Rancho Cucamonga has become too expensive, and there isn't much work for me down here anymore. We're going to find a cheap house up in the high desert," he said. The high desert he referred to was an hour away from Rancho Cucamonga. For a bunch of kids who didn't even have their driver's licenses yet, we might as well had been moving to another country.

"What about the wrestling ring? What about BYWA?" I cried.

"I'll build you a new, better ring. And I'm sure the guys

will drive up there. DJ's done with school and you guys are all homeschooled. This'll be an easy adjustment."

Rancho Cucamonga was our home. It was all we knew. But as much as we protested, our parents' decision had already been made.

We hosted our final BYWA show where the main event would be Mr. BYWA versus Slick Nick. We wanted to go out with a bang—the two biggest BYWA stars going head-to-head. As such, Nick and I held nothing back. After he pinned me to the mat (as I knew he would), the entire crew of wrestlers ran into the ring for a big dogpile hug. I cried like I had never cried before in my life. We had all created such a strong bond over the past two years, and I didn't want it to ever end. I even get emotional talking about it all these years later because, more than anything else in my youth, those two years building and running BYWA molded my entire future wrestling career.

May 23, 2003, the day we moved into our new home in Hesperia, was a dark one. Hesperia was only about fifty miles away from our old home, but I swear, as we drove past cactus and tumbleweeds in the middle of the road, I felt culture shocked. We eventually pulled up to a huge house, maybe twice the size of the old one, with a massive Joshua tree, cactuses, and rocks out front. Already missing my friends, I raced toward the moving truck. The only box I had plopped inside was labeled in my sloppy penmanship in black marker: "Computer." Before my room was even put together, I plugged in and reached out to all my friends on AOL Instant Messenger. Not three hours had gone by and I missed them completely.

A couple weeks passed. Before even officially settling into the new house, my dad kept to his promise and began con-

struction on our new wrestling ring. We had learned a lot more about rings in the previous two years, so we were determined to make a better one, with strong cable ropes this time around. With all hands on deck, we had this new ring up in five days. The softer sand in the desert was one of the only obstacles, making it difficult to cement the four steel posts in without them shifting. At last, we eyed a carpet store on Main Street, took all their unused carpet padding, and ordered a custom red ring canvas from a factory. I could sleep better knowing our new place was starting to feel more like home.

But I felt lonely not having my friends with me at every waking moment as I had had before. I also longed for the companionship of a girlfriend. I'd pretty much dedicated my entire life at that point to wrestling and never even thought about girls, but now that I was eighteen I wanted to meet someone. Before social media became popular, there were websites called HotOrNot.com and RateUSA.com, where you'd put up a picture of yourself and people would rate your physical attraction from one to ten and make comments below your photo. Sounds shallow, right? On July 1, 2003, I received a comment from RateUSA.com user "RoxyRiverChick."

"Hey, is this Matt Massie?" she wrote. "I think we used to go to school together?" I clicked her profile and immediately recognized her. It was Dana Kruse, and she was thin, with beautiful green eyes, blond hair, and a winning smile. I had barely paid attention to her at my previous school. I always thought she was cute, but now? Now she was a total babe. We swapped AOL Instant Messenger screen names and started chatting further. "I'm sorry for being a dick that one time at that football game," I wrote to her. She acted like she didn't know what I was talking about, but she knew exactly what I was referring to. When I was a sophomore and she a freshman, our friends attempted to set us up at a high school football game.

Apparently, Dana had a pretty big crush on me. At the concession stands, which was to be the meet-up spot, Dana was practically pushed by her friends to meet me. She blushed and smiled, her braces showing. She was adorable. But I wasn't really interested in having a girlfriend at the time, and I felt embarrassed that my friends were watching and judging me. Also, I knew how *uncool* it would be to date a freshman. So, I smiled back, said hello, and then turned around and walked away. She would later admit to me that she tried to erase that memory from her mind because it was humiliating for her, and in our instant message chat I profusely apologized. She was impressed that I remembered it at all.

After chatting for a few minutes, we realized that we grew up in houses only one block from each other in Rancho Cucamonga. We were practically next-door neighbors for about eighteen years, and I'd had no idea. In turn, she had no clue about BYWA or that I'd had a wrestling ring in my backyard. But she was curious about whatever happened to me at school, because, as she saw it, one day I just disappeared. We hit it off and traded cell phone numbers. Great talking to you tonight, stud. Xoxo, was the first text message she ever sent me. I remember lying in bed and reading it over and over. The fact that we were now many towns away stung even harder.

The following evening, we had a marathon conversation on the telephone that went into the next morning. We discussed our dreams, goals, family, relationships (or my lack thereof), and everything in between. Not long after, she drove the hour each way to come see me, and we spoke in person for the first time since the football incident. No other girl had ever paid attention to me or spoken to me the way she did; we had a chemistry that was hard to contain. She might not have known at the time, but I knew right then and there that one day she would become my wife.

High Risk Wrestling

NICK

Everything about Hesperia was different: we didn't have many food choices, shopping, or even entertainment. To go see a movie and shop at the mall, we had to drive thirty minutes over to the next city, Victorville. I feel bad about it now, but I gave my parents the silent treatment for at least a couple of weeks. When I did talk, I told them in bitter terms, "This is the worst thing that's ever happened to me."

The only thing I didn't mind about Hesperia was the house. It was a lot bigger than the one before. My brother Malachi and I were used to sharing a small 150-square-foot bedroom in Rancho Cucamonga where we had bunk beds; now we had separate beds in a room three times the size. That wasn't the only benefit, though. The new house was also, well, more peaceful than the other one. I don't know if I believe in the paranormal, but strange things happened at the old house that we still cannot explain.

Nighttime at the house in Rancho Cucamonga was eerie, and I don't remember ever not being scared. As a matter of fact, I'd be so scared lying in bed that I'd refuse to go to the bathroom and just wait until the sun came up. On the rare occasion I did use the bathroom in the middle of the night, I would run as fast as I could, flick the light on, and pee with the door open. What prompted this fear of mine? Lights would randomly turn on and off all of the time. Or the TVs would turn on and then the volume all the way up with it, which would wake everyone in the house. Sometimes, our car horns would be set off (by what, I'm not sure) and wake the neighbors. Doors and drawers would slam shut without explanation. At a certain point, when enough of the family started noticing these peculiar events, we took night shifts and sat by the TV to try and discover what was creating these disturbances. I would hold a flashlight in the cavernous silence and hope I'd have nothing to report come morning.

We never found anything.

One time at the dinner table with the family, I heard a faint voice, almost like a whisper, say my mom's name.

Joyce.

Upon hearing it, we looked everywhere inside the house, and then out in the backyard and the front yard to see where the voice came from. Returning with no answers, we settled back at the dinner table, and then heard it again.

Joyce. Joyce.

We never found out what said her name.

Friends visiting for the first time would notice occurrences, too. One night, Daniel Grubbs slept over, and we stayed up pretty late in Matt's room. By the time we got ready to go to sleep, we started talking about how creepy the house was. In the middle of the conversation, Matt turned on the strobe light he had in his room and the entire room lit up, prompting us to

scream. The second we found out it was Matt, we all laughed and shook it off. A few minutes later, we decided to try and sleep, and as soon as the room was dead silent, the strobe light went off again. We panicked and Matt shouted, "Guys, this time it wasn't me!" I told Matt to unplug the strobe so the light couldn't possibly go off again. We watched him unplug the cord and lie back down, several feet away from the outlet. To everyone's shock, the strobe light went off again! We slept with the lights on for the rest of the night, enveloped in the cold terror that had presided over the room. I can't remember Daniel ever staying the night at our house again.

Matt might've experienced the strangest encounters of all. One time, upon unlocking the front door, it pushed right open and he saw something run into my sister's bedroom. He went to investigate, but being too scared to do so, called my dad and demanded he come home. A few minutes later, we arrived to find Matt sitting on the kitchen counter, shaking and holding steak knives in both hands. Per usual, my parents found nothing or nobody there.

My parents would never admit to seeing or hearing anything out of the ordinary. Well, not until the last day in that house. The day we moved out my dad called for a family meeting. We all gathered in the empty living room where he finally admitted to us that our uncle Dave, who is a police officer, warned them before we moved in that a girl had been shot and killed inside years before. I'm not sure if his telling us this before would've helped us understand the occurrences or made us more fearful, but at that moment I was grateful for getting the heck out of there.

As time went on, we started getting used to Hesperia's desert lifestyle. And as a gift to me and my brothers, Dad gave Dustin Bogle his old work van that sat eight to ten passengers; that way, Dustin could drive all of the wrestlers from Rancho

Cucamonga to our place in the desert. Dustin was the only one among us with a driver's license, and he didn't mind doing the one-hour-long drive up the hill and one hour back, once a week, to keep the wrestling going.

Since we had moved and were getting older (I was now fourteen and Matt eighteen), we felt like BYWA needed a name change. We came up with High Risk Wrestling, or HRW for short. We thought this name fit perfectly because we all loved doing dramatic moves like dives, flips, and tumbles. It was a new era and things were evolving a lot faster. We were stronger and more athletic, which naturally made our matches more thrilling. With the changes, Matt also decided to start going by *Mr. Instant Replay*. He said, his moves were so unbelievable, you'd have to go back and watch it again. While Matt and Dustin would go to actual professional wrestling trainings and teach us what they learned afterward, I felt like this wasn't enough. I wanted to go and try it for myself. So, one day, I went with them to Rudos Dojo wrestling school. There was an age restriction, but by this time Matt had gotten his foot in the door and talked them into letting me train. On this day, an experienced wrestler named Black Metal was helping lead the class, and, to intimidate me, would yell, "Get up, little sister! You can do better than that, little sister." He was mocking me for being Matt's younger brother, and also for being tiny. Remember, I was only fourteen years old, probably five foot two inches tall, and super skinny, with long blond hair. Black Metal's derision, while it hurt, also made me work harder to prove that I was able to keep up with any of the older (and larger guys). I was on my way.

But first, let's talk about wrestling gear! BJ Walker, who was now known as "Sexy" Sonny Samson, was the first person to come to our backyard shows with full gear. He had wrestling boots, a singlet, and knee pads, and we all thought he looked

like an actual professional wrestler. He'd come up with the idea to wear boas, sunglasses, and to act more flamboyantly. His big move was called the Sexy Elbow, where he'd take his shirt off and feel up his own chest, sometimes going as far as to lick his own nipples. It was effective insofar as it would get an enormous reaction from the audience. Sexy, who was also the most advanced wrestler among us, influenced us to go and buy more legitimate wrestling outfits. We took to the greatest tool we had at our fingertips: The internet. This led to my finding the website Highspots.com, which was where the majority of us would order our first-ever pair of wrestling boots. To save money and avoid shipping and handling fees, we went to local sporting goods stores and found singlets and spandex, and we went to arts and craft stores like Michael's to find iron-on letters or logos to sew onto them. My favorite color has always been blue, so I got short spandex that were dark blue and I embroidered "Slick Nick" on the back of them.

We were running HRW shows every weekend, and I got over being mad at my parents for moving away. Malachi and I thought it would be a great idea if we covered the walls in our room with wrestling posters, so we started taping up photos from the *Pro Wrestling Illustrated* magazines that we collected. By the time we were done, every inch of our room was covered with posters (credit goes to my parents for allowing it). I look at pictures of the room now and think they were crazy to let us do it, but my parents never thwarted our passion for what we loved.

I wanted to be doing something that involved wrestling, but I also grew up loving basketball. Pursuing basketball professionally didn't seem possible because I wasn't very tall, but wrestling seemed like something anyone could do. My size didn't stop me from playing a lot of basketball as a teenager, though. Some of my fondest memories growing up involved

pick-up games with my dad and all the other wrestlers. We got so competitive that many games would end in a huge fight or a twisted ankle. We also broke plenty of glass windows during this time because the basketball hoop was so close to our house.

At this age I'd been to enough WWE shows to know in my heart that it was something I was going to do for a very long time. This was verified after going to a live *Monday Night Raw* on October 7, 2002, in Las Vegas at the Thomas & Mack Center. The main event happened to be a Tables, Ladders and Chairs match with three of my favorites: Jeff Hardy, RVD, and Chris Jericho. I had never heard a crowd roar the way it did after seeing those guys crash through tables and soar off of ladders. And coming home from that match, Matt and I knew we had to keep going after this dream of ours. As a result, our backyard shows became heightened, more dramatic.

We wanted our biggest show of the year, *Highway 2 Hell*, to be spectacular, so we used fireworks for some of the wrestlers' entrances. For Dustin, the show's main event, we had to think of something even more special. Dustin himself came up with the brilliant idea: he asked his dad, a diesel truck driver, to drive him toward the ring while he stood on the hood of the diesel. So, when it came down to showtime, my dad snuck over and opened the big gate, Dustin's trademark Diablo music played, and out came the massive truck with Dustin on top of it to the delight of the small audience. Even today, in a world full of special effects and countless cinematic moments, it would be a pretty remarkable way to enter the ring.

Matt and Dustin continued to go to Rudos Dojo for sessions, and Ron Rivera was more impressed by them by the day, as they seemed to pick up the basics faster than most of the students. After Matt and Dustin went to wrestling school off and on for about a year and a half, Ron finally asked them to come to a show that was being run at a park during a Memo-

rial Day festival in Arcadia, California, on May 31, 2004. I say "show" loosely, as it was more or less a street fair where a random wrestling ring was set up in the middle of a field. There were no admission tickets and anybody could just sit by a tree and watch the matches.

Sonny Samson and I came along with our gear to see if we could get booked. Ron, upon seeing us, offered us this deal: if we set the ring up and helped tear it all down after the show, we would be able to wrestle on the show. We both happily agreed; it was a small price to pay for my first "professional" wrestling match as a fourteen-year-old.

Ron said it would be Matt and me versus Dustin (Diablo) and BJ ("Sexy" Sonny Samson) in a tag match. Around this time, Matt and I were singles wrestlers or usually opponents to each other, but getting to wrestle with him assuaged some of the nerves I felt. The Memorial Day festival featured tons of other spirited events, but even so, a couple hundred people came over to watch us. And we must've been good, too, because after the event Ron invited us to another show. An actual professional wrestling show. But to protect us, he wanted us to be hidden under masks the next time around. While we had potential, we were still very green, and sometimes it's hard to shake off a bad first-time impression. Ron knew we weren't quite ready to be completely out there. The masks protected our identities.

On August 7, 2004, Ron told me, Matt, Dustin, and BJ to come down to the Frank and Son Collectible Show, where he had an opportunity for us. He had conceived a silly idea in which a bunch of the less experienced wrestlers (including us) and students who'd never even had a professional match would dress up in Halloween-type gear and have a comical eight-man tag match to kick off the Revolution Pro show. One team would be called the Monsters and the other team would be called the Hillbillies. BJ, playing a werewolf, would fend off Dustin, who

wore overalls and a mask with a wig on top, and whose name for the evening was "Mullet." Matt had the best costume of all. He wore a full bodysuit, complete with fur and a tail. His mask had big ears and whiskers. As Matt was getting dressed, Ron looked at the costume and laughed. "You're going to be 'Fluffy the Dog,'" he told him.

Sure enough, when Matt and Dustin entered the ring, Dustin walked Matt out on a leash. I was assigned referee duties for this particular match, but I wasn't an ordinary ref. Instead, I wore a luchador's mask, and I had a fun spot where I got frustrated that the wrestlers wouldn't get back into the ring and fight. That's when I dove off of the top rope onto every wrestler in a giant pile. The building exploded. The segment was a huge hit, and Ron was thrilled.

On October 19, 2004, Ron told me to go into his locker room and open a black bag where my costume for the night could be found. A few minutes later, I pulled out a yellow-and-red mask with a beak, and a full body suit with feathers around the neck. It was a chicken outfit. *This was some sort of joke*, I thought, but then, considering how much confidence Ron had instilled in me over several months, I told myself this: *Do your best, and be the best chicken you can be.* Ron said the name of the gimmick was called "El Gallinero," which translates from Spanish to English as "Henhouse." This time, I teamed up with "Sexy" Sonny Samson and wrestled Matt, who was back in his Fluffy the Dog costume, again teaming up with Dustin as Fluffy's hillbilly dog owner, Mullet. Once more, we committed to the bit and had a great segment.

December came, and with it rumors that Revolution Pro was going to close its doors. On December 4, while we set the ring up for the show, the rumors were confirmed when Ron pulled me, Matt, Dustin, and BJ aside and told us he wanted to reward all of our hard work by letting us open Revolution Pro's

final event. I had a lot of respect for Ron, and I realized that he was putting us in an important spot on his final promoted show. It meant the world to me. Matt and I would team up this time, and both of us would don the chicken costumes, collectively calling ourselves Los Gallineros. Even though it was a big opportunity for us, I hated having to wear a mask. Matt and I entered the ring, clucked like chickens, and wrestled our hearts out, while Dustin got to play his Diablo character and BJ played his "Sexy" Sonny Samson persona. We had the crowd rocking, and probably had the best match of the show. It was clearly the most exposure we'd ever had up to that point. "Congratulations, guys!" shouted an excited Ron, who was waiting behind the curtain. As he hugged me, I could feel the emotion contained in his body. I didn't realize the gravity of the situation. While this was just the beginning for us, it was the end for him. Ron would never run a show again, and it would be the last time I'd see him, even to this day.

Everything in wrestling, like in life, comes full circle, and now that we had some experience, we wanted to pick up more bookings. We returned to a familiar place: the Anaheim Marketplace. We started out by going to a show that was headlined by Frankie Kazarian, a handsome, jacked, long-haired wrestler we dreamed of looking like one day. My brothers and I were huge fans of Frankie because he would wrestle for Ultimate Pro Wrestling, or UPW, which aired on one of the local channels that we'd stay up late to watch. UPW was where we first heard about a lot of the Southern California wrestlers, and it was where I first saw guys like Christopher Daniels, Aaron Aguilera, and a Canadian twin brothers tag team called the Ballard Brothers. UPW was also a farm league for the WWE. Around this time, WWE was still the number one wrestling company in the world, but it was certainly on a downward slope, coming off of its most popular years in the late 1990s. Still, every

aspiring wrestler dreamed of one day working there, and UPW was helpful in getting one to that place. After watching Frankie Kazarian mesmerize us and the dozen other fans in attendance that day, we talked to Martine, owner of the local independent company called World Power Wrestling (WPW) and asked him if we could get a spot on his shows. He already knew us from the previous times we'd been around, and we'd built a friendship. He told us that if we showed up next week he would see if he had anything for us.

We'd return to the Anaheim Marketplace almost every weekend and help set up chairs, pass out flyers, referee the matches, and film them. It was the same stuff we did in the backyard, but now we had confidence in what we were doing. And most important, we learned a couple tricks of the business: most pro wrestlers knew how to plan their matches in the locker room, never having to step foot in a ring. They plotted their shows formulaically, almost like they had a cheat sheet that we never knew existed.

All of this is to say that we still wanted to run our shows, but now we wanted to do it more professionally. And to be more professional, we needed a wrestling ring that we could transport. We also needed an actual building to run the shows inside of. Since some of our neighbors in Hesperia weren't as friendly as the ones in Rancho Cucamonga, we kept getting the cops called on us for noise disturbance until, finally, the city officials came and tried to shut us down. We took this all as a sign that maybe it was time to move on. So, Matt did some research online and found a website called MonsterWrestlingRings.com. My dad, again one of the most supportive men I've ever met, promised to pay the $5,000 it would cost to buy the ring and have it delivered to the house. He told us he was investing in our business—one, I believed, that would pay dividends.

We looked everywhere around the high desert but couldn't find any buildings for a fair price. We didn't have much of a budget to work with because Matt and I would be fronting the bill for it all. One day, while meeting up with my cousins who had recently just moved up to Hesperia, we gathered in an old skating rink called Holiday Skating Center, off of the Palmdale exit from the 15 freeway, a little past Victorville. The family wanted to skate, but while there the only thing my dad and I could think about was how this looked like the perfect building for a wrestling show. The built-in sound system and lights that were already there lent a professional feel, and all it needed was a ring and chairs. My dad spoke to the owner, Barry, and pitched the idea right then and there. He got Barry's contact information, and a few days later Matt drove over to the skating rink to make a deal with Barry, who had agreed to rent out the building from 5:00 P.M. to 9:00 P.M. for the bargain price of $300. We would be let into the building at 5:00 P.M., so we'd only have an hour to have the entire ring, chairs, and locker room set up and ready to go. That would be tight. The other major obstacle was the building's availability. Barry wouldn't agree to rent the building out on a Friday, Saturday, or Sunday night because that was when they did their biggest business, so Matt agreed, haphazardly, to run a show on a Thursday night.

When the night came, the doors opened right at 5:00 P.M. on the dot, and like a well-oiled machine we had the entire show ready with several minutes to spare. My dad was the host and welcomed all two dozen fans to the inaugural event. We charged $6 admission to try to make up the cost of the venue, and all of the wrestlers happily worked for free. We didn't care how many seats were filled that night; we were in this for the long haul. We put together a short five-match card, and two hours later, the fans went home happy. Although it was our first

real event, it ran smoothly because we'd already had experience with running shows for years.

At home, Malachi and I shared a bedroom that my dad converted from a garage. Since we were homeschooled, we spent most days together doing our classwork before joining Matt who was usually in the ring outside training, or clanking dumbbells together in his room. All of us were growing bigger, becoming more and more obsessed with the aesthetic of professional wrestlers. Mom and Dad would complain that we were "eating them out of a house and home," as they struggled to keep the refrigerator fully stocked for three growing boys, not to mention several other wrestlers who frequented our home on a never-ending conveyor belt. Us Massie boys were smaller in stature, so we'd never look like the wrestlers we grew up watching, but we were going to work our hardest to look like pros.

Even if I wasn't the biggest guy, nobody was going to match my perseverance. To this day, my parents call me "the Survivor" referring to how I survived my mom's pregnancy. That nickname became something I wore like a badge of honor, every day of my life. My unwillingness to lose and competitive nature defined me. I was an animal on the basketball court, playing until my feet were full of bleeding blisters. I would compete against much older, bigger guys, and almost never lose. I wasn't more talented than them; I just played harder. Many video game marathons with my brothers would start out friendly and end with one of them slamming down their controllers while I celebrated. They didn't have the stamina and energy that I had, but nobody really did. I lived to win.

We continued to run successful High Risk Wrestling shows and would get booked on several smaller shows in the area. Instead of enjoying what we had achieved, however, I kept thinking about the next phase. The Survivor in me needed more.

Superhero Origin Story

MATT

FEBRUARY 16, 2005

We pulled up to the historic Grand Olympic Auditorium, a building in Los Angeles famous for rock concerts, roller derby, boxing, and, of course, professional wrestling. Gorgeous George, Buddy Rogers, Roddy Piper, and Andre the Giant had all once competed in this venue, and we couldn't help but feel we were entering the domain of kings. If you ever ran into an old-timer in Southern California, and wrestling was mentioned in the conversation, he would have a story about how his dad used to take him to the Grand Olympic Auditorium.

A brand new lucha-based company for which we were fighting called Full Contact Wrestling, or FCW for short, had sold that night's show out, so in a few hours around seven thousand people would pack the building. It was by far the biggest event we'd ever been booked for. I was a nineteen-year-old kid,

and only in my second year of having professional wrestling matches.

A couple months earlier, Joey Kaos of Xtreme Pro Wrestling fame had seen us at a little independent wrestling show called Hybrid Pro Wrestling, in Culver City. Nick and I were in a match, on opposing sides, working against each other that night. Joey was helping book talent for the FCW event and was impressed with what he saw. A few days later, while we were working on a construction job site with our dad, he called my cell phone and offered us each $75 to come wrestle him and his partner, Mongol, in a tag team match on the big FCW debut show. I nearly dropped the phone. Before then, we usually only made somewhere between $5 and $25 a show, so $75 was huge! Dustin would soon get a similar call.

Inside the locker room at the Grand Olympic, we felt out of our league because right next to us were guys who'd been in the business for years. Mexican wrestler El Hijo Del Santo, a legendary, silver-masked folk hero, was the big draw for the evening, and he walked around, casually greeting everyone. I looked over to the wall where I saw a piece of white paper being taped. It was that evening's card. I raced over and looked to see where our match was being placed on the card. I scanned the paper, but I couldn't find Slick Nick, or Mr. Instant Replay, anywhere. Finally, I found our opponents' names written on the card. And next to it read, "Matt and Nick, the Young Bucks." Joey Kaos saw me looking at the card and said, "Hey man, we didn't know what to call you guys, in fact, we couldn't even remember your work names, so every time we discussed you guys, we'd go, 'What should we call those young bucks, Matt and Nick?' So, we figured, Young Bucks was perfect!" I smiled and agreed, but my heart sank. I thought Young Bucks was the worst name ever. And what about our sweet gimmick

names, Mr. Instant Replay and Slick Nick? We're just Matt and Nick now?

Showtime approached, and the building started to fill with a largely Hispanic audience who made their presence known with blow horns. Dustin, who was still wrestling as Diablo, had his black singlet on with the red numbers "666" on the back. His match, the first of the evening, was a Four Corners Match, where all four guys were in the ring at once. We wished him luck and grabbed a spot by the monitor to support our friend. His appearance in front of such a large audience made my stomach churn, and it suddenly felt too surreal. The match was going fine until one of the other wrestlers we knew, a short kid named Less Than Perfection, or LTP for short, mistimed a move and fell directly on his head. We all stood there, watching the monitor, waiting for him to move. But he wouldn't. The match concluded, and minutes later LTP was being stretchered out to a waiting ambulance, wearing a neck brace. Whatever fears I had going into this match were now magnified by one thousand.

It was time. I looked at my fifteen-year-old brother, Nick, stretching and psyching himself out, dressed in a blue singlet with the words "Nick of Time" embroidered on the back. Nick had told Joey Kaos that he was eighteen years old, and since Nick had really bulked up in the previous year, Joey bought it. I was wearing red, short spandex with "Instant Replay" embroidered on the back. We didn't have matching gear because we weren't a tag team at the time; we had high hopes to be individual wrestlers on the independent scene. For whatever reason, being a full-time tag team together never crossed our minds. Earlier that day, we had gotten together with Joey and Mongol and planned a match that seemed a bit aggressive. The company had "Full Contact" in its name, so I think they wanted

that part to ring true. Either way, our parents were in the crowd and we knew this would be the type of match they probably wouldn't enjoy very much. Not to mention they were already spooked about what happened earlier to LTP. But all my fears were laid to rest when "We're Not Gonna Take It" by Twisted Sister blared through the arena. Empowered and pumped up, Nick and I looked at each other, and I thought, *This is going to be a good night.* However, the moment the spotlight hit us the entire crowd booed in unison. "Gringos!" they shouted, before we were showered with every homophobic word in the book. We were so green, and clearly in over our heads, that we smiled and yelled, "Come on, baby!" because that was what we had seen Chris Jericho do. Meanwhile, Joey and Mongol entered through the curtain like absolute rock stars. The crowd erupted. Two average-sized Hispanic men, but certainly in the best shape of their lives, they might as well have been Elvis Presley that night, as they marched toward the ring.

The bell rang, and Joey and Mongol came at us quick, knocking us down with stiff shot after stiff shot, showing us what it felt like to be in the ring with men. Of course, every hit on us was done to the approval of the bloodthirsty crowd. Soon, Mongol loaded me up on his shoulders belly first, and began to spin in circles, as Joey climbed to the top rope. I closed my eyes, knowing that this was the finish . . . all I had to do was survive this last move. Joey came off the ropes with a picture-perfect Missile Dropkick, knocking me off Mongol's shoulders, then pinning me. Match over.

As Nick and I helped each other to the back, I thought that that night was an absolute thrill. But it got even better when we received our envelopes. Instead of the $75 we expected, there were crisp one-hundred-dollar bills for each of us.

The next day, we were booked at a small independent show, not far from Grand Olympic Auditorium. Everyone in

the locker room looked at us differently because of what we had done the night prior. Working on a show as massive as that was no small feat and something most of the guys in that locker room had never done—not even the most experienced wrestlers. This show was tiny, drawing maybe thirty fans. I looked out into the little audience and thought about how just twenty-four hours ago we were in front of thousands of rabid people. It was my first indication of the highs and the lows that come with this business. It wouldn't be my last.

Just days after our appearance at FCW, our phones started ringing, and several local independent promotions wanted to book the Young Bucks. At first, we insisted that everyone still call us Mr. Instant Replay and Slick Nick, and we even preferred to be booked as singles wrestlers. In fact, at High Risk Wrestling, we continued to book ourselves that way. But the more we resisted, the more people wanted us to team together. Indeed, every time we were booked, we'd be advertised as Matt and Nick, aka the Young Bucks. Eventually, we just gave in, realizing we couldn't go against what the Southern California wrestling fans seemed to want. After being nudged by Joey Kaos to get matching gear, we bought the ugliest neon yellow spandex shorts from a sports warehouse we'd ever seen, along with tall, white boxing shoes that were on clearance from a boxing website. Truth was, we didn't have much money, so we couldn't afford to buy custom-made wrestling gear from a seamstress like the pros did. We had to get creative. We took the shorts to an indoor swap meet and found an artist to airbrush "Young Bucks" on the back of them. We thought it would be clever to incorporate money into the design, and make a play on words, changing the s in "Young Bucks" to a dollar sign. Call us the rappers of the wrestling world.

Meanwhile, Nick and I transformed our bodies in the gym. We started drinking protein shakes daily and paying closer

attention to our diets. One night, I put on the Arnold Schwarzenegger bodybuilding documentary *Pumping Iron* and was inspired by the poses the bodybuilders did during the competitions. Some were absolutely silly, sure, and sometimes the bodybuilders flashed the tackiest smiles, but the performative aspect interested me. We had the tag team name. We had the matching gear. Now, all we needed was some type of pose we could do. Right then and there, I came up with the idea for us to do the double bicep leaned-over pose, which these days is commonly referred to as "the Young Bucks Pose." While backstage at the next FCW show, we took pictures doing that very pose, and we've never stopped since.

Though our careers were taking off, my relationship with Dana had gone through a rough patch. Dana's mom, Sue, didn't like me. I was broke, shy, socially awkward, had a ponytail, and wrestled practically for free. I might as well have been in a garage band, hoping one day I'd sign with a major record label. I wasn't exactly a catch. I'd eventually win Sue and her husband, Dave, over by treating their daughter right and being honest with them, but I think they had their doubts about me in the beginning. But who wouldn't have their doubts about a dreamer like me? My goals didn't seem practical. How would I ever support Dana from a business like wrestling? I still wonder how I did it.

Dana and I were the cheesy couple that communicated every second of the day, held hands, kissed too much, and spent hours fantasizing about the future. "When I sign my big contract one day, I'll give you everything you've ever wanted," I said to her one night as we snuggled on her parent's living room couch. Dana supported my wrestling, but she thought it was likely a phase in my life, she told me years later. But she was always at my side despite how she might've thought about it. At the end of our days wrestling in the backyard, she would

come help me lace my wrestling shoes, or wet my hair before my matches as I sat behind the shed near where we'd enter to the ring. One time, I even convinced her to walk me down the aisle to the ring. She was flexible with me, basically giving up every weekend so I could chase my passion. And by this point, Nick and I were finally gaining some momentum on the independent scene with our newfound fame as the Young Bucks, so I couldn't skip an opportunity, which meant, if I had to break a date with Dana for a wrestling show, I would. To her, it felt like I continually chose a hobby over her and that I was neglecting our relationship. Wrestling wasn't paying the bills—I might've made $25 to $50 a weekend—so I worked with my dad in construction full-time during the week, which was extremely hard labor on my back, but which paid $100 a day. I was also taking a few courses at community college, just so I could get the financial aid. That didn't last long. And, just about to turn twenty years old, I still lived at home with my parents and wasn't even close to getting my own place. Between my and Dana's busy schedules, and living an hour apart, it took a toll on our relationship. One day we got into a massive fight, whereby she told me she had had enough of being my second priority and gave me an ultimatum. She said wrestling wasn't going to get me anywhere, and I needed to take school seriously and get a degree. It was either her or the silly wrestling thing. I argued that if she truly loved me, she wouldn't make me pick. We broke up that day. I'd never felt pain like that. I drove home and cried like a baby for an entire hour and locked myself in my room for weeks. None of it made any sense to me. Dana was supposed to be my wife, and we were supposed to have a family together. I'd already seen it play out in my head. What happened? Where had I gone wrong?

Reeling and depressed, I made the decision to go full force into wrestling. It was the only thing that made me feel better.

With the extra time I now had, I dedicated myself to the business. The HRW crew and I would hit the streets and spend three nights a week putting flyers and posters out for our latest upcoming show. Dustin and me, being the oldest in the group, had the entrepreneurial spirit, even at a young age. We would visit local businesses and pitch sponsorship ideas. We made an agreement with the local smoothie shop to pay for our ring skirt if we put their company logo on it. We convinced local restaurants to sponsor events, and in return we'd print coupons on flyers that we handed out. I'm not sure what the business owners were thinking when two twenty-year-olds with ponytails and tank tops walked into their offices and stores and unleashed pitches about how their pro wrestling company could benefit their business, but nonetheless it worked. On Saturday mornings, we'd set the ring up in my parents' backyard and teach kids the basics of wrestling, charging $10 a head. There were times the ring was filled with twenty eager kids, ready to learn. We knew we weren't yet seasoned pro wrestlers, but we also knew we could teach bumping, rolling, running the ropes, and basic spots. The people who came to train had either heard of us online or had been to one of our shows. Everyone had to sign a waiver before entering the ring. Our parents had taught us well: avoid trouble at all costs.

On April 3, 2005, the entire gang drove down to Los Angeles to watch *WrestleMania 21* at Staple's Center, where the infamous Shawn Michaels and Kurt Angle match took place. The two went counter for counter, and had the most back-and-forth, athletic wrestling match I'd ever seen in person. We somehow managed to get tickets to the big show, but our seats were spread out and we were forced to sit with strangers. I remember mak-

ing friends with the people next to me and telling them I was a professional wrestler, and that one day I would be famous. I told them I was Matt Jackson, and that they should remember me. Three years later, after wrestling as an extra against Chuck Palumbo on *WWE Smackdown*, one of those fans I sat next to sent me a message on Myspace. He told me he'd been following my career since that night and was so happy for me. That was when I realized how tight of a community the wrestling community is.

The highlight of *WrestleMania 21* was Hulk Hogan coming out as a surprise guest. I'd never heard a crowd erupt like that. Hulk had always been my favorite, and I was happy that I'd gotten to experience him in person. After his appearance and the Shawn versus Angle match, I left the arena inspired and hungry.

A few months later, on July 16, 2005, FCW was running its third consecutive sold-out show at Grand Olympic Auditorium. We were booked against one of the most popular tag teams in Southern California, Los Luchas, two wrestlers named Phoenix Star and Zokre. We had gained tons of confidence since the first FCW show and were now working regularly every weekend as a tag team. We meshed so well with Phoenix Star and Zokre and tore the house down that night, performing the best on that night's card. We were still treated like the bad guys during the match, but we could slowly feel the light touches of acceptance. The highlight of the show was sharing the locker room with one of our favorite wrestlers, Chris Kanyon. His big run came in WCW years earlier, where he was mostly known for making the bigger stars look good. He was probably the first wrestling star I watched regularly on television with whom I got to meet and mingle. Taking a big swing upon talking to him for the first time, I mentioned how my brothers, friends, and I ran an independent wrestling company called HRW, and how

we'd love to have him on a show one day. He expressed great interest and told me he'd love to. A few days later, sure enough, Chris Kanyon called me. "Hey bro, it was so nice meeting you and your brother the other day. I'd really like to come do your show."

Months later, Dustin and I waited at arrivals at LAX Airport for Chris Kanyon to show. Kanyon and I had become friends by then and spoke on the phone a couple of times a week. He had agreed to do our Halloween wrestling show on October 27, 2005, for a bargain price of $500. Nick, Dustin, and I split the cost among the three of us. That night we noticed what a difference there was in crowd size when booking a former television star. We had about three hundred people fill the Holiday Skating Center on a Thursday in Victorville, our biggest crowd to date. Kanyon wrestled in that evening's main event, teaming with Tarantula to take on Luke Hawx and Nick. He even insisted that the opposing team win.

Kanyon and I would continue to chat all the time on the phone. He shared everything with me. It was he who told me the news of Eddie Guerrero's death before it was publicly acknowledged. Another time, he called me and with a serious inflection said, "I don't want you to think of me any differently, but I really need to tell you something." I insisted to him that he could trust me, that I'd always be his friend, no matter what.

"Bro, I'm gay," he said after a prolonged silence.

"Dude, that's cool," I immediately replied. "I honestly don't care either way, but I appreciate you telling me this."

"Okay, but I also have a confession to make," he said. "When we first started talking, I was hoping you might be gay, too. You're so my type."

"Chris, I'm not gay," I said, trying to defuse the awkwardness and make him laugh. "I'm exclusive to vagina."

And laugh he did. Dana and I were still broken up at that

time, and my full focus was on wrestling, so I think he noticed women weren't a big part of my life. Often, I'd tease him for hitting on me. I thought it was cool that he trusted me enough to tell me something he hadn't even gone public with yet. He also revealed that his plan was to write a book about how he'd be the first openly gay wrestler in the business, and how this would be his ticket back to the WWE for one last run.

Spending time with Kanyon, and talking to him on the phone so often, I realized something was definitely wrong. He'd ride a super positive high before crashing low. He told me he was bipolar or manic-depressive, but that was a condition I hadn't yet had experience with in my younger years. One night, Kanyon called just as I was about to get into the shower. He was hysterical and could barely speak. Sobbing, he admitted to me that he was considering killing himself right then and there and he needed a friend to talk to. "I don't even know if I believe in God, but can you say a prayer for me, kid?" he asked. I prayed and talked to him while the shower water ran for forty-five minutes. In my eyes, Kanyon was a famous, rich wrestler who'd *made* it. He'd accomplished all of the things I had dreamed of, so I didn't understand his profound disappointment. But our conversations over time had shown me that he was also a human being, and a supremely genuine and sensitive one. Talking to Chris made me realize that even the toughest, most successful wrestlers also struggled and had their moments of weakness. I calmed Chris down, and had him laughing by the end of the conversation. I still think about that conversation often.

We'd bring Kanyon in again on December 15 of that year to wrestle "Sexy" Sonny Samson in the main event. Again, Kanyon insisted on losing in order to help establish our band of wrestlers. The next day, he helped us set the ring up in my parents' backyard and led a seminar with every member of HRW. I remember how patient he was, how he took his time while

lending countless experiential anecdotes that made us think as much as they made us laugh.

Dustin and I drove him to the airport later that day, but before saying good-bye he pulled out an 8×10 photograph of himself and wrote a message to me, thanking me for being such a great friend. We gave each other a big hug, but little did I know that that would be the last time I'd see him. Over the years I'd watch from afar as he publicly spiraled out of control. He conducted controversial interviews wherein he'd accuse past employers of firing him because he was gay. On one occasion, he showed up at a WWE event and caused a disturbance by running down to the security railing in an attempt to derail the show. Eventually we fell out of touch. Five years later, on April 2, 2010, I got a call from Dustin telling me that Kanyon had committed suicide by overdosing on antidepressants. I thought of the phone call with Kanyon from years earlier and was devastated. He was the first wrestler whom I was close to that had died.

By 2006, we were running a full-scale operation. We'd book each card, write every story line, organized sponsors, and sell merchandise. Most important, we were making money.

On July 27, 2006, we had our biggest show ever at the Holiday Skating Center. It was technically our sixth annual *Highway 2 Hell* event, but we stopped counting after we had left the backyard. For the main event of the evening we featured "the Fallen Angel," Christopher Daniels, who was in the middle of a hot run with Total Nonstop Action, or TNA, at the time. Before TNA, Christopher Daniels was maybe the most well-known independent wrestler of all time and helped usher in the new style of fast action and high spots that are used today in ev-

ery major company. With him, we'd turned our little backyard wrestling company into something legitimate.

Also around this time, we'd bump into Scorpio Sky every weekend at a different Southern California independent show. From my first day a few years earlier at Rudos Dojo, where he looked after me, to now, he was still trying to help us out. "I keep telling Super Dragon to book you guys at PWG. You guys are ready! But he won't listen to me," he said to us. Super Dragon didn't like me because of the way I acted all those years ago during that class he guest-trained, and I guess Nick caught some of that heat by association. It was disappointing because we knew PWG was the place to be, and if we had any plans on expanding out of California, we had to make it there first. So, we kept plugging away. That same year, we began working for National Wrestling Alliance, or NWA, who filmed local television. It was our first time learning how to wrestle "TV style," which means finding the stationary camera that usually has the best shot. Additionally, we had to learn how to work with commercials and with time cues. These tapings would go on for hours, and on most occasions we had to wrestle multiple times a night. We upgraded our yellow spandex shorts to shiny yellow pleather shorts and added big black dollar signs on the sides. On October 7, 2006, before an NWA taping, a producer came up to us and said, "You guys need more TV-friendly names. 'Mr. Instant Replay and Slick Nick, the Young Bucks' just doesn't really roll off the tongue. You guys will now be 'Matt and Nick Jackson, the Young Bucks.'" We hated it. We felt like "Jackson" didn't fit us at all. But since NWA was only one of many places we wrestled, we decided we'd be the Jacksons here, and Mr. Instant Replay and Slick Nick everywhere else. But again, that ended up not being the case. Everyone started advertising us as "Matt and Nick Jackson, the Young Bucks." We decided to just roll with it.

Since FCW ran several bigger shows at buildings like the Anaheim Convention Center, the L.A. Memorial Sports Arena (where *WrestleMania 7* was held), and the Great Western Forum, which was the old Lakers arena, we got to check a ton of legendary buildings off our list at an early time in our careers. Unfortunately, news came out that the main sponsor of FCW was a realty company. The owner of the company pleaded guilty to committing fraud, and many people lost a lot of money. After that, the money was gone, and the writing was on the wall: FCW would continue to host much smaller events periodically until finally shutting down in 2009.

Meanwhile, Dana and I had kept communicating and sometimes even saw each other. Even during our breakup, I had zero interest in dating anyone else because I had convinced myself I would one day reunite with her. That day came on April 5, 2007, while Dana was celebrating her twenty-first birthday in Las Vegas with a bunch of friends she didn't really care for, when she texted me, Come save me. So, at 12 A.M., without a minute to spare, I packed my bag and headed to Las Vegas. As I drove my 2000 black Saturn up the 15 freeway toward Vegas, I remembered thinking, *I gotta win this girl back.*

I don't remember the details of that fated weekend, but we knew we were better together. She congratulated me on all my success and apologized profusely for making me pick between her and wrestling. I told her I wanted her in my life, but this time for good. A few months later, on August 23, 2007, we poetically returned to Las Vegas, where I was booked to wrestle for NWA. But that wasn't the big occasion. The big one was getting to propose to the love of my life. I had a plan at an Italian restaurant where the waitress would deliver the ring on top of a rose, but realizing that Dana, like me, is shy, I opted for a more secretive engagement. So, once back in our hotel room, I got down on one knee and cried my way through the

entire question. She said yes, and I slid a ring that I couldn't afford onto my future wife's finger. I had put all the money I had to my name down on that ring and financed the rest. The company who sold me the ring would eventually stop getting payments from me and would sell the debt to a debt collector agency. I would ignore their phone calls for years. I didn't care about the cost of the ring; I was overjoyed that I was finally going to marry the woman who had been with me since the very beginning. The only woman I've ever loved.

Extra Talent

NICK

While Matt had just proposed, I was in my first serious relationship with a girl named Crystal. Months earlier, me, Matt, Mal, Dustin, and Brandon were at a small theme park called Scandia in Victorville the night after an HRW show when I saw a dark-haired, green-eyed girl working at the counter where one cashes in tickets for prizes. I asked her for her number, she said yes, and I invited her to an HRW show to break the ice. We immediately hit it off and went on a couple of dates.

In 2007, our careers were on an upward trajectory, and we would soon be blessed with a huge opportunity. Matt and I were nailing down shingles on a rooftop with our dad in the blazing California sun when Matt's phone went off. It was a Myspace message from a member of the PWG team asking if we were available to wrestle at PWG on June 10. This might as well have been our golden ticket, and we couldn't believe it. At the same time, I remember being so nervous because

PWG had a huge reputation among hardcore fans as well as local wrestlers. We had been to a couple of the shows as fans over the years, and even watching from the seats made us feel intimidated. But it was now or never, and we knew we had to impress them, especially given the way Matt had rubbed Super Dragon the wrong way in training a few years back. We'd apparently been blackballed from working PWG. Several of our friends had been trying to get us a shot there for years, but Super Dragon still detested Matt. "Oh, you want me to book the show-off who doesn't listen?" he'd ask them.

When June 10 arrived, every one of our friends wished us luck as we drove to Burbank, a city twelve miles northwest of downtown Los Angeles that was known for hosting *The Tonight Show*. It was jammed with traffic, and we idled on the busy street as car horns beeped and airplanes took off and landed right over our heads. As soon as we arrived, Human Tornado, a charismatic independent wrestling standout who played the gimmick of a pimp and had recently made it big because of a viral video of him dancing in the ring, came up to us and said, "It's about time y'all are booked!" That was the stroke of confidence we needed.

I looked around at the empty white chairs, the wrestling ring, and the famous gorilla logo on the apron skirt. It all looked so familiar, just like any other wrestling show we'd done in the past. Except, it wasn't. This was the cream of the crop, where the best independent wrestlers in the world competed. And on that particular night guys like El Generico (Sami Zayn), Kevin Steen (Kevin Owens), Bryan Danielson (Daniel Bryan), and Tyler Black (Seth Rollins) were billed. Not only did PWG have a loaded roster, but it had great exposure. They had landed a major DVD deal with Highspots.com and even sold some of their DVDs at Best Buy stores across North America. If we wanted a part of that action, we'd have to dazzle the audience.

As the hours progressed, we noticed our opponents hadn't showed up yet. We were wrestling a team known as Arrogance, comprised of Scott Lost and Chris Bosh, two independent wrestlers from Southern California at the time and the number one tag team in the area by a wide margin. Scott was a technician whose beauty was in making everything he did look effortless. Chris, meanwhile, was the clever showman who amazed the audience with his quick wit and humor. If you weren't ready to snap back, he'd eat you alive out there. We started asking around if anyone else had seen Chris or Scott. It turned out they were somewhere on the east coast the night prior doing an independent show and had run into some delays during the flight home; they'd be very late to the show. So our match kept getting pushed further and further down the card, and by the time the evening began we were doubtful we'd even get to go on. We needed to knock it out of the park this night, but how could we do so without even being able to talk to our opponents, whom we'd never worked with prior to this, before the match?

Eventually, Matt found Scott Lost's phone number and called him during intermission. Scott answered and said that they had finally landed and that they'd change into their gear while driving to the building. We started planning our match over the phone. Scott, the most experienced of the group, took the lead and told Matt exactly what we were going to do. I could tell Matt was nervous because his hand was shaking while holding the phone, and every time he'd share what Scott was saying with me, his voice cracked. He was trying to retain all of the information being dumped on him so quickly and was overwhelmed. We would typically spend hours planning matches with our opponents, so this was new to both of us. Once Matt hung up, we paced in the room behind the stage and were startled every time the explosive crowd reacted loudly

to something happening in the ring. All that action seemed so close yet so far.

Scott and Chris arrived minutes before our match began. We quickly talked over what we planned on the phone, but it was time to go. Our theme song hit was "MMMBop" by Hanson, a 1990s three-piece band of young baby-faced brothers with long hair who were famous with teenage girls (I know some of you remember this). We specifically chose this song to show the tough audience that we also had a sense of humor and didn't mind making fun of ourselves. At a different show sometime before this one, a few people heckled us by shouting "Hanson Brothers!" Instead of defending ourselves, we came out to their music the next show, and it seemed like people loosened up once they realized we didn't take ourselves too seriously. On this night at PWG, it worked too, and we came out to a rapt audience.

The match itself went very well, better than what we could've wished for given the circumstances. While I was nervous making our entrance, I remember feeling comfortable once we got going. *This is what we do every weekend,* I thought to myself. *We're ready for it.*

The match started and right away we were getting big reactions for all of our tandem tag team moves. Our chemistry with Scott Lost and Chris Bosh was clearly strong; every interaction looked like we'd been working together for years. I knew we had earned the crowd's appreciation when I dove through Matt's spread legs while he hung upside down from the ropes. It was one of our best tricks, and the fans loved it! As the match concluded, the fans' reactions peaked, the loudest and most enthusiastic they'd been all night. I knew we'd done better than anyone expected. And surprisingly, we had even impressed Super Dragon, who asked us afterward if we'd be able to do more shows. Despite our unrelenting stress prior to the match, he

told us that we had done a great job. Driving home late that night, we scarfed down celebratory burritos from the Taco Bell drive-thru as we relived our favorite highlights of the match, sitting in bumper to bumper traffic on the 101 freeway, even at that late an hour. We were in no rush to get home; I could've lived in that moment forever.

In between doing independent shows every weekend in Southern California, we were still running HRW. For 2007's annual *Highway 2 Hell* show, we wanted to book Marty Jannetty after becoming aware that he was still taking bookings. Marty, an average-sized wrestler with shaggy brown hair, ushered in a faster-paced style by utilizing gymnastic moves from the 1980s and '90s. He was now older but could still go hard. Just the very thought of having Marty on our own event made me feel the same way I felt watching him as a child.

Dustin Bogle made contact with Marty, who accepted the booking. There was no question either: if Marty was wrestling on an HRW show, he was going to team with us. We saw the chance to live out a childhood dream while scoring a promotional opportunity with his presence. Marty was going to make it a double-shot weekend, meaning he'd do two shows. On Friday night, he'd wrestle in Salt Lake City, Utah, and on the second night would fly over and do our show at Hesperia High School on August 4, 2007. We decided to try running a show on a weekend as opposed to the usual Thursday, which meant we needed a different venue from the Holiday Skating Center. Hesperia High School had a large gymnasium with bleacher seats, perfect for a wrestling show.

Back in the day, Marty and his squad, the Rockers, were known for their colorful, wild costumes that were covered in

animal prints and fringe. Since we'd be teaming with Marty, we decided it was time to put away the shiny, yellow biker shorts we'd been wearing for the last couple years and invest in gear that would better match Marty's style. We wanted to look like a three-man team—perhaps a new-generation Rockers? So, after saving some money, we hired a seamstress to create some neon-green Rocker-like gear covered in tassels. It was going to be either hilariously obnoxious or a cool tribute. We were hoping for the latter.

Once Marty showed up to the gymnasium, we were shocked to find out that he had chosen to wear a basketball jersey and mesh shorts. We wrongly assumed—and this wasn't the first time—that he would brandish his old style, but, man, were we off! At the very least, we asked if he had tassels to wear around his ankles and wrists, but he did not. Luckily, Matt and I had some extra tassels to spare and would make do with what we had left. Marty happily obliged, understanding what we were going for. Mostly, I think he could tell we were huge fans.

The main event of *Highway 2 Hell* would be Young Bucks and Marty Jannetty wrestling Dustin Bogle (Diablo), Joey Ryan, and Karl Anderson. Karl Anderson was from Cincinnati, Ohio, and had moved to Los Angeles to train at the New Japan Pro-Wrestling dojo. At the time, National Wrestling Alliance and New Japan had a partnership, and we had met Karl earlier that year on various shows and became close friends.

The match was fast-paced and full of double-teams that the Rockers used to do. As Marty and I shot Diablo into the ropes and delivered simultaneous elbows, dropping Diablo down to the mat, I looked across and saw Marty smiling. Then, just like the Rockers, we dropped our fists onto Diablo and kipped up to our feet. Matt and I used to do this very sequence in our living room, but here I was doing it with Marty to the delight of the five hundred screaming fans in attendance. Marty was

even doing dives to the floor with us! To secure the win, Marty nailed a beautiful Superkick and covered Diablo. The crowd exploded, and Marty reveled in glee, looking like his old self.

We all caught our breaths and hugged behind the stage, and Marty said we reminded him so much of himself and Shawn Michaels from back in the day. Furthermore, he gave us his blessing to keep dressing like the Rockers. "You guys are the new-generation Rockers," he said, which was the biggest compliment we could have received. He wanted a copy of the match, so Dustin stayed up late that night to get the DVD copied and delivered to him before he flew home the following day.

After that fateful event, Marty would call us all regularly and we'd talk for hours. His soft, humble voice had a philosophical tone to it, and we'd listen in as Marty would impart wisdom. He'd teach us where to place moves in the match, how to build a strong hot tag, and how to string together a proper comeback. We talked every week for the next couple of years. We basically had a cheat sheet right in front of us, and we soaked up the knowledge he was giving us.

Between our hit PWG appearance and our own *Highway 2 Hell,* our career was making big strides. We were booked for PWG's biggest show of the year, called *Battle of Los Angeles,* a three-night tournament consisting of the best independent wrestlers from all over the world competing in singles action. Super Dragon spared no expense and flew in wrestlers from all over the United States, Europe, and Japan. As far as independent wrestling shows go, this was one of the biggest spotlights you could get. We were booked as the opening match on the first night of the tournament. Many wrestlers will say the

opening match might be the most important match on the card because a good match sets the tone for the rest of the night. On this night, we were wrestling a tag team we were very familiar with, Phoenix Star and Zokre, collectively known as Los Luchas. We'd been wrestling them all over Southern California at the time, tearing the house down everywhere we went, so we were thankful to have an opportunity like this with two of our favorite opponents.

We knew if we made an impact, we'd be able to create additional opportunities. What we didn't realize at the time was that experienced Japanese wrestler Cima, also the head scout for a promotion called Dragon Gate, was also booked on this night's card. Dragon Gate is a huge wrestling promotion based in Kobe, Japan. It was and remains popular among younger fans because of its fast, athletic style and its inclusion of theatrical elements like over-the-top characters and dance routines during entrances. That night, we ended up having a crazy, high-flying match full of dives and stunts that ended with our finishing move, More Bang for Your Buck. The move consists of Matt rolling an opponent off of his shoulders toward the corner of the ring, then me flying from the top rope with a 450 Splash, which is a full front flip plus another half rotation, where I land belly first onto the opponent, followed by Matt spring-boarding to the top rope and doing a Moonsault Splash, a backflip where he lands belly first onto the opponent. Sound complicated? It is. It's a whirlwind of spectacular moves and always gets a thunderous reaction. People who have seen the move for the first time have told me that it's taken their breath away. And people feeling the effect of the move have said the same thing . . . literally. It was the first time we did the move with my 450 Splash variation, which was lucky because that was what caught Cima's attention. More Bang for Your Buck

would earn a reputation as being one of the most insane sequences in wrestling and would become one of our signature moves.

Right after the match, Cima, whose smile can light up a room, came up to us accompanied by an older Japanese man. He was Satoshi Oji, a bilingual executive of Dragon Gate who helped book foreign talent.

"Great match!" Satoshi Oji said.

Cima complimented us on our finishing move, More Bang for Your Buck, but because he spoke very little English, he got right to the point. "Would you guys like to come to Japan?" he asked.

"Yes, of course we would!" we responded, not quite sure of what we had agreed to. It wasn't until the next day that the shock wore off.

Satoshi Oji reached into his wallet, handed Matt a business card, and told him to email him right away.

The next morning, Dana helped Matt compose an email, which officially kicked off the journey that would transform our lives. We had watched tapes of Japanese wrestling for years and knew that Japan was a place we had to visit eventually to get our names out and to gain more experience on an international level. Additionally, after reading every successful wrestler's books and listening to every interview they gave, one thing was a constant: all of the greats had spent time in Japan. We then coordinated the long process of getting a Japanese working visa and planned for a future tour.

Four months later on January 5, 2008, we'd get another opportunity at PWG to show the Dragon Gate office and wrestlers how good we were. This time we had a chance to wrestle two of the best wrestlers in Dragon Gate, Naruki Doi and Masato Yoshino, a tag team called Muscle Outlawz. At the time, they were pound for pound the best tag team in Japan. Nobody

hit the ropes as fast as Masato Yoshino. He was thin but ripped, and he moved through the ring like a track star. Naruki Doi was short but very muscular and transitioned between moves effortlessly. Together, they strung together sequences of tag team moves most wrestlers hadn't seen before. They wrestled so often, and at such a high level, that I was scared at the prospect of keeping up with them. But our self-esteem had gotten better, PWG was now booking us every month, and Super Dragon had finally gained faith in us.

Putting the match together was a difficult process. Muscle Outlawz spoke only broken English and carefully explained each and every move in the back, sometimes having to pick each other up to physically demonstrate what they wanted to do. The match was fine, but certainly not a home run. The crowd seemed tired and there were a few hiccups during some of the high spots. Wrestling someone who didn't speak the same language proved to be difficult and something we'd need to adjust to. There were awkward moments where they wanted me to fight back but didn't know how to communicate that to me in the ring, so the match had long stretches of time where nothing happened. In an incredibly embarrassing moment, Matt misjudged where Doi was lying on the mat, and came off the top rope with a leg drop, completely missing him. Matt still can't watch that on tape to this day. Despite the couple of mishaps, they seemed impressed, assuring us the next time we wrestled it'd be in Japan, and it'd be better.

The following month, in February, Matt got a phone call from Frankie Kazarian. As a favor, Frankie was helping WWE employee Tommy Dreamer find some local wrestlers to do extra work on the WWE television shows, *Raw* and *Smackdown*, the

next time WWE was in town. Extra work could range from being an enhancement talent against a superstar in an actual televised match to playing the role of a security guard. Or, often times, if one isn't needed in any capacity, one could just sit in catering all day. It wasn't much, but it was a foot in the door. Frankie asked if we could make it to the upcoming tapings, and of course Matt said yes (he usually did). Our goal was to work for WWE, and this was the way in. Or so we thought.

We told Marty Jannetty about it; he encouraged us to do it and said he would call his old tag team partner, Shawn Michaels, to see if he could take care of us. We didn't know if Marty was actually going to call or if he was just trying to impress us. Marty sometimes told us stories and we couldn't tell if they were fiction or nonfiction. Oftentimes he was a hero who stood up to the bully wrestler. Other times, he pulled off an impossible prank that made him sound like the cleverest man alive.

The Anaheim Pond, which is now called the Honda Center in Anaheim, was the sight of that night's *Raw*. We had heard there was a mandatory dress code at WWE events and wanted to be prepared, so we showed up early in short-sleeved polo shirts—to show off our arms—and slacks with dress shoes. As we grabbed our roller bags out of the trunk of my car and headed to the back of the arena, we saw dozens of WWE trucks with several of the wrestlers' faces plastered on the sides. Entering the building, I was surrounded by wrestlers I recognized from television, and felt starstruck. WWE superstars Brian Kendrick and Paul London walked by us. Then Randy Orton. Then Triple H. I thought to myself, *Just act like you belong.*

It wasn't until we ran into a familiar face, another local independent wrestler, that I felt safer. He'd done WWE extra work several times before and led us into the catering room.

"Let's just hide out in here for now," he said.

Nervously, we all grabbed trays and stood in line with several WWE superstars. I loaded up my plate with chicken and salad, and then scoped out the room for a table. If this was the first day of school, we were the new kids whom nobody wanted to sit near. Miraculously, we spotted a table that was wide open and sprinted over to it. Seated just steps from that table was another familiar face: Jesse Hernandez, a promoter for an independent company in California called Empire Wrestling Federation. Our favorite current wrestler, Shawn Michaels, was sitting with him. Back in the 1980s, Jesse used to do some refereeing for WWE, then WWF, and was buddies with Shawn. Jesse looked at us and waved us over. When we stared back mutely, he waved us over again, this time more animated. We both stood up and headed over.

"Shawn would like to meet you boys," said Jesse.

I looked down and there was Shawn's hand, waiting to be shook. "Hey guys, nice to meet you," he said. "Marty has nothing but good things to say about a young tag team called the Young Bucks, and that must be you two?"

I couldn't believe he knew our tag team name. *What was going on?* I remember staring at Shawn while he spoke, distracted by his stardom, but also by something in his mouth. His lip looked swollen. I was either too young or naïve to realize he was chewing tobacco.

"Any friend of Marty's is a friend of mine," Shawn said, before spitting into a bottle that was half-filled with dark liquid. He invited us to sit down at his table and then gave us advice on how to stand out if we were to be given a tryout or a dark match at the taping. "Just pick two or three of your best spots, don't rush, and make those two or three things look the best you can," he said. We conversed about tag team wrestling psychology, which was similar to what Marty had taught us months ago. The fact that Shawn was imparting this knowledge made it feel

even more significant. "I'm gonna get you guys taken care of. Follow me."

He took us to meet Johnny Ace, the head of talent relations at the time. "Please take a good look at these guys," Shawn said to Johnny. "Marty Jannetty really has high praise for them." Johnny told Shawn that things were really busy that day, but the next day was a *Smackdown* taping and would be the perfect opportunity to take a proper look at us. "But, Shawn, if you say these guys are good, then they're good. We're definitely giving them a look."

Shawn told us again to follow him. He took us over to Sergeant Slaughter, who worked in payroll, and said to him, "Please pay these guys, and if they need a hotel, please get them one. They're needed for tomorrow." We were handed $300 each in cash, which was an enormous payday at the time, but we played it cool. It turns out that pretending you're not freaking out is half of success. Before leaving, Shawn said, "I know you guys want to be like Marty and me. Feel free to act like we did in the ring, but please don't act like how we did outside of the ring." In the 1980s and '90s, the Rockers were notorious for being big party animals and would often find themselves in a lot of trouble, getting into fights and trashing hotel rooms. Due to our Christian upbringing, Matt and I always stayed out of trouble and didn't worry about stuff like that. Still, we heeded the advice from our hero and thanked him profusely.

Apparently, another local wrestler had witnessed our interactions with Shawn and pulled us aside and said, "I've been doing WWE extra work for years and I've never seen anything like this. You guys are for sure getting signed."

The next day, we drove down to San Diego for the *Smackdown* taping with high hopes. In our minds, we were now Shawn's boys and were going to get a shot. We walked into San

Diego Sports Center with our heads held high and approached Johnny Ace once we saw him.

"Hey Johnny, good to see you again!" I said. I stuck my hand out, and we shook while he looked off in the distance. Then, just as Matt and I were about to make small talk, he walked away.

The conversation didn't go as I envisioned. This day felt different. Shawn Michaels didn't wrestle on *Smackdown*, which meant he wasn't there, so Matt and I were stuck fending for ourselves. This was a valuable lesson for us in show business. Don't ever set your expectations too high, even if one of the all-time greatest wrestlers is going to bat for you.

Matt did end up getting booked as an enhancement talent that night, where the massive motorcycle rider Chuck Palumbo destroyed him in mere seconds. Matt looked uncomfortable wearing another local wrestler's green spandex trunks; his Young Bucks gear looked "too flashy," according to the producer of the segment, former wrestler Jamie Noble. The trunks were riding up Matt's butt, and he kept trying to adjust them when he should've been selling the moves he was taking. During one spot, in an effort to show his great facials, Matt pretended to cry. It looked pretty pathetic.

Matt was still excited he made it onto TV, but it wasn't the try-out match we fantasized about, and we certainly didn't get signed like the experienced local wrestler had predicted we would the day before. In fact, nobody really had anything to say to us at all after the show. Our drive home was much quieter, and I'd be lying if I said Matt and I weren't doing a lot of self-reflection. After spending a couple of days as extras, this was the first time we had a little bit of doubt about where we wanted to end up as wrestlers. Maybe WWE wasn't everything we thought it would be. Maybe we were just naïve. Or

maybe the bright lights and big pressure were too much for us. Whether it was true or not, I felt like I was having an identity crisis. I was always the kid in school who would one day grow up and headline *WrestleMania*. It was all I'd ever dreamed of, and now I wondered if that was still something I wanted. But I allowed myself to think more short-term—we had a trip to Japan to prepare for, and that thrilled us. If WWE possibly wasn't the end goal, maybe we could find success elsewhere.

Culture Shock in Japan

MATT

MID-MAY 2008

Mom, Dad, Mal, my fiancée, Dana, and Nick's girlfriend, Crystal, waved us good-bye at LAX as the flight to Tokyo Narita Airport boarded. Up until that point, I could probably count on one hand how many times I'd stepped foot on an airplane, and I imagined the eleven hours to Japan would feel like an eternity. Before I kissed Dana good-bye, she held on to me as we both cried.

"It's just five weeks. One tour," I said to her. And at the time, I thought that that was true. Neither of us knew that she would be signing up for a lifetime of this. Travel, events. More travel. Additional obligations.

Nick and I boarded the plane with a couple hundred bucks each and roller bags filled with canned chicken and beef jerky. We were completely broke and needed to do everything we could to be frugal. Dragon Gate had offered us $100 each per

match (the most we had seen then), but on top of that we fig-
ured we'd pack and sell merchandise to make an additional
income. A few months earlier, we'd decided to invest what little
money we had in some Young Bucks merchandise. At the time,
merchandise at independent wrestling shows wasn't really a
thing: most wrestlers didn't even sell merchandise, and the
ones who did usually only had a single 8×10 photograph that
they'd autograph for the customer. This was also before every
person in the world had a camera on their phone, which meant
it was before people stood in line and paid for selfies with their
favorite wrestlers. Since we had nothing to lose, we packed one
hundred Young Bucks T-shirts and several 5×7 glossy photo-
graphs we had ordered from Costco. The photos were us pos-
ing in neon orange spandex in front of a zebra pattern blanket,
which we had hung up on Nick's bedroom wall. The T-shirts
were black and had a basic bright green Young Bucks logo with
a lightning bolt on the front. It was one of our first designs.
Even if we sold one T-shirt for $20, it'd be an extra $10 each
in our pockets and would pay for that night's dinner. Our hope
was the Japanese audience would enjoy our act and would want
to bring home a Young Bucks souvenir. But, besides a little bit
of buzz online, we were coming to Japan as relative unknowns.

We stayed awake the entire eleven-hour flight, too excited
to sleep. As soon as we got off the plane, the feeling of being
somewhere foreign hit me hard. I looked out on the runway
and saw several minivans. Miniature types I'd never seen back
home. As we walked through the terminal, unable to read any
of the signs, a woman's voice spoke Japanese on loop on the in-
tercom. We grabbed our bags, cleared customs, and then went
to meet our ride. Except there was no ride. No one was there
to pick us up. We chose a spot to sit and wait. After an hour
passed, we started to panic a little. Neither of our cell phones
worked internationally, so I exchanged what little money I had

and purchased a calling card. I pulled out the business card for Dragon Gate's executive, the one Satoshi Oji had handed me months prior at PWG and tried reaching him on the local telephone. Because of the unfamiliar language, it took me nearly twenty minutes just to figure out how to place the call. When I finally did, nobody picked up the phone. Anxious and defeated, I walked back toward Nick, where he waited with our bags.

To my surprise, Nick was standing and having a conversation with someone wearing a Dragon Gate T-shirt.

"Um. Sorry! So late," said the young Japanese man.

I was so happy to see him I almost wrapped him in a hug. You have to remember that I was as anxious about being in a city as big as Tokyo as I was about embarking on this career development. In both cases, I felt self-conscious and wholly unprepared.

Relieved that our ride had arrived, Nick and I squeezed into a tiny car and sat in Tokyo traffic for ninety minutes until finally arriving at a hole-in-the-wall hotel in downtown Tokyo. The elevator was so small that Nick and I had to take turns riding up and down, one person at a time. The rooms themselves could basically only fit one person, plus a bag. Feeling uneasy about not being able to communicate with anyone, and afraid of getting lost, we wanted to stay close. There was a convenience store next door called "99 ¥en" where everything was under 100 yen, which was equivalent to around one American dollar. Too afraid, we didn't want to walk past that store or farther than we had to. I had anxiety just paying the lady working the cash register the correct amount of money. I didn't have a grasp on anything yet. Having trouble getting my laptop to start, and not finding an international telephone that worked, we hadn't even been able to reach anyone back home to let them know we had arrived safely. That night, Nick asked if he

could sleep in my room. I could tell he was a bit spooked, too. We didn't realize it at the time, but for a couple of young guys who hadn't really ever left home prior to this, we were suffering pretty traumatic culture shock.

Early the following day, I spotted a familiar face in the downstairs lobby. It was PAC, a young, British, high-flying wrestler whom we'd run into at PWG a few times before. PAC had been on several tours with Dragon Gate already, so he was quite experienced with Japan and the Japanese culture. He assured me that he would help if we ever needed anything, to which I responded with relief. PAC was happy, too, because we'd be the only other English-speaking people on tour. It turned out we would really bond over the next several weeks. Between seeing PAC and finally getting my laptop to boot up so that we could say hello to friends and family, my trip was starting to feel less lonely. Everyone back home wished us luck on our big debut taking place later that night at the famous Kōrakuen Hall in Tokyo.

Kōrakuen Hall is a legendary venue in Japan, located on the fifth floor of a tall building in Tokyo Dome City. It's famous for hosting either a wrestling, boxing, or mixed martial arts event nearly every single day. If you're a successful wrestler, you've passed through there.

Atop the stairway of the entrance was a wall covered with hundreds of signatures from foreign wrestlers who'd performed in the building. All of our friends who signed the wall insisted we do the same. We autographed our names on the wall, and underneath it wrote the date, "May 14, 2008." These names remained on that wall up until sometime around 2016, when the owners decided it needed a fresh coat of paint.

"Dragon Gate is a small crew of guys. We all do our part to help with the set-up and tear-down." This was PAC assuring that we knew the unwritten rules of the company. We knew

what he meant: Masato Yoshino and Naruki Doi, arguably the best tag team in the world at the time, were carrying big ring posts out of the ring truck. The charismatic BxB Hulk was setting up the merchandise area. Respected veteran Don Fuji was sticking seat number labels on the back of the ringside chairs. We, too, pitched in, realizing this really was a team effort.

That night, we'd be wrestling Susumu Yokosuka and Ryo Saito, two young guys who hit hard and were extremely sharp. We'd done research heading into this match, but we were intimidated by how quick they moved and how intricate their high spots were. Dragon Gate was a style unlike anything else in wrestling, as the guys moved a million miles per minute. Each match was like an action movie with a car chase scene that never slowed down. We struggled to talk over a match with Susumu and Ryo in the back because of the language barrier, and because it was by far the most high spots we'd ever had to memorize. *I don't know if I'll ever get this good,* I thought to myself, as Susumu effortlessly called the match back to us in broken English. I didn't realize at the time that these guys wrestled almost daily and did a lot of the same spots and sequences every single night, for years. Their confidence came from repetition.

The locker room at Kōrakuen Hall is on the lower floor, so when it's time to wrestle, you walk up one flight of stairs and step through a curtain. We stood on the stairway, and just like every match before this one, and every match after, we closed our eyes, and said a quick prayer. We then entered to Hanson's "MMMBop," wearing neon-orange, black-tiger-striped spandex that had bright green tassels hanging from the bottoms of our knees. The humor of our entrance music went right over the audience's heads, but the seats were filled with young teenage girls and men in their twenties, so they clapped their hands and played along. Dragon Gate drew a hip demographic

because its roster consisted of mostly young, striking men. Conversely, we were the definition of white meat babyfaces, energetic good guys with huge, cheesy smiles. We ignited our trademark Young Bucks pose, and hundreds of camera flashes went off. One of these photos would follow us over ten years on advertising materials.

As our opponents, Susumu Yokosuka and Ryo Saito, came out to a thunderous ovation, completely outclassing us. I looked around at two thousand people and took it all in. Though we were suffering major culture shock, wrestling remained a universal language, and once the bell rang, we were back in our element. The worried look I saw on Nick's face the night before had gone away, replaced by the confident one I was used to seeing. Our killer instincts took over and we basked in the madness. The audience liked the action, but they loved if you interacted with them, we noticed. At one point, Susumu and Ryo were cheating right in front of the ref, choking Nick and entering the ring without tagging. I came into the ring and pled my case multiple times. Finally, defeated, I stood on the apron toward the audience, made a funny face, and threw my hands in the air. The crowd laughed. That's when it clicked: participation with the crowd got just as big of a reaction as many of our dangerous moves. We were always so focused on our in-ring physical stuff but had sort of been neglecting the audience without ever realizing it. People enjoy watching wrestling, but if you can make them feel like they're part of the action, they become even more compelled to interact. It'd be like watching *Mission: Impossible* at the movies and Tom Cruise peers into the theater and speaks to the person in the front row. Wrestling is an art form that happens to take place live, onstage before an audience, and that audience wants to be part of the action.

Our chemistry with our opponents was extraordinary. By the time Nick and I stood up on opposite corners of the ring

and did simultaneous 450 Splashes, we had completely won the crowd over. We were booked to lose the match, but we knew we had a successful first outing. We didn't have much time to celebrate our successful debut, though, since PAC soon reminded us it was time to tear everything down and load it into the ring truck. And that was how it went, week after week. We'd hop on a bus, travel to a new part of Japan, set up the ring, fight, break it down, and repeat the formula. There was a real feeling of being part of a systematic team. We made friends quickly, and since most of the guys were obsessed with American culture, they took a liking to us.

On our days off, we stayed in a city north of Tokyo called Kobe. It's a place known for its extremely tender steak, Kobe beef. Dragon Gate owned a building in the city that they oddly called the Sanctuary, where they kept a wrestling ring and gym on one floor, an office on another, and a dormitory for a few of the foreign wrestlers to stay on the last. Nick and I shared a small, dirty, unkempt room with a bunk bed. PAC stayed in the room next to us and would be woken up every morning from our loud Skype conversations with loved ones back home. When we were at the Sanctuary, we'd usually sleep all day, exhausted from the tour, or Nick and I would go on long walks through the city, where we'd venture off for sometimes eight hours or longer. With PAC's guidance, we became more comfortable in Japan. We were so strapped for cash, we gave ourselves 1,000 yen each per day, which equals out to about $10 American. We'd either load up on McDonald's cheeseburgers or buy a loaf of bread, peanut butter, jelly, and bananas, and live off sandwiches and fruit for a couple of days. On a rare day off, we'd visit the Dragon Gate dojo, where they kept a wrestling ring along with crash pads. In the front of the dojo was a pet monkey chained to a tree who we were told was the Dragon Gate mascot. Whenever we'd walk by, he would scream loudly,

throw rocks at us, and angrily perform continuous backflips. I was terrified of that monkey and knew that something was off with it. Eventually, it would come out some time after we were done touring Japan for Dragon Gate that some of the wrestlers were terrorizing and torturing that poor monkey, and as a sign of shame several of the wrestlers shaved their heads and publicly apologized for committing animal cruelty. It was terribly disappointing, especially in Japan, a country and culture that prides itself on respectful behavior outside the ring.

One day at a Lawson convenience store in Tokyo, we picked up the weekly wrestling magazine that's published every Tuesday to see if any pictures of us made it onto the pages. Before finding ourselves, we paused when we saw pictures of a young, fit guy with curly blond hair. There were photos of him wrestling outdoors, jumping off of vending machines, and doing all sorts of other crazy stuff. His name was Kenny Omega, and he came from Canada. He had recently put out a video on YouTube that went viral of he and a friend having an "Anything Goes Match," in which the two of them fought inside of a house, on a hilltop, and even in a lake. It was comedy gold. After Nick and I did some quick research, we found out that this was Kenny's first tour of Japan as well. We thought it was cool that we weren't the only foreign wrestlers in Japan.

Two or three weeks into our trip, I really started to miss home. Dana was having trouble being alone and had started planning our wedding to keep herself occupied. I'd stay up all hours of the night talking to her on Skype while Nick tried to sleep on the top bunk of the bunk bed, covering his ears with a pillow while Dana and I traded sappy, teary-eyed conversations. For a long time, Dana and I had been attached at the hip, never

not together or at least communicating all day long. Now she was depressed, unsure of how to function without me. If I was excited after a great match, I almost felt guilty sharing my enthusiasm upon hearing how sad she was at home.

Our significant others weren't the only things we missed. No matter how much we tried, Nick and I couldn't get ourselves to enjoy the cuisine. Any time we were taken out to dinner, we would sample everything that was put in front of us out of respect: chicken heart, liver, horse, raw beef, and so on. We'd hold our breath and take a swig of water to wash it down, pretending it was delicious when we were asked what we thought. It was rough. When Nick ate any seafood, he would have an allergic reaction and either break out in hives all over his body or have explosive diarrhea. Me? I just couldn't stand the taste or texture of seafood, and in Japan, 90 percent of the food comes from the sea. Needless to say, we spent most of our time searching for the golden arches of McDonald's.

As the tour started to wind down, Nick and I started to learn the patterns and psychology that the Japanese wrestlers used to plan their matches. We were going from town to town as unknowns, but by the end of the matches people loved us. We also became experts at setting the ring up in record time. One evening as we set up the arena, we saw a bunch of the guys approaching one of the veteran wrestlers, Masaaki Mochizuki, to congratulate him and shake his hand. We asked another young wrestler, Akira Tozawa, what all of the noise was about, and he told us that Mochizuki just received a call back home that his wife had delivered a healthy baby. I remembered being shocked, asking Nick, "Why is this guy here at this random small show, instead of by his wife's side?" But then I remembered: if you're a wrestler, you don't miss a show. It's just the culture of the business, the one I had been conditioned to respect. You only miss a show if you're hurt, and even then,

most times you just work through it. I felt like this way of think-
ing needed to be changed one day.

We only had a few shows left on the tour but realized that
we had a whole lot of T-shirt inventory still available. People
liked us, but apparently not enough to spend 2,000 yen. Most
of the money we made at the gimmick table was from our little
5×7 portraits that we'd sign and sell for 300 yen, and all of that
currency went toward calling cards to call back home. It's crazy
to think, but WiFi wasn't around in Japan in 2008, so the only
way you could reach home was from a computer that was con-
nected through an ethernet cord, or by using a calling card on
a telephone. On the last show of the tour during intermission,
we sat at our gimmick table without a single person in line to
meet us, when Cima, the top wrestler in the company, noticed
we had a stack of shirts still to get rid of. He grabbed a bunch
of the guys from a new popular faction in the company called
World-1 and handed them silver sharpies. The wrestlers signed
their names on the shirts, and Cima started speaking loudly
to the fans browsing the tables. All of a sudden, a crowd of
people surrounded Cima with handfuls of cash. I watched as
the pile of our shirts shrank, and the stack of yen got bigger.
Finally, when the last shirt disappeared, he looked at Nick and
me, smiled, and said, "Sold out!" He winked at us. He had just
made sure we were going home with pockets full of extra cash.
I'll never forget that.

The next day, we returned to Tokyo Narita Airport to catch
a flight back home. It'd only been five weeks, but we felt like
we had become mature men during that time. Before boarding
the flight, I used a calling card to call Dana. She picked up,
and with a sad tone told me, "Listen. Crystal isn't coming to
the airport."

Nick mentioned his girlfriend, Crystal, hadn't been reply-
ing to his emails or picking up when he tried calling, the previ-

ous few days. She'd been distant all tour long. Still, Nick and I had been counting down the days to seeing our ladies and parents waiting for us at airport baggage claim for weeks, so I just didn't have the heart to tell him what Dana had just told me. We landed, and as we disembarked to find everyone waiting, Nick was crushed to find that Crystal wasn't there. I held Dana in my arms, who cried like I had been mired in a war zone. It takes a special type of lady to be with a professional wrestler, and it only took one whole trip for Nick's girlfriend to realize this wasn't for her.

The moment we came home from that first Japan tour, everything changed. In the locker rooms, the boys looked at us differently, and in the ring the fans treated us with more respect. We had street credit now. We returned to Pro Wrestling Guerrilla, which was now located in Reseda, a neighborhood in the San Fernando Valley in Los Angeles, at American Legion Post #308. It was basically an oversized hole-in the-wall bar where veterans would drink during the week, and a place that hosted wedding receptions on weekends. No matter what time of year, the room was like a sweatbox, with air conditioning that seemingly never worked. It didn't seem like it at the time, but this venue would play an important role in our careers. When we walked through the curtain that night, the tiny room full of fans stood to their feet and passionately clapped. It was like a homecoming; we had graduated to the next level, and everyone took pride in that.

Cima asked us to come back to Japan in August for Dragon Gate's Summer Adventure Tag League Tournament, which would be a grueling three-week tour, with a tag team match practically every night. We accepted, though this wasn't the easiest conversation I had with Dana. She hated the idea of being away from me for so long, but she knew how important this was for my career, so she gave me her blessing. I was excited to

go back to Japan, but I worried about how she would cope with my absence.

Going to Japan felt different this time. We were prepared. The Dragon Gate office noticed we were getting over with the crowd, and the rumor was that we were going to get a big push. In wrestling, a push means the opportunity to win several matches and be highlighted strongly on the shows.

The tour kicked off again at Kōrakuen Hall in Tokyo, where we'd wrestle legends Don Fuji and Masaaki Mochizuki. As we prepared for our match downstairs in the locker room, we watched the opening match from a monitor. After one of the wrestlers ran against the ropes, Nick pointed out that something with the ring didn't look right. It looked like the four posts were starting to become unbalanced. Every time someone touched the ropes, or took a bump, the posts moved slightly. We alerted the others in the locker room and watched in horror, as it looked like the entire ring might implode at any moment.

It was the first time this particular ring had ever been used. Apparently, they had wanted a more American-style ring with a softer bump, so they'd had it shipped in a few days prior from California. But something had clearly gone wrong. The match rushed to a finish, and by this point, the ring was barely standing. Since the wrestlers were the ring crew, everyone ran out, in gear, to check out the damage. It was determined that the ring was unfixable. We assumed the show would be canceled, so we went back downstairs and waited for the building to clear out. But then Don Fuji approached us and declared, "Our match is next. We need to make big change!"

We didn't understand what he meant until we looked back at the monitor and saw a team of wrestlers rushing to take the ring down. The poles and metal frame were put away and a bunch of the padding was laid onto the floor of the venue. They

were building a makeshift ring! Don Fuji, being the experi-enced veteran, began adjusting the match we had previously planned to a safer-style match with less bumps. As we finished calling the new version of the match, we looked again at the monitor and saw the canvas starting to be taped to the floor. The only thing separating the canvas from the concrete would be about two inches of padding, and there would be no ropes to use, which would make things even more complicated. Yet the makeshift ring was now complete, and when they announced over the PA system that the show would continue, the place exploded. Dressed in neon-green spandex, we ran through the curtain and hopped into what was supposed to be a wrestling ring. We stood there, realizing how bizarre a situation this all was. We'd go on to wrestle a short but fun match with Fuji and Mochizuki. I took very few bumps that night, but when I did, the impact took my breath away. We rolled them up for a quick upset pin, and our stock at Dragon Gate soared. We'd rack up more and more wins as the tournament progressed.

Our biggest upset of the tour came when we were booked to beat Naruki Doi and Masato Yoshino in the most grueling match of our careers up until that point. By the end of the match, my legs felt like cement blocks. I'd heard stories about how Masato Yoshino had never been "blown up" (or been tired) during a match, but when I looked at him, he looked just as tired as I did. That gave me great comfort. We'd eventually be eliminated from the tournament and came home again— even more mature and more traveled.

A month later, I received a call to come back and be an extra on *WWE Smackdown*. My and Dana's big wedding day was only a couple of weeks away, so while being an extra wasn't the most glamorous job, I wasn't at a point in my career where I could say no to anything. I didn't necessarily have high hopes of getting a contract based on my past experiences, but I knew

it would be a good opportunity and, most of all, a decent pay-
day. "Just don't get hurt. No marks on your face, and no black
eyes. I want you to look good for the wedding pictures," Dana
said to me. Another fellow local wrestler, who also booked the
gig, rode with me to Thomas & Mack Center in Las Vegas.

Before the *Smackdown* taping, all the extras gathered in the
ring with former wrestler and current producer Jamie Noble.
Jamie would roll around with us, run through the basics, and
then pair some of us up to perform exhibition matches. After
the matches, many of the WWE wrestlers surrounded the in-
side of the ring, rehearsing their spots for later in the night.
Apparently, word had gotten around that I took really great
bumps. A big, jacked African-American wrestler named Eze-
kiel Jackson was making his debut that night, and he needed to
practice his new finishing move.

"Have the kid in the red pants take it!" shouted Pat Patter-
son, who was watching ringside. Pat was a former wrestler and
now worked in the office. I felt bad for the poor guy wearing
red pants until I looked down and saw the red Adidas pants I
currently had on.

"You mind, man?" Ezekiel politely asked me. He grabbed
me by my left shoulder, tossed my right arm over his arm, then
muscled me up into the air and threw me down onto my back
with blunt force. Upon impact, it felt like my body had been hit
by lightning. Everyone surrounding the ring approved.

"Do it again!" shouted Pat.

Up I went. And down again I went. This time I saw stars.
As I stood up and dusted myself off, I thought to myself, *Don't
sell it.*

"Again!" said Pat.

"Sorry, man." Ezekiel whispered into my ear before picking
me up and tossing me down once more.

I stood up, this time a bit dizzy and looked around at a

lot of the people surrounding the ring, laughing under their breath. Then, seven-foot-tall Big Show approached me. "Hey man, you mind if I practice my choke-slam on you?" People around the ring couldn't hold it in, and I heard chuckling. Big Show's finishing maneuver was a move where he grabbed opponents by their throats, held them over his head, and tossed them down to the mat with force. Trying to prove myself a team player, I replied, "Let's do it!"

The giant of a man grabbed me by the neck, and up I went. As I was held up in the air, so high up, I realized I'd never seen the ring from that perspective. All the people watching ringside looked small.

CRASH! And back down I went. It hurt, but I popped right back up to my feet. I don't know if I did this to refuse to sell the joke I was obviously in on or to look tough, but either way it worked. Big Show asked if he could give me one more. I agreed. Up I went. Down I went. *CRASH!* Although the second time I wasn't able to pop right up like before. I kneeled by the bottom rope, trying to catch my breath when the friend I rode with to the show grabbed me by my leg. "Get outta there, they're gonna kill you," he said.

Minutes later, after I had safely exited the ring, I was approached by Jamie Noble. "You're gonna wrestle Big Show tonight and he's going to put you through a table," he said.

I climbed back into the ring where Big Show was waiting, and we started to plan where the table would go. I was excited, because taking a good table bump on television could really help me possibly get a job. But I was also nervous, considering what Dana had said about not coming home with any marks. Going through tables is never pretty. Interrupting my thoughts, I heard, "Kid. Hello? The boss is talking to you."

I looked and Jamie was facing me and pointing down to the chairman of WWE, Vince McMahon, who was standing

outside of the ring. I'd watched Vince commentate my favorite matches as a child. I watched him famously get beat up by Stone Cold Steve Austin in my teenage years. Now, he was talking to *me*.

"I said, are you comfortable taking that bump through the table?" an annoyed Vince McMahon said.

Nervous, but refusing to show it, I gave a thumbs-up and replied, "Oh, absolutely!"

Vince McMahon, Big Show, and Jamie Noble discussed how the match should go down, while I stood there silently and pretended I belonged. Later that night, Big Show had his hand around my throat again, but this time in front of a jam-packed arena. He picked me up over his head and choke-slammed me through a table. *CRASH!* The Las Vegas crowd erupted, and I survived without receiving any marks.

A few days later, my phone rang. It was someone from WWE asking if me and my brother could make it to be extras on October 28, just eleven days after I wrestled Big Show.

Soon after, we drove to San Diego Sports Arena, where Nick and I were chosen to dress up and parody D-Generation X, which was comprised of legends Shawn Michaels and Triple H, during a segment called "The Dirt Sheet" that would air live on the WWE TV show *ECW on Sci-Fi*. We sat in one of the media rooms and watched old YouTube videos of the duo in order to learn their mannerisms. Nick would play the role of Shawn, and I would play Triple H. We were given blue jeans, DX T-shirts, and green glow sticks, and then we were taken to the hair and makeup room where we were fitted for wigs. Then, to my surprise, they pulled out a six-inch nose and glued it to my face so it wouldn't fall off. Triple H is sometimes picked on

for having a rather large nose. It was early in the day, so I had to walk around with that thing attached to my face for hours. At one point, after attempting to hide out all day long because of embarrassment, I inevitably ran into Triple H. "It seems like that thing gets bigger every time they make fun of me," he joked.

Eventually, the D-Generation X music hit, and out we came and did our best impressions. We had fun with it, adding even the smallest details and nuances, down to the way we impersonated their voices. The live audience reacted to everything we did. When we finished the segment and got to the back, female wrestler Victoria came up to us, still laughing. "I heard the boss even loved it!" she whispered to us. Things had gone so well, we couldn't help but have high hopes as we drove home that night. But again, for whatever reason, nothing came of it, and we wouldn't work another WWE show for three years.

Four days later, on November 1, 2008, I stood in a white suit with my groomsmen: Nick, Malachi, Dustin Bogle, Brandon Bogle, and Dana's younger brother Scott in an old church in Upland, California, watching my beautiful soon-to-be wife Dana walk down the aisle with her dad. She looked angelic. I kept telling myself to remember this moment, to take it all in, because you only get one of these. I didn't know where my wrestling career was going to go, or how I was ever going to be able to support us, but I knew I loved her, and that I wanted to be with her forever. We were young, had collected over $10,000 in credit card debt, and just moved into a tiny one-bedroom apartment we could hardly afford, but we loved each other. After we kissed and the crowd erupted (a celebration that eclipsed any wrestling show I had been in and will ever be part of), we walked back down the aisle hand in hand, ready to begin the rest of our lives together. I had told her five years earlier that one day I'd marry her. Sometimes, you just know.

At the reception, Nick gave his best man speech, and then told Dana and me that he had to leave. He was booked in Pro Wrestling Guerrilla's *Battle of Los Angeles* show, which took place that night. He felt guilty for leaving our wedding party, but I understood. We were both at a time in our careers where we couldn't afford to pass up an opportunity. Nick arrived at the building and settled in for the show, when someone he recognized approached him and stuck out his hand. "Hey, nice to meet you! I'm Kenny."

Sweaty Nights in Reseda

NICK

"So, where is your brother?" Kenny Omega asked me at the Battle of Los Angeles.

"Oh, I just left his wedding to come wrestle here tonight." We shared a laugh over how ridiculous that sounded. After only one exchange, I knew right then and there that we would become friends. Like Matt and me, he was thoughtful about the wrestling business and shared the same sense of humor as us.

The next day, Kenny and I happened to be in a massive ten-man tag team match together, where we bonded even more. There was a very scary moment during the match when a wrestler by the name of Davey Richards, a smaller guy who reminded me a lot of famous Canadian wrestler Dynamite Kid, threw Kenny into the ropes. As soon as Kenny's back hit them, the top rope snapped, and Kenny went flying to the floor. His head smacked the concrete, and the whole audience went silent with shock. I thought my new friend was badly injured, but to

everyone's surprise, he got right up and continued the match. The match was a train wreck, considering we had to contend with a broken ring, but it was yet another example of how we found humor in the absurd. I remember calling Matt while he was on his honeymoon and telling him, "You're gonna love Kenny Omega. He's just like us."

NOVEMBER 22, 2008

I was booked at an independent wrestling show at a bingo hall located in Los Alamitos, California, for a small-time promotion called Battle Ground Pro Wrestling. I was still heartbroken from my breakup with Crystal, so I took as many independent dates and singles matches as possible to keep my mind off of things. While wrestling made me happy and was a great distraction, there was definitely a void in my life. I saw the success of Matt and Dana's relationship, and it made me a bit envious. I too wanted someone to call back home to check in on after a hard-fought match.

This night, I was booked in the opening match to lose against a wrestler named the Drunken Irishman. As my entrance music hit (still Hanson), I energetically ran through the curtain and encouraged the small crowd of fifty people to clap along. Watching a DVD of this moment all these years later, it's crazy to realize that my future family-in-law was clapping along with me.

But there were her parents and aunts seated in support of a tiny rookie wrestler named Ellen Degenerate, who was to perform later in the show. Her gimmick name was an obvious spoof of comedian and daytime TV talk show host Ellen De-Generes, but for some reason, she entered the ring in schoolgirl attire, and wore pigtails. I met Ellen that night backstage in the locker room. I'd wrestled for practically every company in

Southern California, but I'd never see her before. As I went to say hello, the first thought I had was, *This girl is too cute and innocent-looking to be in the wrestling business.* I would later be surprised by how fierce and aggressive she was when she performed in the ring, even though her gimmick still didn't make much sense to me.

Once back home and surfing the web, I noticed she was friends with me on the most prominent social media website at the time, Myspace. She'd been on my mind, so I sent her a message telling her how nice it was to meet her. In hindsight, I was absolutely going after her, even if I didn't realize it. She quickly responded, and we hit it off from there. Given my thoughts about her innocence, I also thought I was much older than her, though maybe it was because she was quiet and wore that schoolgirl outfit as her wrestling outfit. After talking to her, it turned out she was actually three years older than me and way more mature than I was, already in college and working toward a degree. This proved to be an inspiration, but the nervousness about asking her out never subsided. And it wasn't until the day after Christmas that I gathered the courage.

During early March 2009, I was checking Myspace messages (I told you, Myspace was *the* place) and happened to find an unread message from wrestler and promoter Mike Quackenbush that asked if Matt and I would be interested in wrestling for the promotion he owned called Chikara. Chikara was a super-hot independent company with a roster like an assembly of comic book heroes. Most of the wrestlers wore colorful masks and shiny costumes that covered them head to toe. Some even had capes that would hang off of their shoulders during their entrance to the ring. Chikara ran shows on the

east coast, but their biggest show was a three-day, six-man tag team tournament called *King of Trios*. The trios were packed with homegrown Chikara wrestlers, some representing other independent wrestling companies, past WWF/WWE legends, and current international stars from Mexico, Japan, and the UK. It was a very diverse weekend full of great characters, and the internet buzzed about it. Quackenbush wanted us to team with El Generico to represent Pro Wrestling Guerrilla, which was to be named Team PWG. Without even negotiating a payday, we agreed. Simply being offered a costly flight out of Southern California was enough for us. People would tell us all the time to move to the east coast because living in California was like being on an island. "You're stuck there all alone, and nobody will ever find you" was what the veteran wrestlers who lived out east would tell us.

It would be the first time we'd ever been to Philadelphia, and, even better, we'd be wrestling at one of the most famous wrestling venues in the world, the ECW Arena. This building was made popular by Extreme Championship Wrestling because of the historic shows the company ran throughout the 1990s and early 2000s. At one point, the venue had the reputation of holding the craziest, rowdiest, most bloodthirsty fans in the world. But since then, it has become the most popular spot for almost every independent company on the east coast to run shows, and a bit of that mystique has been diluted. Still, to this day, every wrestler in the world has this dark and dingy arena on their wrestling bucket list, and we were excited to cross this one off of ours.

On March 27, 2009, Matt and I flew to Philadelphia, walked into the old dusty building where legends like Mick Foley, Terry Funk, and Tommy Dreamer spilled their blood, and embraced the feeling of invincibility.

"What a dump!" Matt affectionately whispered.

He was right, of course. The place was cold, smelled like mildew, and looked like an abandoned building where drug addicts or homeless people would encamp. Still, we looked around and thought of all the great moments that had happened within these walls. I would be lying if I said I wasn't intimidated.

If there was ever a weekend to try selling merchandise, this was it. So, we invested a couple hundred dollars into black T-shirts with a neon-green Young Bucks logo printed off to the corner of the front of the shirt. Merchandise still hadn't become prevalent on the scene just yet, but we and a few other wrestlers stood behind a table like we were at a swap meet and tried our best. But the only one who had any kind of action was Rami Sebei, aka El Generico. He stood the entire time in his El Generico mask and struck up energetic conversations with his fans by speaking Spanish and broken English. He was bubbly and inviting, and every person he met left with a piece of merchandise and a wide smile. At the same time, the other wrestlers were seated and looked disconnected and withdrawn. This included us, who sold only one T-shirt. Even as the show was about to begin, our trios partner Rami was still out hawking merchandise as El Generico. Man, he took this merchandise thing seriously. We and the other opponents for the night were panicking, since we needed to prepare for our match, but since Rami was the most experienced wrestler out of all of us, out of respect, we refused to plan any of it without him. At the last second, he strolled in with his hands full of cash and told all of us what we were going to do. He spoke quickly and with confidence, and I remembered thinking how all of this was just a business for him. It was his livelihood, as natural as waking up and going to sleep.

The first match was under way, and every time the crowd

popped for a huge move, I grew even more nervous. But shortly after, we went on to steal the show. It didn't seem possible. Twenty minutes prior to our entrance, we didn't have a single high spot prepared. But everyone besides Rami seemed shocked that things came together. For Rami, it was business as usual.

After our match, Rami invited us to take a walk with him and another guy, a Chikara wrestler named Trevor.

"You're in Philly, you've gotta try a Philly cheesesteak from Tony Luke's," said Rami, acting as our tour guide. For those who have never had a cheesesteak (And you should change that *now*. Seriously, put down the book.), it's a Philly staple that consists of finely chopped steak with melted cheese (whiz, it's called!) and caramelized onions. Tony Luke's is a quick walk from the ECW Arena. As we bit into the delicious sandwiches, we struck up a meaningful conversation about wrestling economics that I still remember to this day. Wrestlers hardly ever spoke about money; for whatever reason it was basically taboo. Rami proudly told us he was on his way to making around $25,000 for the year in wrestling. "A large chunk of that is from my merch!" he said. That number shocked me, and apparently it also did Trevor and Matt, who sat with big eyes. Matt and I were lucky if we made $5,000 each for a year's work. "I just assumed the only way to make a living wage in this business was with WWE," I said. And the idea of going there still didn't seem realistic to me. This gave me hope, but it also reminded me that we really needed to step up our merch game.

On the walk back to the ECW Arena, Trevor, who was a quiet, skinny nineteen-year-old with a big afro, was inspired by Rami's words from earlier and started opening up to the three of us. "Man, I just had a baby, I really need to make this wrestling thing work for me," he said. I too dreamed of one day having children of my own, and Matt the same. That all

seemed like such a far-fetched fantasy though. How would I ever be able to support a family on nickels and dimes?

The match from *King of Trios* 2009 that got the most attention took place on the second night, a four-way match that tore the house down. It was that night we met Kota Ibushi for the first time. He was a handsome, polite, young Japanese guy more athletically gifted than anybody I'd seen up until that point. He had tons of buzz from his matches against Kenny Omega in Japan, for their home promotion called DDT. DDT is a non-traditional wrestling company that has gained a cult following from their heavy use of comedy and specialty matches.

Kota Ibushi was DDT's golden boy. He, El Generico, and one of Chikara's masked homegrown talents, Jigsaw, would be my three opponents for the night. Sometimes when you're out in the ring, everything just goes right, and you can tell you're in the process of making a classic. This was one of those nights. While apparently some of the veterans in the back were rolling their eyes as we went from high spot to high spot, the energy in the crowd just kept growing, ultimately peaking during a big showdown between El Generico and Kota Ibushi. At the end of the match, not only did I hang with three of the best independent wrestlers, but I *looked* like I belonged. It was a sporadic, innovative match that ignored many of the traditions of wrestling but was universally praised by fans, and it was a clear example that the style Matt and I were practicing definitely had a spot in the marketplace. By the third night of *King of Trios*, it felt like we were made men when we walked out for our entrance. There were even a couple of people in line to buy our merchandise at intermission. It sounds obvious, but

I remember this being the first time it registered to me how important it was to get fans to like you—or, in wrestling terms, get over with the consumer. If they like you, they'll want to support you by buying your merchandise. It felt like our wrestling matches from the previous days were our infomercials, and now people were convinced to buy our product.

A few weeks later, we were back on a plane headed to Japan for our third tour with Dragon Gate. We had no idea it would be our last. Matt struggled any time he was away from Dana, and I was now in a new relationship with Ellen. As we touched down in Tokyo, I couldn't help but think about what happened the last time I went to Japan while dating a girl. But I could tell Ellen was different. She was comfortable with my lifestyle and supportive of me.

While competing in Japan, we received an email from Adam Pearce. We'd met Adam a few years prior when he was the matchmaker or booker for a little independent company in Southern California called Alternative Wrestling Show. Though charismatic, he was a hothead who would famously throw his water bottle down on the ground and curse to the heavens any time something went wrong on the show. He loved old-school wrestling, and to this day might be the best talker I've ever been in a room with. He was a big fan of us and had recently gotten promoted to head booker of Ring of Honor, the biggest independent wrestling company in the world at the time, known for its hard hitting and acrobatic style of wrestling. He cut right to the chase and offered us multiple dates for $100 each, in addition to offering to pay for our travel. The money was not much, but we knew the exposure would be invaluable. Not to mention the idea of being able to travel and work in cities like New York, Philadelphia, and Detroit sold us. We needed to go different places and have new experiences. Before this offer, the only real travel we had done in the U.S.,

outside of California, was in Philadelphia at Chikara's *King of Trios*. We were constantly told to move to the east coast, where wrestling was more popular. But because of the buzz we garnered through Pro Wrestling Guerrilla, Chikara, and Dragon Gate, we were given another opportunity to chase our east coast dreams.

The day we landed back home after three weeks in Japan, I came home to Ellen, who was waiting with her arms wide open. Truthfully, maybe I was still a bit traumatized over what happened to me last time, almost anticipating her not to be there. I hugged her tight, thinking about how different this relationship was compared to my last one. The familiarity of the smell of her hair and clothes put me at ease. *I love this girl*, I thought to myself.

Later that day, we received an email from Dragon Gate's Satoshi Oji, inquiring about our availability. We are starting a new promotion in America called Dragon Gate USA with Gabe Sapolsky and we would like to use you guys on our first show in Philadelphia on July 25th, the email said. Gabe Sapolsky had a reputation for being the genius behind the early success of Ring of Honor. He'd recently lost his job as head booker, so Dragon Gate swooped him up to help them jump-start their new promotion. The pay was only $75 each per match, but again, we were just happy to get our flights purchased at the time. All of these bookings were suddenly falling into our laps.

On May 22, 2009, we were back in Reseda, California, at PWG's *DDT4* tournament, an annual tag team tournament where the winner would have to be successful in three tag team matches in one night. At this point we had been the PWG Tag Team Champions for over a year and had gained major momentum. We advanced past the first round, defeating our buddies Dustin and Brandon Bogle, who saw the success we were achieving as a brotherly duo and started teaming as well,

calling themselves the Cutler Brothers. For the second round, we would face Kenny Omega and Chuck Taylor. Chuck, a Kentucky native with a hilarious disposition, looked like a normal dude but had a hell of a skill set. He was deceptively strong and had a sharp mind for creating great matches. He and Kenny were fan favorites, and pairing them together for the first time made them extremely popular with the Reseda crowd. While at first it felt like our hometown crowd celebrated the success we achieved outside of Reseda with us, it started to feel like they might've been a little resentful that their best-kept secret was starting to get out. The fans began to post hateful messages online, on the PWG wrestling forum, saying that we had forgotten where we came from, and that our act had gotten stale and boring. Or maybe they'd just grown tired of us. After defeating Kenny and Chuck in an exciting second-round match, we were shockingly booed out of the building. I was hurt and confused. We'd been working hard for this company for two years, so why was the crowd beginning to turn on us?

For the last match of the evening we were booked against Roderick Strong and Bryan Danielson. Both were average-sized guys but heavy-hitting technical wrestlers, most known for their amazing matches at ROH. Bryan Danielson was then the most popular independent wrestler on the planet, and by far the most respected. The plan was for us to beat them next in the finals and continue a winning streak that we had going for quite some time. Bryan and Roderick just watched the crowd turn on us completely but had a plan to try to fix it.

"This is going to sound strange, but we're really going to have to give you guys a beating tonight to make this work," Bryan said. The idea was, if we could suffer enough damage, we could get the crowd to sympathize with us and get them back on our side. Except . . . that plan didn't work. Every time Bryan kicked, slapped, or chopped us, the crowd wanted more.

Every time Roderick suplexed or body-slammed us, the crowd wanted more. And guess what? When we tried to fight back, the audience booed. Too stubborn, Roderick and Bryan were convinced they could still flip the crowd, so they continued to give us a beating. The crowd continued to cheer. Finally, feeling taken advantage of, Matt and I began to defend ourselves, and suddenly the match felt like a real fight. But the more we fought back, the harder they hit us back. And the harder they hit us, the louder the bloodthirsty fans got. All our chests were purple and blistering. And while Bryan continued to deliver multiple stiff elbow strikes to my head, I yelled, "Okay! That's enough!" I didn't want to look like a punk, and I respected the hell out of Bryan, but I simply couldn't take any more.

In the audience I saw Matt's wife, Dana, in tears. She'd watched Matt perform for years, and she could tell something was going awry. Brandon and Dustin watched from the crowd, later telling us they came close to running out and getting involved, thinking it had turned into a real fight. We went to the scheduled finish, where we'd hit our finisher More Bang for Your Buck, and the audience showered us with boos as the referee counted to three. We lay there for a second, feeling a bit violated and disturbed. When we got to the back, the usual loud, spunky locker room had fallen to a hush. Everybody sat quietly with their heads down. Brandon, Dustin, and Kenny Omega were the first to approach us. "Are you guys okay? My God," Dustin said, putting his arms around us. Dana rushed into the room, her face wet with tears. Matt promised her he was okay. Roderick pulled Matt and me aside, and he didn't look happy. "I'm sorry. I don't know what happened out there. We thought we could turn them back," he said.

Dana drove us home that night, as Matt and I sat in silence the entire drive home, not even making our usual stop through the Taco Bell drive-thru. We were so disappointed in

the fans and in our colleagues. We've since forgiven Roderick and Bryan for what was clearly an excessive beating, but Matt still refuses to replay the match.

The next weekend, we returned to ECW Arena in Philadelphia for the second time to make our debut for Ring of Honor at a set of television tapings. They currently had a deal to air a one-hour weekly show on billionaire Mark Cuban's cable channel HDNet. We had two short introductory-type matches that featured us as the stars. Afterward, we met ROH owner Cary Silkin, who would eventually become a close friend of ours. Cary was a middle-aged New York City guy who loved to tell stories. He pulled us in and congratulated us on our successful debut.

"You boys are good!" he said. "Eventually we'll start flying you into these shows and paying you!"

Adam Pearce caught wind of the conversation. "Cary, we already are flying these boys in and paying them!" he shouted.

That night, we crammed into a cheap hotel room with eight other wrestlers, and I shared the floor with Matt. I understood that we were paying our dues, so I refused to ever complain. There was pay, yes, but I imagined that things would be a tad more glamourous.

We made the decision around this time to discontinue running High Risk Wrestling shows in order to fully dive in and concentrate on ourselves. We wanted to get into the best physical shape possible and needed to completely fill our calendar with more independent dates. It felt like we'd been neglecting HRW, and it didn't seem fair at the time. I remember how painful it felt when we came to the realization that it was time to stop running shows. With our closing of High Risk Wrestling

also came the end of the road for many of our closest friends and even younger brother. Malachi, Dustin, Brandon, BJ, and many of the others would all soon decide to stop wrestling and try different career paths. It weighed heavy on my and Matt's hearts, almost feeling like we were leaving everyone behind. But, selfishly, we knew though that our careers were taking off, and we couldn't let anything hold us back. It was going to be now or never.

On July 25, we again had a show at ECW Arena, which was becoming a regular setting for us. But this wasn't just any ordinary event. It was Dragon Gate USA's *Enter the Dragon*, the first official show for this new promotion that would be taped and later shown on In Demand pay-per-view. The event charged nearly double the price of most independent wrestling shows but promised to be a special can't-miss opportunity. It sold out immediately, and people buzzed about seeing the Japanese wrestlers from Dragon Gate mix it up with the hot independent stars in America. Our match in particular excited people from the moment it was announced. It'd be Cima and Susumu Yokosuka versus me and Matt in a match that had a lot of potential to steal the show.

As the seats began to fill, all we could hear was intense chatter. Then the lights in the building were turned off and the hype video for the event played on the big screen. All eyes locked onto the screen. The anticipation was building. Finally, the video ended with a countdown clock that went from ten to zero to signal the beginning of the show. Matt and I watched from behind the curtain, giddy with expectation. It felt like we were part of something historic.

Once we entered the ring, the place went crazy for us. "Young Bucks! Young Bucks!" the crowd chanted, as we made fists and bounced around in our blue tie-dye pants with silver tassels. We could feel the pressure here, knowing very well that

this was probably the most important match of our career so far. The match started off slowly by design, but after Matt took a bit of a beating and I eventually got the hot tag, it turned to chaos in the best possible way. Since Gabe Sapolsky saw big things in us, he had booked us to beat Cima and Susumu in a giant upset. As the referee banged down on the mat with his hand, the entire audience counted along to three. Afterward, all four of us hugged and raised each other's hands in the air, receiving a standing ovation from the fans. Matt got on the microphone after and proclaimed that the ring was our turf and we were no longer the "tag team of the future;" we proved on this night that we were the tag team of the present. Mike Johnson, a reporter for Pro Wrestling Insider, wrote that it was a star-making performance. Looking back, I have to agree.

A few days later, on July 31, we returned to American Legion Post #308 in Reseda where we'd be wrestling El Generico and Human Tornado. Prior to the show, we argued with Super Dragon that it was time to let us be heels, or bad guys, at PWG. He disagreed and thought that the happenings at *DDT4* was an isolated incident and that we were far too good at being babyfaces. We were still pretty hurt by how the fans treated us the last time we were there. We felt like all of our hard work for the company was forgotten, and we were offended. We'd rather not have gone out there and pretended everything was okay, when all we felt was negative energy. But Super Dragon insisted we play the good guys.

When "MMMBop" played, we heard a chorus of boos. We walked out pumping our fists, pretending we instead heard cheers. We'd stick to the plan. Early on in the match, Matt finished a high spot, but again the crowd booed. Soon after, we connected with one of our trademark double-team moves that always got a great reaction, but instead, this time the crowd reacted by chanting, "Same old shit, same old shit!" Matt fi-

nally cracked. He tagged me in, looked at me and said, "Do it again." I smiled and went along. We repeated the exact same move. The crowd laughed at our cleverness, happy that we were addressing the situation. Then they booed even louder.

We'd finally figured it out. The Reseda crowd had just grown tired of our white-meat babyface act and wanted something fresh. We also felt they had a little resentment for us because we'd had success outside the walls of Reseda. So at that moment, a change occurred in us. We started walking different. We started using different facial expressions. We had more swagger. But we weren't pretending. We were pissed off at the audience, and it felt good to openly express it. It was real, raw emotion. We were learning how to have more range as characters, and unbeknownst to us, were also developing characters that would benefit us later in our careers. After the match, we got to the back where a smiling Super Dragon met us at the curtain.

"Okay. You're heels," he said.

Sign the Bucks!

MATT

Our wrestling careers were going well, but our financial situation was not. As busy as we were on the road, we weren't making much money. This whole time, when we were home during the week, to make ends meet, we still worked in construction with our dad. Many weeks, during the day we'd sweat our butts off on a roof nailing shingles down from Monday through Thursday or Friday, and then wrestle Friday night through Sunday night. But suddenly, like hundreds of thousands of other small businesses, our dad's construction business came to a screeching halt when the recession came. We went from not having enough hands on deck to get all the work done to not having any work at all.

My dad's company, Massie Construction, would never recover. My parents could no longer afford the beautiful home they bought in Hesperia several years back, and it would be foreclosed upon. Now a married man, I wasn't just looking out for myself anymore. I was looking out for Dana, too.

My father-in-law Dave owned a business called Metal Rubber in Monrovia that made various metal and rubber parts for companies across the United States, inside of a machine shop. Dave was nice enough to hire me to work in the rubber molding department, starting me at $10 an hour. I think he sympathized with me and wanted to make sure his daughter was looked after. At work, I wore an apron, thick gloves, and poured hot liquid rubber into metal molds where they'd then be placed into ovens to cure and harden overnight. I'd burn my arms at least once or twice a day. Sometimes, I'd get burned so badly that pustules and scars would form, some of which I still have. Dana also worked at Metal Rubber, as a secretary, so getting to see her throughout the day was a highlight and made the one-hour commute each way bearable. In a job as dirty and dangerous as that one, it was a pleasant surprise whenever I turned a corner and saw her smiling at me.

But the work wasn't enough, and after taxes I was only taking home $300 a week. Dana and I quickly found ourselves sinking into debt, unable to pay all our bills each month. I was paying a monthly bill on a new truck I couldn't afford. Also, I had recently stopped paying the bill on the credit card I'd gotten to purchase the expensive engagement ring and wedding band for Dana, and the bill had been sent to debt collectors. The truth, and what we didn't want to acknowledge, was that we just couldn't afford the life we had.

My credit had fallen completely. Our financial life was a mess. We resorted to eating ninety-nine-cent burritos at Taco Bell most nights, or filling up the grocery cart with cheap canned food. Each morning while having my coffee, I'd peek outside the front window to the parking lot to make sure the IRS hadn't repossessed my truck.

What choice did we have but to keep pushing onward? Back on the road, we settled into our new jobs at Ring of Honor,

performing shows most weekends around the northeast. It was exciting working in front of new fans and getting a sense of how to operate with a full-time schedule, something we were not yet used to. When we weren't flying to make an ROH event, we were wrestling locally or joining up with an independent show. The key was in keeping ourselves motivated and busy so as to be prepared for the attention that bigger shows would draw. Sure enough, we'd finally gained enough of a following that some promoters must've felt we deserved a cross-country flight along with a small payday. We now had the pleasure of working regularly in Boston, Philadelphia, and New York City. We'd officially "gotten off the island," which was something very few wrestlers from Southern California could do. That in itself gave us the feeling of making it far in the business. In fact, we'd made it much further than most of our Southern California colleagues.

We still spent most of our time at ROH, however, where Kenny Omega was. Nick was right: Kenny was exactly like us. He was goofy, didn't take anything too seriously, and had the spirit of a child. But he also had a deep passion for the wrestling business. I noticed that Kenny was extremely hard on himself and usually returned from his matches unhappy about his performances. While in the ring, he was the most charismatic, lovable character, but outside of it he was quiet and socially awkward whenever he was around someone he wasn't comfortable or familiar with. In that sense, he was a lot like me, which was maybe why we'd bonded. In addition to our shared philosophy about the business, Kenny was also our protector, so much so that when he wasn't around, we'd make sure to get into the hotel room where the calmer wrestlers slept so as to avoid the peer pressure that came with being a professional wrestler. For years, we'd gather after a show and observe how the beers would come out and how everyone would attempt

to get the "good Christian boys" to drink alcohol for the first time. I remember what a breath of fresh air it was when I realized there were actually other wrestlers in the business who, like us, were not into the party scene. One of these guys was Tyler Black. Tyler, like Kenny and me, was an introvert and seemed to be misunderstood by the other wrestlers as being arrogant. After becoming friends with him, we learned that he was just shy, yet confident in his in-ring abilities. Being around guys like Tyler gave us strength in numbers.

One of the first times we hung out late at night after a show, Tyler confidently said to us, "I'll be in the main event of *WrestleMania* one day." He'd later become WWE's Seth Rollins, and he'd do just that. Jimmy Jacobs, a short wrestler who wore leather pants, leopard print shirts, and eyeliner (even outside the ring), was another person we hit it off with right away. He was so intelligent and looked at wrestling like no one else did, and I could spend three hours just listening to him preach about the business. He'd sometimes get so worked up about his opinions on wrestling psychology that he'd stand atop the bed in the hotel room in his boxers, with a Red Bull in one hand, and shout until we'd get a noise complaint. On the other side of those fervent conversations was usually El Generico (Rami), another wrestling genius, who also recognized the little nuances of the business. Nick and I were usually idle participants, respectfully quiet as we tried taking in all the information flooding our senses.

Tyler Black, Jimmy Jacobs, El Generico, and Nick and I would often laugh and joke about how everyone else on the ROH roster was out drinking and partying while we were talking about our all-time favorite wrestling matches. We dubbed our hotel room "the Scrub Room," but it became our paradise. Complete with two queen beds and all the pizza we could intake in a night's period, we'd stay awake until the sun came up

and discussed all things wrestling. We had a rotating door, too, where other guys with common interests like Kevin Steen and Bryan Danielson would sometimes pop in as well. One night, at around three in the morning, Bryan sat there and weighed his future in the business. "I don't know, maybe I'll wrestle here a few more years and eventually work at the local mill," he said sadly.

Jimmy didn't like Bryan's attitude, and pulled his cell phone out of his pocket. "Call Shawn Michaels right now and ask him to help get you a job!" he said, waving the phone in Bryan's face. Bryan was famously trained by the great Shawn Michaels who had connections in WWE.

"Jimmy. It's three A.M. I'm not calling Shawn Michaels!" Bryan screamed.

"He won't mind!" shouted Jimmy.

The whole room laughed. Bryan was currently the most popular independent wrestler in the world, but even he had his doubts about the future, and hearing them made me humanize him more. It was a reminder that nothing was guaranteed in this business, not even for the someone who seemed like the chosen one. Although Bryan would leave ROH later that year to go to WWE, where he'd make millions of dollars and become a multiple-time world champion, I'll never forget those conversations in which everything seemed to hinge upon our dreams.

Luckily, those dreams also were noticed because during this time the owner of ROH, Cary Silkin, took a real liking to us. He noticed we were excited about being in different cities, so before each show he'd make sure to take us around to see the sights everywhere we visited. Our eyes lit up as he led us through Times Square in New York City for the first time. We smiled big posing for pictures in front of the White House in Washington, D.C. Cary took great pleasure in letting us be

tourists, in turn enjoying our youthful spirit. He was a self-made millionaire, mainly through his third-party ticket-selling business, where he'd sell rock concerts, sporting events, and Broadway play tickets. Intrigued, we'd pick his brain all of the time in an attempt to learn about his success. He'd repeat adventure stories about hustling out on the streets of New York City, being a scalper for big-ticket events, and eventually working his way up the ladder. One thing he always made clear to us was also the most surprising to us: ROH wasn't making him much money. In fact, he was losing money, and a lot of it. He explained to us what went into running a wrestling show financially, and it opened our eyes to how this all seemed to work—from building and owning a wrestling ring with a ring truck to flying in and paying a crew of thirty-some-odd wrestlers, plus referees, plus other staff members. Not to mention venue costs, and insurance costs, among several other items. He told us ROH would most likely close soon unless he could find a buyer. Although we were nervous about our prospects, Nick and I kept that info between the two of us. We had faith in Cary and what he was building toward.

Back in Reseda, we began working as heels, which was a totally new thing for us. It was fun because everywhere else we wrestled we were still white-meat babyfaces, but in Reseda, they booed us. I'd remembered always watching Shawn Michaels obnoxiously chew his gum when he had to turn into a bad guy, so that was my immediate go-to as well. We also started to have more of a sense of humor in the ring, unafraid to "show our ass" or "slip on a banana peel," which in wrestling means looking vulnerable. While many wrestlers are fearful of looking weak, we took great pleasure in it, and played bad guys who would get outwrestled, fall down, and embarrass themselves but somehow pull off the victory in the end. The fans enjoyed this version of us.

Back in April 2009 at PWG, before our heel turn, we had the privilege of wrestling a dream match against Alex Shelley and Chris Sabin, The Motor City Machine Guns. Alex and Chris wrestled for the second largest wrestling company in the world at the time, Total Nonstop Action. TNA, now known as Impact Wrestling, was then run by its majority shareholder, Dixie Carter, whose father was the founder of Panda Energy, a company that had controlling interest in the company. Alex Shelley and Chris Sabin looked like an updated version of the Rockers. Both flaunted great style and dressed like members of a punk rock band, with studded leather jackets and dark tights with intricate designs. When they came to PWG, they had a mystique about them. They looked, moved, and carried themselves like stars, especially compared to the rest of us. After the match, and impressed with us, they asked if we'd be interested in working for TNA. "We need another team to work with, and we'd stick our necks out to get you guys a job," Alex Shelley said. Excited, and ready for any opportunity, we told them we'd be thrilled. TNA was a much bigger company than ROH, so if there was a chance to work with them, we knew we had to take it. It would certainly complicate things with ROH, but we figured we'd cross that bridge when we got there.

A few days later, Shelley followed up with a quick text message: Please send me a resume and DVD with one of your favorite matches, along with a sizzle reel. I'm going to get this into Terry Taylor's hands asap. Terry was a former wrestler but was now head of talent relations and helped with a lot of TNA's hiring. Twenty-four hours later, I was at the post office shipping out a package.

Terry received the package and apparently was raving about us to his coworkers. We had high hopes. We waited. And waited. But we didn't hear anything.

Eight months later, on a cold morning in December, I was

working at Metal Rubber when my phone rang. "Hey Matt, this is Brian Wittenstein. I'm the live events and talent relations coordinator for TNA Wrestling, and we'd like to bring you and your brother down to Orlando for a tryout match against the Motor City Machine Guns on December 21."

I couldn't believe it. I said yes to the invitation and went into the office to tell Dana. After celebrating, I finally came to the realization about what this could mean for our ROH careers. If we did really great at the tryout and were offered a job, it would most likely mean we'd have to finish up most of our independent commitments. At the same time, I didn't want to get too excited, because around this time, independent wrestlers signing contracts with the big companies was extremely rare. It just didn't happen.

Was TNA going to be the answer to our prayers?

Now I had the difficult task of telling everybody we currently worked with the news, starting with ROH's Cary Silkin and Adam Pearce. This would be particularly difficult, as they were both close friends of ours, and ROH had just offered us each a two-year exclusive per-appearance contract that bumped us from $100 to $220 per match. While it was a lot more than what we were currently making, we still realized it wasn't much compared to the rest of the industry, and we needed to see what else was out there. Cary and Adam weren't happy but respected our decision. It was difficult to separate business from friendship, but this was one of our first lessons in doing so.

Next I sent an email to Dragon Gate booker Satoshi Oji and told him the news. He basically let us know that because of wrestling politics, our time in Japan would come to an end if we worked for TNA. DGUSA didn't run frequently, but it always

booked us in major roles, so I felt it was only right to let Gabe Sapolsky know about the opportunity as well.

December 19 came, and we were booked in New York City for ROH's Final Battle show at Hammerstein Ballroom, an old opera venue that had been turned into a concert venue. It was one of my favorite places to perform in. Because of the positions of the balconies, whenever the crowd erupted, you'd feel it from every direction. We spent the day in the city with Cary Silkin and Kenny Omega, walking through Little Italy and grabbing lunch before the show. The weather was bad, and a giant snowstorm was predicted. As we made it into Hammerstein Ballroom for our call time, the snow started coming down, but we had no idea how bad it really was about to get. After our match with Kevin Steen and El Generico, we were alerted that our early morning flight to Orlando for our TNA tryout had already been canceled. In fact, pretty much every flight out of New York City was canceled. By the time the show was over, the storm had gotten so bad and so much snow had fallen that almost every major road in the city was closed. It looked like a scene from a disaster movie; New York City was completely abandoned. The only thing we *could* do was eat, and so we went to a local bar with Kenny and tried to figure out how we were going to get to Orlando. While searching the internet we learned the only way to the airport was by train through Penn Station, so we needed to get there quick. And just as soon as we had arrived, we left. "Good luck on your tryout," Kenny said as the three of us stood outside the bar, shivering. "I know you'll find a way to get to Orlando. Let's keep in touch." We hugged and said good-bye as snow pelted us in our faces. We didn't know it then, but we wouldn't see him face-to-face for a very long time.

After spending the entire night waiting in the ticketing line at the airport, we finally made it to the front. The airport was

an absolute zoo. At the Delta check-in desk, we were told not a single flight would be going out. Thinking fast, we asked if there were any other airlines that had an available flight to Orlando. It turned out that Continental Airlines, an airline that is no longer in operation these days, had one so we switched lines, got to the front, and crossed our fingers as Nick handed over his credit card. Miraculously, it went through, and we were on our way to our tryout.

We were exhausted by the time we landed in Orlando. We'd been up for twenty-four hours, hadn't showered since we'd wrestled, and both of us were still wearing the same clothes from the previous day. TNA sent us a driver, yet another service we weren't used to, and we couldn't wait to get to the hotel and get some sleep for our big tryout the following day.

But when our car turned into the Universal Studios backlot, I realized the hotel wasn't the first stop. The car parked, and I looked out of the window and saw Kevin Nash walking around casually. Then Mick Foley. Nick and I looked at each other with big eyes and silent acknowledgment that we had arrived at the Impact Zone, the home of TNA Wrestling, where all of the shows were broadcasted. TNA had a pay-per-view called *Final Resolution* being broadcast. Once out of the car, we felt like actors being dropped off in the middle of Hollywood for the first time.

We bumped into Christopher Daniels, who said, "Hey boys! Happy you made it. I heard you have a tryout tomorrow. Let me show you around." He knew we were also from Southern California, but he had no clue we'd already met a few years prior when we booked him at our company, High Risk Wrestling. I wasn't about to remind him. He sat us in front of the monitor and handed us bottles of water. "Let me know if you guys need anything else," he said before walking away to prepare for his main-event match that night against AJ Styles. We

sat and watched, mesmerized by the big-time production and feeling a bit out of our element.

The next day, for the all-women's show that was being taped, we were set to wrestle Shelly and Sabin halfway through the show as a "dark match," or a match that wouldn't be filmed. Before the taping began, we stepped into the octagon ring for the first time and tried to get a sense of what it felt like. Former WWF wrestler now turned agent D'Lo Brown approached us. "I've got you guys tonight. You've wrestled Shelley and Sabin like a hundred times, right? You've got eight minutes. Guns up. Just do your thing. Kill it. Get a job today!" I'd heard horror stories about working with agents, and how many of them micromanage every little thing you do. D'Lo was the total opposite. Cool, calm, professional.

Shelly and Sabin were excited to see us, and they had the entire match laid out already, so we just took their lead.

"Boys! Never mind. Format change. You've got fifteen minutes now!" D'Lo shouted as we rehearsed in the octagon ring.

"Guys. That never happens. They clearly want to see what you guys can do today," a surprised Sabin returned.

Nick and I said a prayer before the match, asking God to help us impress enough to earn a job. As soon as we hit the curtain, the Impact Zone popped and started chanting "Young Bucks!" which put us at ease. Like a comedian getting his first big laugh, we now had the confidence to perform.

The Motor City Machine Guns soon entered the ring, and Shelley winked at me as he stepped through the ropes. "Let's tear the house down, boys!" he screamed into my face, making it look like he was talking trash.

And that's exactly what we did. It was only the second time wrestling Shelley and Sabin, but it felt like we'd been doing it for years.

"Sign the Bucks! Sign the Bucks!" The Orlando crowd chanted by the end of the match.

"Home run!" Nick shouted into my ear and grabbed my face with his hands.

As soon as we entered the backstage area, Terry Taylor was waiting for all four of us. "I'll cut right to the chase," he said. "We want to offer you guys contracts to come wrestle for TNA Wrestling!" I couldn't even fathom what he'd just said.

"Our head of creative Vince Russo was watching from the back and was already coming up with ideas for you during the middle of the match," Terry continued. Vince Russo is credited with helping write for WWE during the most lucrative time in wrestling history, back in the late 1990s, usually referred to as the "Attitude Era." The Attitude Era was a time in wrestling that leaned on edgier storylines and sex appeal. Gone were the days of good guys and bad guys; it was all characters with attitude.

"Welcome to the TNA family!" Terry said, with his hand stretched out. We shook on it, and I tried my best to keep my emotions in check.

Once outside, while Shelley and Sabin continued to hurl congratulatory words our way, I hid away behind a dumpster and called Dana, hiding my tears. She was commuting home from work.

"How'd it go?" she asked.

Thinking of how hard things have been financially, and the road it took to get to this point, I could barely speak. "Baby, our lives are about to change. I'm going to start taking better care of you. They just offered us contracts."

She broke down into tears, while I sat and just listened to her cry. Finally, through her tears, she whispered, "Matt, I'm so proud of you."

Welcome to TNA

NICK

We came home from Orlando on an absolute high, feeling that we'd finally made it. It was the holidays, but you wouldn't know it being in Southern California, where everyone was still wearing flip-flops, T-shirts, and shorts in the beautiful seventy-five-degree sunny weather. At the annual Massie family Christmas Eve party, we strolled in like we were superstars, while family members watched us with big eyes and wordless expressions. We were the most popular guests at the party, sipping on hot cocoa and bragging about how we bravely overcame a snowstorm to make it to Orlando to then get offered jobs on the spot.

A few days later, our TNA term sheets were sent to us. I flipped through the pages in a hurry, looking for one thing and one thing only: I needed to know how much money we'd be making.

My heart sank when I found it. The offer was for three years, with no guarantee, at $300 each per appearance. Each

year after, we'd get a $100-per-match bonus. It was still better than the $220-per-match offer we had on the table with ROH, but not by much. I learned even worse news once I read the fine print. We would be responsible for our own hotel and transportation to the shows. With that in mind, there wasn't going to be a lot of meat left on the bone. This didn't seem to be the life-changing event we thought it was going to be, after all.

Matt and I discussed everything, ultimately deciding that TNA still would be the smarter move. TNA Wrestling had a national television deal at the time with Spike TV, a popular, edgy cable channel with a mostly adult male audience, and more shows on their schedule where we could potentially be booked, in comparison to ROH. TNA had also just brought in our childhood hero, Hulk Hogan, to help both in the office and as an on-screen character; alongside him was Eric Bischoff, former WCW president and the driving force behind one of the hottest story lines, or angles, in wrestling history, the nWo, or New World Order, a 1990s outlaw stable. Our contract also specified that we could still do independent shows, just as long as the bookings went through the TNA office and didn't interfere with our new schedule. This was a big opportunity for us, and we weren't confident enough to ask for a better offer—something I'd later regret. So, we signed it and officially became TNA wrestlers on Christmas Eve, 2009.

Two days after Christmas, Terry forwarded an email that Vince Russo had sent him:

> They need to cut their hair shoulder length—and get
> new gear—a "hot Topic" look, much like Jeff and Matt
> Hardy. Tell them to not wear the exact same thing.
> They will be called, "Gen Me." [Generation Me]
>
> Peace,
> Vince.

My heart sank. *A new name? A new look? Cut our hair? Did they actually like anything about us?* The only good thing that came out of this thinking was that they wanted us to get to work right away. January 5 was the television taping in which were booked to make our debut. The problem was, that didn't give us enough time to get new custom gear made. That sometimes took months. We had no idea what the expectations were with such little time to prepare, but we wanted to make a good impression. We ran to our local mall, Ontario Mills, and following what little instruction we were given in the email, attempted to find some street clothes that would suffice. I realized how ridiculous this whole thing was: two adult men, scrambling to find costumes to wear on a cable television show at the very mall we used to shop at for back-to-school clothes, just a few years prior. We went to Hot Topic, several skateboard shops, and shoes stores and wrangled up dark skater jeans, bandanas, and high-top sneakers. We didn't have a good feeling about any of it, but we were desperate.

On January 4, we flew into Orlando, where TNA Wrestling was hosting its first live Monday night episode of *Impact!* that was set to go head-to-head against *WWE Raw*. At the time, it was an experimental one-time special, but the world was buzzing about the idea of the "Monday Night Wars" possibly returning. On every Monday night during the late 1990s through the early 2000s, WCW and WWE would air shows opposite each other on different cable channels, each battling to get the biggest possible rating. As we sat in bed and followed along online with what was happening at both shows, we were in disbelief that all of this was happening the night before our debut. It felt like our timing couldn't have been more perfect.

When we arrived at the *Impact!* taping the following morning, we were told by Terry Taylor to go to the hair and makeup room to get our hair cut. We liked having long hair and felt like

it was a major part of our identity. This haircut was something we had been dreading since we read Russo's email. As soon as we sat in the chair, we told the hairdresser just to take a couple of inches off, which she did. We approached Terry, trying to sell him on our not-so-drastic makeover. "Let's go show Vince Russo and get approval," he said. "Grab your gear, too."

Until this point, we hadn't even met Vince. We followed Terry up a few stairs where a trailer was, and he knocked. "Come in!" muffled Vince, who, using all but two words, displayed the heaviest New York accent I'd ever heard. Vince was facedown on a massage table, his bare ass halfway hanging out over a towel while a masseuse rubbed on his back.

"Vince, I wanted to introduce you to the Young Bucks," Terry began. "They wanted to show you their haircut and gear."

Vince reached up—his ass exposed even more now—and shook our hands. "Nice to meet you guys. Welcome to the team."

Phew.

But then Vince said, "Hey bros, I'll be honest with you guys. It's not short enough." Not wanting to make a bad first-time impression, we agreed to cut our hair even shorter. Then we presented him two options for gear: the stuff we bought at the mall or a pair of standard Young Bucks gear. Obviously, we wanted to wear Young Bucks gear, and we tried our best to persuade him, but he chose the mall stuff instead. Defeated, we went back to the hairdresser and asked for a couple more inches to be taken off. She did just that, and as she dusted off my shoulder of any stray hair pieces, I couldn't help but feel embarrassed looking at my reflection. If my hair were any shorter, it would have been a "bowl cut." Matt and I had already experienced major criticism over how young and nonintimidating we looked, but now we both looked fifteen years old.

We hadn't found out until earlier that day that our debut

would be against the Motor City Machine Guns. And, surprisingly we would be *winning* the match. That news made up for the other stuff, I have to tell you. We settled into a trailer that was dubbed "the X Division Locker Room," where most of the other X Division wrestlers changed. The X Division was dedicated mostly to the high-flying, risk-taking style of wrestlers. Sitting next to us were Shelley, Sabin, Amazing Red, Jay Lethal, Doug Williams, and Desmond Wolfe, although there was always a rotating door of talent. They were all people we were pretty unfamiliar with, besides Desmond, whom we'd spent some time with at ROH the year prior when he was known as Nigel McGuinness. Nigel, a quiet British gentleman, was great to have around because, in addition to being an interesting person, he was a wonderful magician, always entertaining the whole locker room with his card tricks.

It was intimidating to walk around the backstage area and see so many of the wrestlers we'd grown up watching on television. To our left was legendary tag team the Nasty Boys, whom Matt and I would watch endlessly back when we were kids. To our right was one of the most decorated tag teams in the world, the Dudley Boyz, known here as Team 3D. I remember making small talk that day with gold medalist turned multiple-time world champion, Kurt Angle, and even peeing in the stall next to one of the top wrestlers in the history of the business—"Nature Boy" Ric Flair. None of it seemed real. *Act like you belong,* I kept saying to myself, and I know Matt was thinking the same.

Looking into the mirror one final time before our big debut, I could hardly even recognize myself. Black skinny jeans, purple-and-black shoes, and a purple bandana obscuring a haircut even my mom wouldn't like. And, as if we weren't already suffering an identity crisis, we were told that Matt and Nick would no longer be our ring names. When we inquired

about what our names would be, they asked us to come up with some ideas and told us they'd edit it into postproduction, since this wasn't a live broadcast.

At last, the generic rock music played (you know, full of power chords and pedal effects) and Matt and I entered the Impact Zone through the tunnels. The crowd, not caring that we looked like a couple of high school kids pulled out of a skate-park, popped big for us and chanted "Let's Go Young Bucks!" We didn't know who we were as characters, so it didn't even feel right to do our old trademark pose. We just hopped around and stretched in the most uncharismatic way possible. It was dreadful. Shelley and Sabin were the opposite and entered like stars with their trademark poses. They knew *exactly* who they were.

We'd done short eight-minute matches before, but never a television eight minutes, which meant a strict hard-out. As the bell rang and the action unfolded, we realized just how rushed we were for time. Everything felt like a sprint. In be-tween spots, the ref would come and update us on remaining time, "Six to go!" "Four to go!" etc. We didn't feel comfortable in our own skin, but when it came to the wrestling, we felt at home. I came in for my usual comeback that I'd been doing everywhere, which was extremely polished, so by the end the crowd was with me. After a series of sequences that left every-body's heads spinning, we finally connected with our finisher More Bang for Your Buck, and the ref counted to three. We sold the finish like it was a giant upset because, well, it was.

As far as the Young Bucks in-ring action is concerned, it's still one of the best debuts ever for a tag team (Shelley still tells me so). Matt grabbed me by my neck on the way back up the ramp, and, clutching his fist, told me, "We're made men."

My family and I watched *Impact!* about a week later when it finally aired, all of us packed into Matt's tiny one-bedroom

apartment. When we appeared on the TV for the first time, the family cheered, but I was almost as nervous as I was when we actually wrestled the match. Then we noticed that the announcers started referring to us by certain first names. I was Jeremy and Matt was called Max. "I guess this is how we find out, huh?" Matt groaned, feeling a bit blindsided. "So happy they asked for our input!" We didn't let it ruin the moment, though, realizing how surreal it was to watch ourselves on television alongside our family.

Every time we wrestled for TNA, the crowd continued chanting "Young Bucks!" They refused to refer to us as Generation Me. Given that, the creatives decided to give Jeremy and Max the last name "Buck," as a wink and a favor to the fans who knew us prior to TNA. This was worse—Jeremy and Max Buck sounded more like porn names! I was embarrassed any time I had to sign autographs on the TNA programs.

Shortly after our successful debut, Brian Kendrick came over to TNA as well. We'd spent a little time with him in the indies after he left WWE, where he was a tag team champion. Like me, Brian had a young face, blond hair, and was small in stature. He, too, lived in Southern California and wrestled in a similar style to ours, so naturally we became friends. Brian felt like an older brother; yes, he was only a couple years older than me and Matt, but he looked out for us. Before TNA, one of the first times we ever traveled with him, we arrived at our hotel to find that the independent wrestling promoter forgot to book our rooms. Without hesitation, Brian pulled out a credit card and booked each of us our own rooms. "Don't worry, the promoter will pay me back," he confidently said. On another trip, after we headlined a PPV show, we sat in a diner and had a conversation that's typically taboo in the wrestling business:

"Let me ask you guys," Brian began. "You were the main

event tonight, on a show that'll air on pay-per-view. What were you paid?"

Matt, embarrassed and surprised by the honesty, whispered, "Seventy-five dollars."

"What the fuck!" Brian was livid. He ranted for an hour, in an attempt to teach us a lesson about self-worth. "If you're in the main event of a big show, you should be getting paid more than seventy-five dollars," he reasoned. "And no promoter in the world is just going to hand it to you, you've gotta ask for it." While we were of the "just happy to be here" mentality, we knew Brian wasn't wrong. This was a business, and we needed to treat it like one, because no one was going to look out for our well-being. Although it'd take us some time to put what he was teaching us into play, we asked that particular promoter for double the pay the next time, and you know what? We got it.

Brian quickly moved into the X Division locker room, where he fit right in and took on the mantle of the leader of our "group." When we traveled on the road for "house shows," which are nontelevised events, we always rode with Brian, who was fascinated with conspiracy theories and religion, among other topics. Any time he saw us on our phones he'd give us grief: "Your generation is just glued to that screen. You're like robots!"

One day on the shuttle drive over to Universal Studios from the Holiday Inn Express Hotel, we saw two people seated in the back we'd never seen before. It was an older Japanese man with a ponytail and a young, tall, skinny Japanese man who seemed very shy. Feeling comfortable speaking to Japanese people because of the time we spent out in Japan with Dragon Gate, we went and introduced ourselves. In near-perfect English the older man responded, "Nice to meet you. I am Tiger Hattori. This is Japanese young boy, Kazuchika Okada." We shook their

hands. He continued, "He come here for education. To learn American-style wrestling. Maybe he live here for some time."

When we parked at the Impact Zone, we invited Okada to dress in our locker room, and showed him around. He was appreciative of our hospitality. We told him all about our days in Japan with Dragon Gate, while he talked about his home promotion, New Japan Pro-Wrestling, or NJPW for short. NJPW was the largest wrestling company in Japan but was coming off of a cold period in the 2000s, with business being drastically down compared to the glory days of the 1970s, '80s, and '90s. Okada told us that Tiger Hattori was a senior referee who also helped book foreign talent in Japan. We had no clue he'd one day be our boss.

Our locker room was always a blast to be in, and its members became our family. Jay Lethal was the class clown, and the most liked person in the locker room. He was always cracking jokes and popping the boys with his dead-on impersonation of wrestling legend Macho Man Randy Savage. He singlehandedly kept morale high every time we were on the road. Amazing Red, one of the first independent wrestlers to become wildly popular in the early 2000s, was shy and kept to himself. He and Shelley would practice chain wrestling, or trading wrestling holds repeatedly, in the ring for hours before bell time. Doug Williams was an older veteran wrestler from England whom everyone respected. He could have a good, realistic match with pretty much anybody. And as Kazuchika Okada came around more, he opened up more and showed his true, silly side. He was an absolute character, never taking any moment seriously. He and I would endlessly rib each other, hiding each other's gear whenever one of us left the locker room. Or when we weren't pranking each other, we'd play fifteen rounds of the children's game that Brian Kendrick bought for the locker room, Gator Golf. We would build intricate obstacle

courses out of everyone's bags, or whatever else was around, and compete for hours. When we had easy days at work, or weren't needed for a match, sometimes we'd open the gate and sneak off into Universal Studios to enjoy some of the shows or go to some of the attractions. We had a special security badge that sometimes helped us get to the front of the lines, if the ride operators didn't look too closely. One time while several of us were enjoying an afternoon at the park, a Universal employee was letting people take a photograph while holding the X Division title belt, as a way to entice tourists to come watch the TNA television taping happening later in the day. Me, Matt, Okada, Alex Shelley, and Brian Kendrick caught wind of the situation, and we had no choice but to take the opportunity to get a special picture with all of us, each with a hand on the championship belt. The Universal employee had no idea we just so happened to be wrestlers.

One day, the never-serious Okada approached Matt and me, but this time he seemed legitimately scared. "They want me to bleed tonight. They want me to cut," he said, while pointing to his forehead. "But I don't want to. Please help me." In wrestling, to increase the level of drama, wrestlers will sometimes secretly cut themselves with a tiny razor blade. The act is referred to as "blading" or "gigging." In the old days, it was a normal, common occurrence, but around this time it was done less and less and was becoming quite controversial in the business. We approached the producer for the segment, Pat Kenney, who was a former wrestler named Simon Diamond, and explained the situation. "We're gonna have to talk to Vince," said Pat. Like approval over our haircut, all the decisions came down to Vince, no matter how big or small.

We found Vince shortly after and told him how nervous Okada was about blading. We outright said we didn't think it was needed. To his credit, he quickly agreed. We came back

to Okada and told him it was taken care of, and I'd never seen anyone more relieved. It was the least we could do for one of our own.

It had been about two years since Ellen and I started dating, and I could tell that she wanted to get married. When my brother Mal proposed to his girlfriend, Heather, I sensed that Ellen was pretty jealous. "Wow, your younger brother is getting married before you, eh?" she would sarcastically say to me. I knew she was definitely the one, but financially we weren't as ready as I'd wanted to be for something so big.

Ellen told me she was going to start looking for an apartment to move into. I told her that it was a bad idea to waste money paying rent and suggested she look for a house to buy. She told me she couldn't afford a home loan on her own, so I told her we should both look for a house. Because of the housing market crash, houses were very inexpensive. She preferred we lived in Anaheim, but I convinced her that Hesperia, California, would be the perfect—and much more affordable—place to get our first home together.

When I say the first house we looked at was literally the home we bought, you might think I was crazy, but that was how it happened. It was a two-thousand-square-foot home with a pool for the low price of $105,000. It was too low *not to* put an offer in. The offer was accepted, and since everything was moving so fast, I thought that the next logical step was to marry this wonderful woman. There wasn't really a romantic proposal or anything. We had just got the keys to the house, and the next day I asked her if she wanted to get married. She unromantically responded, "Duh! It's about time!" So we set a date for April 3, 2011, deciding to host the ceremony in our big,

new backyard. My dad was ordained to officiate weddings and had done my sister's wedding years prior, so I decided it would be great if he also did ours.

The wedding went great for such a small budget, but the biggest shock of all was Ellen's father, Greg, who gifted us $5,000 cash. I remember that helping us so much at the time, as I had just started at TNA and was struggling to make money. I'll forever be grateful for him helping us when we were just starting our lives together.

We had a five-night honeymoon in Honolulu, Hawaii, that barely cost us any money at all. I had saved all my frequent flyer miles with Delta throughout the years and had enough for free round-trip flights for the both of us, as well as free nights at a hotel and a free car rental. We just had to cover food and entertainment for the trip. We spent the trip enjoying mostly just each other's company and the beautiful views, living frugally on fast food. The highlight was hiking a trail that led to a beautiful 150-foot waterfall called Manoa Falls. It rained on us during the entire hike, soaking both of us from head to toe. But we laughed at the sight of each other as we embraced and stood transfixed by the awesome waterfall. It was one of my favorite trips of all time.

Back at TNA, a series of great matches with the Motor City Machine Guns would end up being the highlight of our run there. One night, at a show called *Destination X*, after absolutely tearing the house down with Shelley and Sabin in the Impact Zone, Jay Lethal approached Matt and me. "Hey, the Hulkster was glued to the monitor during your guys' match," he said. "You should go ask what he thought!"

Without hesitation, we did just that, catching the big, blond, mustached man as he walked by us. "Hey Hulk, was wondering if you got to check out our match?" Matt asked.

"Brothers, you guys did some amazing stuff out there!"

Hulk said. "That was awesome. Just one thing . . . quit stealing my shit!" But he erupted in laughter, tipping us off to his good sense of humor. Hulk, one of the greatest in-ring performers ever, was never the most athletic wrestler.

In addition to meeting our childhood hero Hulk, we also met Matt and Jeff Hardy, the biggest box office draws in tag team wrestling history, and probably my favorite-ever tag team. They could tell just by looking at us how much they inspired us as wrestlers. On the mat, we looked like them and wrestled like them. I think they were flattered by that. We told them it was our dream to one day wrestle them. Despite their being mega-stars, they were always humble. One time, I broke a forbidden rule in wrestling by using Jeff Hardy's finishing move during a match and was forced by legendary wrestler Scott Hall to apologize to Jeff. Clearly nervous and shaking, I apologized to Jeff for the mistake, who couldn't have been cooler. "Seriously, don't sweat it, man!" he said, putting his hand on my shoulder like he was my older brother. It made me like him even more.

While we had several memorable matches on television with the Motor City Machine Guns, some of our best stuff took place on the road at the house shows. Sometimes we were booked on a three-show loop against each other, and while many other wrestlers would just enact the exact same match night after night, move for move, we would plan completely different matches. It was a fun challenge for us. Not only were the crowds on the edge of their seats, but our matches were known as "curtain sellouts," which meant that every wrestler in the back stood and watched at the curtain.

In March 2010, TNA announced it would be permanently moving *Impact!* to Monday nights to compete with *WWE Raw*. While this created a ton of excitement both in the locker room and at home, it was short-lived. Competing head to head with the massive WWE property proved to be a bad idea, as *Impact!*

wasn't doing well in the ratings, so the executives decided to move it back to Thursdays. Out of the blue, Eric Bischoff told us that it had been decided that we would be getting a huge push and would be turning heel at the September 5, 2010, *No Surrender* pay-per-view. We were apparently in luck due to a reshuffling caused by injuries going on in the locker room. The word going around was they were going to eventually put the tag team titles on us.

Once again, we tore it up with Shelley and Sabin at *No Surrender*, but after the match our characters had enough of playing second string to them, and we decided to attack, dropping Shelley on his neck out on the floor. Just like back at PWG, a transformation took place. Our mannerisms, body language, and facial expressions changed. We had sly looks on our faces, proud of the terrible deed we just did. We smirked like the main villains in a horror movie standing over their victim. It was as if someone snapped their fingers, and magically we had transformed into bad guys with more swagger. We'd done this act before, so we were ready.

All of this excitement and drama built up to one final tag team bout against Shelley and Sabin at *Bound for Glory* in Daytona Beach on October 10, 2010 (or 10/10/10). We were once again our old selves: our confidence had been renewed, our hair had grown long again, and we had started sneakily wearing our old Young Bucks style of gear.

Needless to say, we gave it our all out there, realizing how rare it was to be put in a great spot like this on a major show. It ended up being potentially the greatest match of our career up until that point. Afterward, hardcore wrestling legend Mick Foley pulled us aside and told us we stole the show. The four of us all looked up to Mick and valued what he said. He was one of the few guys of his stature there that mingled with us X Division guys and was always friendly. Thinking maybe we'd

earned some type of recognition after our prior night's performance, we showed up at the Impact Zone and were told we'd be dancing on stage with Tara while she lip-synced in a fake concert. Tara was former WWE women's champion Victoria and at the time the best women's wrestler on television, but being her backup dancers during a comedy routine didn't exactly excite us. Especially not after just having the match of our lives twenty-four hours earlier. *A business of highs and lows,* I remembered. We didn't complain though. We went onstage and danced our asses off and tried to make it an entertaining segment. After the segment, we entered back in the locker room to a standing ovation from the boys. They sympathized with us and were proud of us for going out and committing to the bit, no matter how embarrassing it was. Our family and friends all got a kick out of it, teasing us for weeks, volunteering us to show off our dancing skills anytime there was a get-together. The fans on the internet felt like our talent was being wasted, and angrily reacted.

During our entire time at TNA, our financial situation was pretty tough. Checks would hardly come through on time, and often they would be written out for the incorrect amount. Matt and I would have to contact Terry Taylor to have it fixed, but it'd take several days longer to finally get the rest of the money. Many times, during a multiple TV taping week, we would fly into Orlando and arrive at the Impact Zone to find out that we weren't being used for the day. This meant we wouldn't be paid. Then we'd show up the next day, fingers crossed, hoping our names would appear on the sign-in sheet. No luck. On several occasions we went to Orlando for a three-day shoot and were booked only one time, meaning we'd be making $300 for three days of work and would have to account for our own hotels, transportation, and food. Due to this financial low point, Matt continued working at Metal Rubber while I picked up

work with my dad whenever he had anything extra with his all-but-dead construction business. I remember being embarrassed when my dad would introduce me to a customer whose house we were going to be working on for the day. "This is my son Nick, he's a wrestler! You can watch him Thursday nights on Spike TV!" he'd boast. All I could do was cringe.

"We want to split you guys up."

We were caught completely off guard when Vince Russo told us this before a show in Orlando.

"Matt, you'll go heel on Nick. And don't worry, this isn't permanent or anything, you'll eventually get back together," he assured us. We were in shock.

"Wait a minute," I said. "We feel we're best as a tag team. We came here and got signed because of our work as a team. Are you sure about this?" We had zero aspirations of becoming singles wrestlers, so this was a devastating blow.

On March 15, 2011, Max Buck versus Jeremy Buck was booked on an episode of *TNA Xplosion!* which was an extra hour of content filmed after the *Impact!* taping, for a channel in the U.K. It was a dreaded spot to be on the show because you'd be following a really long television taping, so half the audience would leave or sit there completely exhausted. *Xplosion* was known as the "B" show, at least as far as the boys were concerned. The match was supposed to start as an exhibition match, but early on I kept outwrestling Matt, and he kept getting more and more frustrated. Eventually, this resulted in Matt cheap-shotting me from behind and gaining the victory. This was surprisingly effective: another curtain sellout, and the match was well received. So well received, in fact, that management decided we needed to do it again, but this time

on the March 31, 2011, episode of *Impact!* Truth was, we didn't like this angle, but we were going to try to do our best with whatever we were offered. Again, we had a killer one-on-one match, this time on national television, but we knew where this was headed. A couple of weeks later, we were booked again in a multi-man tag team match on *Impact!* where Matt was finally officially going to turn his back on me.

Performing this angle was painful. We knew we were doing harm to our careers, but we did it anyway, too afraid to speak up. Matt angrily accused me of trying to steal his spotlight, attacked me, and threw his "Gen Me" wristband at me. That felt like the final straw. We could feel it, and see it, from the expressions of the crowd; they didn't want us to split up.

Back in the X Division locker room, morale was at a low. Most of us X Division wrestlers were being left off of most of the house shows and struggling to get by, and none of us were doing anything creatively satisfying. But this made our bind even tighter, as we needed to confide in each other the many problems in the company. Okada, who'd permanently moved into a tiny apartment in Orlando by this time, was only used a handful of times, and they were usually dark matches. Shelley kept shaking his head, disbelieving that they weren't using someone with such potential. "This guy is going to go back to Japan and be a huge star one day! You watch!" he'd angrily shout. It got to the point where Okada wouldn't even show up to most tapings; he'd just ask us to text him if he was needed for the day.

Recognizing our vexation, Brian Kendrick, the clear leader of the group, had us huddle up in Cincinnati, Ohio on April 17, 2011, at the TNA pay-per-view *Lockdown*. "We have strength in numbers. Let's all corner Vince Russo and get some answers," he said. "Why are we being left off shows? What do we need to do be treated fairly!"

Brian, Jay Lethal, Chris Sabin, Amazing Red, Matt, and I found Vince walking backstage and kind of cornered him.

"What is this, bros? An intervention?" Vince asked.

We asked why most of us were being left off a lot of the shows and what we could do to make ourselves more appealing or easier to write for. I don't remember getting an answer that sufficed, but we definitely put him in an awkward, intimidating spot. He handled it as best as he could, taking time to talk to us, letting us know how difficult a job he had trying to make everyone happy. I remember at the end of the conversation actually having sympathy for Vince.

That same night, we wrestled in a multi-man steel cage match. Matt and I, in a full-blown blood feud, had a final showdown at the end of the match. It felt painful to go through. After the match, Matt lay on the floor in the locker room after a big match he had just won and complained, "I hate this place." All of the months of unfavorable bookings and having to track down checks was taking its toll.

A few days later, Matt's phone rang, and it was Jay Lethal, in tears. "They let me go, Matt," he cried. Jay told Matt he'd just received word that TNA was releasing him from his contract. I couldn't help but think this was related to our "intervention" with Vince. It was just too soon to be a coincidence. However, we were told it had nothing to do with it.

A few weeks later, on May 5, seemingly for no reason whatsoever, Matt and I were placed back together as if nothing happened. It really concerned us that our story had such a giant plot hole in it. Although we always wanted to be together, we didn't feel like this was going to help our characters' development. It simply felt like our story had been abandoned.

Then, on May 20, the next domino fell when we were told that Terry Taylor had been released from TNA. We were devastated. Terry had become like a father figure to us and was

always the guy we went to for pretty much everything. We heard rumors that any of Terry's hiring's, or "Terry Guys," were most likely in jeopardy and that the new head of talent relations would be Bruce Pritchard. Bruce worked behind the scenes for years at WWE but was best known for his work as the heel manager named Brother Love. Bruce had just started with the company shortly before and wasn't popular in the locker room. "He's a WWE stooge," most of the guys said.

For much of May and June, we were completely left off the road, and we retreated to home where we didn't make any money. Matt and Dana were pregnant, with their first child due in October. "I'm about to be a father, and they're starving us out," Matt would cry to me. I had a bit more patience, but Matt's was understandably wearing thin. Then, out of the blue, we were contacted by Hunter Johnston, the new head booker of ROH who had taken over for Adam Pearce. Prior to this, we'd known Hunter only as the crazy masked wrestler named Delirious. "We've got a show in New York City on June 26 called *Best in the World*, and we'd love to have you," Hunter said.

This wasn't the only big change that ROH had recently gone through. On May 21, 2011, Sinclair Broadcast Group announced it had purchased Ring of Honor from Cary Silkin. Sinclair Broadcast Group is the largest television broadcasting company in the United States and had begun showing ROH's TV shows in syndication throughout the country.

Due to the stipulations in our current TNA contracts, since this ROH event would be broadcast on pay-per-view, it was agreed that our match would have to be a preshow dark match against two young up-and-comers named Adam Cole and Kyle O'Reilly. Still, our arrival at Hammerstein Ballroom felt like a homecoming. Cary Silkin, still working as an executive for the company, smiled from ear to ear and gave us huge hugs. Nearly 90 percent of the matches we'd performed for the previous year

and a half were in the Impact Zone, so it felt good to get out of that sterile environment.

We met with Adam Cole and Kyle O'Reilly, who were excited and talked at a million words a minute. I couldn't keep up with the ideas they were hurling at us. For the past seventeen months I had been used to simple, short, television-style matches that were produced by someone else, and my brain was on hibernation mode. But Adam and Kyle were hungry and passionate, and they reminded us of ourselves a few years back.

We went out to the ring, and instead of a quiet, exhausted Impact Zone, the building erupted for every single move.

"Young Bucks!" the crowd chanted. "Young Bucks!" We hadn't gone by that name in over a year. By the time we got to the back, we were riding a high that we hadn't felt in what seemed like forever. Jim Cornette, a former heel wrestling manager and promoter who was now working as Hunter Johnston's right-hand man in the office, approached us. "Jesus, Bucks. What a match! I know we can't legally say anything with you boys being under a contract currently and all, but if you ever find yourselves available, you'll always have a spot here at ROH!" I fell back in love with wrestling that night.

The next time we came back to Orlando, we were booked for a match on *Xplosion*, and while talking over the match, our producer couldn't remember whether Matt and I were babyfaces or heels. At that moment we knew our time there was coming to an end.

That night, instead of keeping quiet like we usually had done, we expressed our anger and disappointment online. We tweeted about multiple things we were upset about: Jay Lethal's firing, late payments, and our bad creative. It was so unlike us, but we were beyond frustrated, and it felt like nobody would listen to us whenever we voiced our concerns. We had simply had enough. Naturally, this made us quite unpopular

in the office, and word was Bruce Pritchard had a ton of heat with us. We finally decided the next time we were booked to be in Orlando, we would ask for TNA to release us from our contracts. We'd officially had enough. Matt put it bluntly to me: "We've gotta get out of here before they completely kill us."

On July 10, 2011, before the *Destination X* pay-per-view, we sat outside Bruce's trailer in the hot Orlando sun for what seemed like hours, waiting for him to come out. I practiced exactly what I was going to say to him, in my head, over and over again. Finally, he appeared. As Matt shook his hand, Bruce went to walk away, but Matt held on. "We need to talk."

"I don't have much time, so we're gonna have to walk and talk," Bruce answered.

"I've got a baby on the way, and I'm currently losing money working here," Matt said.

"Well, you and your brother would probably be getting booked more if you didn't complain about everything on Twitter," Bruce replied. He repeated to us verbatim what we had tweeted. We apologized for the tweets—we really did feel bad about them—but it didn't change the fact that our bookings had been atrocious and mismanaged and that we were both broke. By this point, the conversation had turned into more of a loud argument and we happened to be standing right in front of catering where half the locker room was sitting and watching. Brian Kendrick, who knew the contents of this conversation, walked by and rubbed both Matt and my shoulders and whispered, "You guys are doing great!" Brian gave me the boost of confidence I needed. I looked at Bruce, and said, "You want to know the point of this conversation? We want our release." His eyes got big, and he went completely silent. It took him by total surprise. It was unusual for wrestlers to ask for their release at this time. Jobs in wrestling were limited, and once you got in somewhere, you held on for dear life. Bruce shook off the

surprised look on his face and said he'd grant us our release from our contracts, and that he'd do it instantly. We got what we wanted.

A few minutes later, we approached our boss, Dixie Carter, and told her we were leaving. One time at an offsite promotional event during a pay-per-view weekend, Dixie mistook Matt as a fan and mentioned he had a great look and should consider getting into the wrestling business. So, needless to say, we didn't feel like Dixie was too affected by our big news.

That night, we wrestled and lost to two great wrestlers, Shark Boy and Eric Young. I remembered feeling like I was lying to the fans or keeping a huge secret from them when we went out there and wrestled. The match ended, the final bell sounded, and a somberness overcame me. It felt like we had failed.

We shook Vince Russo's hand and thanked him for the opportunity. I think we all realized things didn't work out like we'd all hoped. Then we hugged everyone in the X Division locker room and promised that we'd keep in touch. As we exited the Universal Studios backlot, I thought of all of the fun times we had sneaking into the theme park during downtime, riding Jaws and E.T. with the gang. We had started with TNA Wrestling eighteen months earlier, but we knew it was our time for bigger and better things.

Handshake Gate

MATT

Leaving Orlando felt like breaking up with a long-term girl-friend. We didn't even have a plan—we just knew we had to change our current situation before it was too late. Our value in wrestling had dropped quite a bit after our lackluster story lines and absence from television. On top of that, I was now in a worse financial situation than I was before joining TNA. I had maxed out all my credit cards and stopped making payments on them completely. Thankfully, Dana had found a job as a leasing consultant in the office at the apartment complex in which we were living, which meant discounted rent. I am proud to say that Dana was the official bread winner during that time, all while being six months pregnant and suffering nausea so bad that she was put on medication. "I support you no matter what you do," she lovingly responded to me after I told her I was going to quit TNA. That was typical Dana: op-

timistic and comforting even when everything in life told her not to be.

While switching planes in Atlanta, both of us hungry, we ducked into a Popeyes Louisiana Kitchen located in the terminal. Always frugal, I ordered only a chicken sandwich, which was just a couple of bucks. I handed the cashier my debit card, and he slid it. Seconds later, he was making a face as he handed me back my card. "Want to try another one?" he asked. I didn't have another one. As a long line was forming behind me, I yelled for Nick, who had already ordered and was waiting for his food with his receipt in his hand. "Can you help me?" I said, completely defeated, looking down on the ground. Nick ran over and bailed me out. I felt ashamed and embarrassed. I thought, *What am I doing? Is it time to grow up and go get a real job?* We flew the rest of the way home, and I was in a really dark place that entire flight. I was about to bring a new baby girl into this world—how was I going to provide for her if I couldn't even provide for myself?

I weighed all my options. My dad still barely had any work coming in, and Dana's dad told me his company, Metal Rubber, was closing. It felt like my back was up against a wall. I applied for a couple of jobs. One to be a UPS driver. Another to work as a box boy in a distribution center. I told Nick it might be time to consider becoming singles acts because I needed a job with a little more stability, and I was about to be responsible for another person. He urged me not to quit. "Matt, we've been doing this for so long," he said. "It can't end just like this. You've got to have faith. Something bigger is going to come out of all of this." I agreed to hold on a little longer.

Shortly after, we called Hunter Johnston, who lived up to his promise and said he wanted to use us at ROH but probably couldn't start us up until the end of summer or fall. Jim

Cornette followed up with us on a call and we eventually settled on $500 each, but it'd have to be on a per-show appearance. Our transportation and hotel would also be provided for us, which was big. We verbally committed to a one-year contract right then and there on the phone, with a start date of October.

The one constant in our career was PWG. We'd continued wrestling there the entire time we had been at TNA. We'd been the top guys there for quite a while, and Super Dragon noticed we had a knack for booking, so he started leaning on us to recommend new, talented people he should bring in and asked us to help with some of the story lines on the show. It was our main platform to express ourselves and kept our passion alive during this rough patch.

"You see what RVD said about you guys?" asked Roderick Strong. He was looking down at his phone in the locker room at a PWG show on July 23. Rob Van Dam, or RVD, was an athletic wrestler mostly known for his time as the ECW Television Champion in the 1990s. In my teenage years, he was one of my favorites. One time, Nick and I stood in line for three hours to meet him at a Radio Shack in Montclair Plaza Mall. "One day you'll know my name," I said to him after he autographed my poster. "I hope so, dude!" Rob had replied.

Rob was at TNA with us, but we hardly ever saw much of each other. And what Roderick Strong had referred to was an interview that Rob had done with the *Miami Herald*. He didn't have the nicest things to say about us: "Some of the young guys who are or were there, I don't want to mention any names. There were two young guys who just left and looked like they were out of high school. The whole time they were there, they never introduced themselves or shook my hand. Things are way different than they used to be."

Nick and I were shocked. I realize that we didn't develop the friendship with Rob that we would've fantasized about hav-

ing when we were teenagers or anything, but we certainly were cordial and always said hello. He didn't seem very approachable, so when we needed advice we'd usually go to Terry Taylor, Tommy Dreamer, or Mick Foley.

On the drive home after that PWG show, we noticed that this RVD thing had become quite the news story. Clickbait headlines for wrestling news websites that read, "Young Bucks Disrespect Legend" started popping up everywhere online and portrayed us as ungrateful, bratty kids. The conversation on Twitter between fans and even other fellow wrestlers mostly sided with the very popular and notable wrestling star. People were outrageously angry with us.

Then, a lightbulb went off in Nick's head. "WWE's in town next month," he said. "We should get backstage, so people speculate we're going to sign there. It could give us even more talk and buzz." My stomach churned just at the thought. I told Nick I'd rather not go; being backstage at WWE gave me anxiety. I thought back at our past experiences there, and how it made me feel like I'd been walking on eggshells. While many of the superstars were friendly, we also had a few terrible experiences that I haven't forgotten about. I remembered the time a big, intimidating wrestler turned financial commentator, peaked inside the dressing room full of extras and shouted, "TNA, TNA, TNA," and then sighed, as a way to put us down. I cringed, thinking back when an Olympic weightlifter turned wrestler took one look at us, and said to himself, "You guys are smaller than my son. And he's two!" before walking away. I thought back to when we walked backstage with a fellow local wrestler, and a notable wrestler came up to Joey and said, "Who are these two fags with you?" I'd had enough of working for big-time wrestling companies and the failures that came with it. It clearly wasn't for me.

"Matt. It'll be different this time," Nick reasoned. "We're

not actually trying to get a job. We already know we're sign-
ing with ROH and doing this would strictly be for the buzz.
There's no pressure to do well. I say we do it."

Nick has a way of talking people into things. When he gets
stuck on an idea, he becomes obsessed and will angrily plead
with you until he gets what he wants. He does a thing where
he'll tell everyone else around you the idea so he has strength
in numbers, and then it becomes a group of people against you.
It also doesn't help that his ideas or hunches are mostly always
right. It's agitating, and sometimes I'll just see how long I can
withstand the fight just to be a pain in the ass, but I almost
always lose. We reached out to our old WWE contact, and our
names were put on the list for an August 15 episode of *Raw* in
San Diego and an episode of *Smackdown* in Bakersfield a day
later.

Heading to *Raw*, we hoped we could easily blend in with the
other extras just like we used to do a few years back. As soon
as we entered the building, we knew that probably wouldn't be
the case. Everyone looked at us differently, and according to
friends who worked in the company, there was immediate chat-
ter about us being there. WWE referee Scott Armstrong ap-
proached us and said, "Are you the TNA guys? Get dressed
and get down to the ring. They want to take a look at you."

We quickly got changed and headed to the ring where leg-
endary technical wrestler William Regal was waiting. William
worked as a recruiter for the WWE and was well respected by
everyone in the industry. We introduced ourselves and began
rolling around and working out in the ring. A short while later,
he pulled me and Nick aside and told us to pick two guys out
of the extras to work with and with whom to prepare a short

match to perform. Without a beat, we pointed right at Scorpio Sky and Joey Ryan.

"Hey, let's give them a PWG match." I said to Joey and Sky, smiling. They looked shocked. We'd been wrestling these two for years and knew each other's styles inside and out, so why hold back? All the other times we were put in this situation, we played it safe. We were done playing it safe. Besides, we had nothing to lose. Sky, perhaps seeing this on my face or coming to the same conclusion himself, said, "I'll do whatever you guys want."

We called a wild match filled with high spots and dives to the floor, all culminating in our delivering More Bang for Your Buck. Most tryout matches like this consisted mainly of mat wrestling and basic elementary-style wrestling. Not this one. As we began, WWE superstars and staff formed around the ringside area because their television rehearsal was approaching. Noticing them, we wrestled as hard as we could wrestle and received . . . *complete silence.*

Nick completed his trademark comeback, and then dove to the floor onto Joey.

Awkward silence.

We loaded up Sky and delivered our finisher.

Silence.

The referee counted to three. And then the entire ringside broke into an applause. Nick and I looked at each other and smirked. *What in the world just happened?* I thought.

William Regal shook our hands and told us how much he liked the match. Later in the day, WWE wrestler Curt Hawkins said he'd never seen anything like it. The story of the match spread throughout the business. In some circles it was referred to as "the greatest tryout match ever."

The next day was a long drive to Bakersfield for the next WWE event, which took even longer because of traffic. While

on the drive, we noticed that our tryout had already been leaked online. The internet was abuzz. *Mission accomplished!*

Running late, we hurried into the arena where *Smackdown* was being filmed that night. As soon as we arrived, we bumped into William Regal again. "Get dressed and meet at the ring," he told us. A few minutes later, we rushed to ringside. We looked around where we saw several WWE superstars standing, rehearsing, and stretching. "Hop into the ring, gentlemen."

We climbed in and stood with two huge Samoan wrestlers whom we knew from television as a tag team called the Uso Brothers. We shook hands and introduced ourselves.

"We saw what you guys could do in a spot match, now we want to see you sell," William said. The day prior, our match showcased our ability to do big moves and exciting high spots. William now wanted to see if we had the ability to convey that we were in pain after taking devastating moves. All great sellers use their facial expressions, body language, and verbal skills to convince an audience they're hurt, which if done right garners sympathy. "Everybody, please clear the ring for these guys!"

Without planning a single move, we locked up, and started wrestling. As the match began, I heard Booker T, who was sitting at the announcers table, doing his own personal commentary. "Who are these little tiny guys? They don't even look like they hit the gym," he said loud enough for everyone to hear. Booker T was famously a five-time world champion in WCW and respected as one of the all-time greats. He was now a commentator on *Smackdown*.

The much larger Usos manhandled me, slamming me down to the mat and stomping on my chest, then giving me a few open opportunities to show my selling ability. I grabbed my back, and groaned, reaching toward Nick for a tag, but he might as well have been a mile away. They led me through the whole match, silently whispering to me what they wanted

me to do, every step of the way. They'd clearly been in this situation probably countless times. Eventually, I mounted a little offense, creating enough space from the brothers, allowing me to roll toward our corner, giving Nick the hot tag. The "hot tag" is the physical tag made by a babyface tag team, usually done after the heel team has beaten down and isolated one of the wrestlers for quite some time during a match. When done right, it can be the high point, or climax, of a great tag team match. Nick blew a comeback completely on the fly, or by improvisation. Jey and Jimmy Uso were so good, bumping and feeding like madmen, and creating the space needed and not cramming up Nick. Without ever trying it or even discussing it, Nick sprung up to the top rope and went for a crossbody, but Jey caught him in midair and slammed him down. Jimmy came off the top rope with a splash. It was too good not to be the finish. The referee counted to three, and William got into the ring with a huge smile. "Brilliant. Great, great match, guys!" He shook all four of our hands and then pulled Nick and me in. "Yesterday you showed me you could do the spots, and today you showed me you could sell. Great stuff, gents!" It felt good to get complimented by a legend. William asked us to follow him directly to the green room to cut some promos, where he gave us helpful advice and taught us techniques.

We'd basically been busy from the time we entered the building to right before the show started, where we stood outside of the curtain talking to each other. We were on such a high from the afternoon's unofficial tryout that we had barely noticed Booker T angrily approach Nick. "You're on my coat, sucka!" You're on my coat!" he shouted intensely into Nick's face. Confused, Nick finally looked down and realized he was leaning on a guardrail where apparently Booker's sports coat was laid across. "Oops. I'm sorry about that, I had no idea!" Nick said. Booker grabbed the coat, put it on, and then stormed

off. Nick and I looked at each other. It was possibly the most awkward ten seconds I'd ever experienced.

Nick looked at me and said, "Wait. Was that a rib?" We couldn't figure it out.

The next day, Booker T took to Twitter to talk about the situation:

> A friend RVD made comment few weeks back . . . now I know why, I say a small tag team called the YB's did hay shake my hand no! Yes, I said SMALL!!!

He followed up with:

> Repost:: To make it clear, I saw two small guys at tv this week, then I past them during the day, they never introduce themselves, and later One of them was leaning on my jacket and still never introduce themselves . . . No RESPECTnow do u get it.

This unimportant, grammatically inconsistent Tweet became the biggest wrestling story on the internet, and it took everything in my soul not to defend myself. Other veteran wrestlers began siding with Booker, while younger wrestlers and fans defended us. A huge debate occurred online about locker room etiquette and whether or not we crossed a line. The unwritten rule in wrestling is to shake every wrestler's hand at the beginning of the day, especially if you're new to the locker room. Admittedly, we didn't shake Booker's hand or introduce ourselves that day, because we simply never had the chance.

Either way, this was now the second respected wrestler in a month claiming that we blew them off, so most people figured there was some truth to the story. New articles on popular websites were being written about us daily, each questioning our

character. *Were we young and arrogant? Did we disrespect veterans of the business?* Everybody was convinced so. Our reputation was being tarnished, and it broke my heart. On August 23, 2011, *Bleacher Report*'s Tyler Williams wrote an article titled, "Young & Arrogant: Are the Young Bucks Burying Their Careers?!" which stirred even more drama. The Young Bucks officially became a sullied phrase.

Needless to say, and even after our two great tryout match showings, we never heard a word from WWE after this controversy. Not that it mattered: we had big plans for our ROH return.

SEPTEMBER 17, 2011

The crowd erupted when we entered the ring that night. And once we mocked Booker T and Rob Van Dam's signature poses, it grew even more enlivened. Not only were we not going to ignore the elephant in the room, we were going to shine a giant spotlight on that elephant.

After the match, our opponents offered us handshakes, and, art imitating life and all, we turned our backs to them and walked off. Just a few days later, we started selling T-shirts with a picture of a handshake crossed out. In promos, and on Twitter, we were unapologetic. We loved the gimmick. Instead of defending ourselves, we gave people even more reason to hate us. For the longest time, we were just a couple of wrestlers who did cool moves. Now we found a little bit of an identity. The handshake story followed us everywhere we went. "You do shake hands! I knew it!" wrestlers and fans who were meeting us would say. But eventually the novelty waned, and it felt like listening to the same joke repeated for hours on loop. It

drove me mad. I would worry for a long time that we'd be remembered only for being the guys who didn't shake Booker T's hand.

The following month, on October 28, my and Dana's beautiful green-eyed, blond haired daughter, Kourtney Louise, was born. She had a big head and dimples on her cheeks just like me, and she cried louder than any other baby in the nursery. I held her hand and told her, "I promise to take care of you forever, my little girl." An hour before I was just nervous about the delivery going okay, but upon seeing her I recognized that she was the most important person in my life. My fatherly instincts kicked in; I somehow knew how to change Kourtney's diapers, burp her, and rock her to sleep. And when I watched Dana, the natural mother that she is, my heart grew in size. All of a sudden, the only thing that mattered to me was providing for my family. The drama from the handshake incident, which at one point felt like it was ruining my life, suddenly seemed so meaningless.

It was painful leaving for the road after Kourtney's birth, way worse than before, but I was motivated to do my best. It was nice to catch up with our friends Jay Lethal and Kevin Steen while on the road, who both congratulated me with giant smiles. Kevin was a father, too, struggling to make ends meet for his family as a wrestler, so it was nice to have someone to talk to who understood what I was going through. Jay felt like an old war friend, both of us survivors from TNA. We'd also become pretty close to Adam Cole and Kyle O'Reilly since working with them. They looked up to us and came to us for advice about the business. It felt good that there were still people out there who thought highly of us, despite what the majority were saying. Kevin always kept it real and warned us about what we were getting into with Ring of Honor. "Cornette is actually running this place now and he's running it into the ground," he said.

Jim Cornette's title was executive producer, but many people suspected he was making most of the decisions, and a lot of his decisions were unpopular. Kevin had good reason not to care for him, as Jim once famously sat him out for ten months before his prior contract expired. Cary Silkin was kind enough to pay Kevin while he sat at home. Kevin had since been brought back, but rightfully had his guard up. Jim handwrote scripts for promos with outdated pop culture references. The boys would read the chicken-scratch writing and roll their eyes. He also booked high spots and finishes that worked thirty years ago but not in the modern era. He just seemed out of touch. Worst of all, Jim was known for having a terrible temper. In 2005, at Ohio Valley Wrestling, a WWE developmental company at the time, Jim admitted to losing his cool and slapping Canadian wrestler Santino Marella several times. In 2010, an email that Jim sent TNA's Terry Taylor, and was published online by Jim himself, contained threats toward his archenemy, Vince Russo. They didn't get along when both men previously worked for TNA. The worst part of the email read: I want Vince Russo to die. If I could figure out a way to murder him without going to prison, I would consider it the greatest accomplishment of my life. Luckily, Nick and I never saw that side of Jim in person, but it was apparent that most of the locker room either couldn't stand him or were afraid he'd blow a gasket at any moment.

If we were going to do anything memorable in wrestling, it wasn't going to happen at ROH at this time. We were booked in six-minute and eight-minute matches, squandered in the middle of the card, and doing nothing meaningful. We also felt handcuffed by being told not to do any of our trademark stuff. The night we used RVD's and Booker T's poses, we were told it was "bush league" and that it didn't belong on the show. ROH was doing an angle where piledrivers were banned, so we weren't allowed to do our tandem version of that, either. But the

biggest blow came when we were called out in front of everyone during a preshow speech for using too many Superkicks. Can you imagine that? They were by far our most popular parts of the matches. "This is worse than TNA," Nick whispered when we were given that news.

On May 12, in Toronto, just seven months after signing our contracts, we were called into a room to speak to Jim Cornette and Hunter Johnston. "Unfortunately, because of budget cuts, we can't afford to fly anyone coming from Los Angeles for the next three months," Jim said. "We're giving you the summer off." My thoughts went to my daughter—how was I going to provide for her? We decided to go out that night and have the best match on the show, just to rub it in Jim's and Hunter's faces.

We went home that summer feeling bitter. We also watched Nigel McGuinness, Maria Kanellis, and Mike Bennett, who also flew out of Los Angeles, continue to be booked all summer long. It made us feel worthless and lied to. Worst of all, this meant we pretty much had zero income coming in. Fortunately, Dana and I were eligible for WIC, a federal assistance program for low-income mothers, so we were able to get some groceries for free. Otherwise, I don't know how we would've eaten at the time.

The one person who we could always rely on booking us every month, Super Dragon, had a good thing going in Reseda. And to his credit, he always had us on top in the main-event matches. Every single show at American Legion Post #308 in Reseda would sell out. On July 21, we requested to be put in a Three-Way Ladder Match against Kyle O'Reilly, Adam Cole, and two Canadian wrestlers named Uno and Dos, The Super Smash Bros, whose gimmicks were based on the Nintendo video game. All six of us had one thing in common: we were starving artists trying to make names for ourselves. Nick and I

used the anger over our situation at ROH and directed it toward motivation. We went out and had the performance of our careers, but Nick and I specifically had chips on our shoulders that night. The match was buzzed about all over the world and called one of the all-time great ladder matches. For years, I called it my favorite match ever.

About three months after we were given the summer off, we were brought back to ROH, this time to wrestle at a TV taping in Baltimore. It didn't feel like it, but we were still under a contract, and were obligated to show up whether we liked it or not. At this time, all of the ROH crowds were down in size, and it had very little buzz overall. Prior to the show, Jim called for a meeting where he addressed rumors of low morale in the locker room. "Dammit, if you're unhappy here, come talk to me and Hunter directly!" he shouted. As soon as the meeting ended, Nick and I approached Jim. "Well, since you just said it, here we are, Jim," I said. "We're unhappy. A big reason we left our former job was because you said you wanted to work with us. If you're not planning on using us, maybe we need to go beg for our old jobs back." We had no intention of going back to TNA and hoped he wouldn't call our bluff. "Bucks," he said, "this is coming from higher up. I'm just the messenger. We just can't afford your travel. It's just business. Maybe you should go try to get your old jobs back." At that moment, I regretted leaving TNA and ever coming to ROH.

Before our match that night, Jay Lethal, who knew the entire situation, came to us and gave a pep talk. "You guys are going to go out there, and tear it up like you always do, and show these guys what they're missing out on!" When the red light came on, we went out and wrestled our best. Again, as we slapped hands with the fans on the way to the ring, we felt like we were lying to them.

I went to bed that night not knowing what I was going to do

next. I felt like I had hit rock bottom. WWE had passed on us multiple times. Our run at TNA was a letdown. Now ROH saw no value in us. We were simply running out of options. I always saw myself as a successful wrestler, supporting his family, but maybe I was wrong.

After a few days of sulking, Nick and I had a talk that would change the course of our careers. After he convinced me one final time not to quit wrestling, I came back with a last-ditch effort plan. It would be like throwing a Hail Mary pass during a football game. Our desperate attempt at saving our careers. The plan was to simply stop following the rules. The plan was to save nothing and do everything. The plan was to spit in the face of wrestling tradition. "Okay. Fine. But this is it. This is my last shot, or I'm done. If we're going to do this, we need to do this our way. I'm done listening to other people." Nick agreed, and thought he had the missing piece to our act. "If we can bottle up that magic that we've been creating at PWG in Reseda all these years, and use it everywhere, nobody can touch us," he said. Our PWG characters were fun and fearless. That version of the Young Bucks did as many Superkicks and high spots as they wanted. They used every past wrestler's poses and mannerisms no matter how bush-league it made them look. They did whatever they wanted, whenever they wanted. And despite what anyone could say, the act worked. So, there was no reason why it couldn't work elsewhere, right?

October 1, 2012, arrived, the day our one-year ROH contracts were set to expire. Nobody reached out to us to thank us for our time with the company, but we decided to channel our anger and frustration toward rebuilding ourselves. We were now free agents of the wrestling world. Our world. Once and for all.

Superkick Party

NICK

After ROH let our contracts expire, we got a call from Cary Silkin. He felt terrible about the entire situation and wanted to help us financially. None of this was his fault, but I think he felt responsible in a way. "You guys need to start selling merchandise online," he said. "I'm telling you, it's the future of wrestling. I want to make an investment in the Young Bucks." He sent $3,000 through PayPal to Matt to assist with building a website and to get us a start on T-shirt inventory costs. His generosity blew us away. We'd discussed opening an online shop for years but had never had the extra money to do it.

Colt Cabana, always the forward thinker, started the first wrestler-hosted podcast in July 2010 called *The Art of Wrestling*. The podcast was revolutionary in helping spotlight lesser-known wrestlers, enabling them to tell their stories on a platform people regularly tuned into weekly. For years, being a guest on Colt's podcast for an independent wrestler was like

a comedian getting a Netflix special. On the podcast, Colt was always talking about a T-shirt printing shop called One Hour Tees, a Chicago-based brick-and-mortar business that could print customized T-shirts in as quick as an hour. Colt used One Hour Tees to fulfill his T-shirt orders for his website, ColtMerch.com. Matt asked Colt to put him in contact with the guy who ran the shop, Ryan Barkan. Ryan, a young entrepreneur and workaholic, emailed him back, and within minutes Matt had placed an order for 136 Young Bucks t-shirts to be printed and shipped. There were three different designs among the 136. One was a parody of an old Rockers design, replacing Marty Jannetty and Shawn Michaels with cartoon characters of us. Another design was a shoe print on the chest of a T-shirt, as if the person wearing the T-shirt had been Superkicked by us and it left a mark. And the last design was a neon-green Young Bucks logo with a lightning bolt. Dana, who seems to know how to do pretty much everything, learned how to build a basic website, using Colt's as a reference. It wasn't much, but by the start of 2013, we finally had a website of our own up and running. Matt and Dana's apartment was so little that they stored the inventory of T-shirts on top of their kitchen counter (hey, at least I didn't have to store them at mine!). The operation was truly do-it-yourself: Dana would handwrite each customer's address on the packages, Matt would stuff the packages with merchandise individually, and they'd wait in line at the post office for their weekly drop-off.

We knew we needed to get the word out about our merchandise, so we took to Twitter, one of the only tools we had at the time. We noticed we'd sell something every time we put out a tweet about our web store. It sounds crazy, but around this time there were few wrestlers selling merchandise online, let alone using social media to get the word out. Nowadays, you can't scroll through a wrestler's social media account without

annoyingly being reminded about one of their fifty new T-shirt designs. (Sorry, everyone!)

Eventually, we sold all of the original 136 T-shirts, and per Cary's advice reinvested that money right back into buying more. We were doing our best and making a few extra bucks with the website, but since Ellen and I learned that we had a baby girl on the way, I started planning for our future. I began to understand why Matt seemed so stressed out all of the time. It worried me that we'd just had two back-to-back failed runs in two major wrestling companies. Also, our reputations were still in question from the whole Booker T fiasco.

Instead of turning that into a negative, we became outspoken and honest about how we felt whenever interviewed. While most wrestlers refrained from answering personal and exploitative questions, we made it a point to talk about everything. Nothing was off-limits. As expected, excerpts from our interviews would be made into clickbait headlines, and it would always cause a stir. Good or bad, there was a conversation about us, but as long as people were talking, we were happy. It was then when we learned how to use the media as a character-building tool.

Not many wrestling companies were willing to take a chance on us around this time. Tommy Dreamer, an ECW alumnus, was one of the few people who still saw something in us. He was opening a new wrestling organization called House of Hardcore that had a slogan "No Politics, No BS, Just Wrestling." Tommy felt like we got the short end of the stick for the past couple of years and saw our potential while we briefly met back in TNA. He put us in a headline match, with zero restrictions.

The first time we worked for Tommy in Poughkeepsie, New York, his instructions to us were simple: "Just go. Tear the house down. Steal the show. This is your night." House of Hardcore had all sorts of buzz, and we needed to redeem ourselves.

Luckily, we'd be wrestling the ultratalented Paul London and his partner, Brian Kendrick. We had had a reunion with Brian, who'd since left TNA, earlier that weekend. Brian felt bad for what we'd gone through the past couple years, but he could tell that we weren't the same happy-go-lucky guys that he'd met back in TNA. He liked the change. We were ready to do things our way, and that night was the beginning of that.

We came out as full-blown bad guys, attempting to tap into the idea of utilizing our PWG gimmicks. We strutted down to the ring, and I'll admit that our faces were so very punchable, with Matt playing air guitar and me pointing my finger in the air like Macho Man Randy Savage. We'd been labeled arrogant, cocky, and disrespectful by the masses, so that was exactly the kind of characters we decided to play, backing up all the crap we talked and all the mocking we did in the ring. Beyond what people thought of us as individuals, the biggest criticism we'd gotten, from experts, fans online, and even the wrestlers in the locker room, was that we did too many high spots and way too many Superkicks. But instead of listening to the criticism and doing fewer, we decided to do even more, especially on that night. We had a fantastic match, but more important, our act clicked. It felt like we'd found ourselves.

Mike Quackenbush, who saw star potential in us a few years back in 2009, still did after this match. Chikara was one of the few small promotions willing to pay for our west coast flights, and it provided us consistent work and helped our exposure. We had a 253-day run as their tag team champions, which gave us huge credibility and value as independent wrestling stars. Mike understood the art of wrestling and telling long-term stories that built to a fever pitch climax. Having his respect and validation was invaluable.

Gabe Sapolsky also started booking us for DGUSA regularly again and putting us in big matches on the show. "I can't

believe ROH didn't know how to use you guys," he told us. "I could build an entire territory around you!" Gabe thought like a fan: he booked dream matches often and would write famous preshow emails where his instructions for your match would sometimes deliberately read, Have a spotfest! I liked that. He was also known for having a bad temper (this isn't unusual in this business, as you've come to discover) and screamed and threw bottles when things went wrong. There's a famous story of him interrupting an impromptu basketball game we organized between the wrestlers before a show, where he made his best impersonation of Coach Bobby Knight, grabbing the basketball and throwing it into the stands. "I pay you to wrestle! Not play basketball!" he shouted. Temper or not, we'll forever be grateful that he, too, helped us when we were in a tough spot.

"I've got a genius idea for a T-shirt," Matt said during this time, a smile stretching across his face. "A T-shirt that just says, "SUPERKICK, SUPERKICK, SUPERKICK, SUPERKICK.""

"Wait. That's it? Just the word *Superkick* a bunch?" I laughed.

"That's exactly what I'm saying," he replied.

It was an obvious reference to frequent criticism of our matches: "Oh, you've seen a Young Bucks match? It's just Superkick, Superkick, Superkick, nothing but Superkicks." Instead of defending the criticism, went Matt's thinking, we'd be self-aware and stick it to the critics. But would that translate to a purchase?

Every single person Matt went up to that day howled in laughter when he pitched the idea to them. That was all the proof we needed. We soon printed fifty red "Superkick" T-shirts and fifty blue ones, and brought them to Secaucus, New Jersey, where DGUSA's *Open the Ultimate Gate 2013* was taking place. Before the show started, we stood at the gimmick table

and greeted a fan. Upon noticing the new shirt, his eyes tripled in size. "I'll take a medium!" he screamed. He was replaced by another fan, who stood in front of our table pointing and laughing. "I'll take a large!" she said. After grabbing a large shirt from the box behind the table, I looked up and saw a line so long it snaked around the corner. By the time the bell rang for the show, I looked at Matt and said, "We're not gonna have any T-shirts left for the rest of the weekend."

That night, we again bolstered our new attitudes and held nothing back, defeating Cima and a young high-flyer named AR Fox and becoming the new Open the United Gate Tag Team Champions. Our momentum was growing. Our friend PAC, who had since been signed to WWE and renamed Neville, came to visit and watched from the crowd. He was there for a big show in town on Sunday called *WrestleMania*. "That match was incredible, you guys!" he told us. He admitted the WWE lifestyle was mentally and physically taxing and warned us about how difficult it was. In short, he didn't recommend we ever go. I replied, "Well if we can sell a hundred T-shirts a night, we may never need to!"

On June 1, 2013, we were in Florida for the start of a weekend of independent shows. Matt and I were in the locker room going over what we planned to do in our match that evening. Sometimes when talking over matches, Matt and I are known to get excitedly loud. We often feel like planning our matches can sometimes be just as fun as actually performing them. On this particular day, we kept screaming a particular part in the match where we'd come in and deliver the Superkick. "And here's when I come in. SUPERKICK! SUPERKICK! Then Matt will hit a SUPERKICK! And then we both duck a clothesline, and then a double SUPERKICK!" Lancelot Bravado, one half of another real-life brother tag team the Bravado Brothers, tuned in to our conversation at that moment. "Sounds like you

guys are doing a lot of Superkicks tonight," he said. "It's like a party. It's a Superkick party!"

"Hell yeah. It's gonna be a Superkick Party tonight!" I shouted. While everyone else in the locker room started to chuckle, I looked over at Matt, who stood in silence, completely focused. I could already see the wheels turning.

The next day, we met with Jay Lethal, who was a resident of Tampa, and had lunch together at Hulk Hogan's restaurant. Jay and I were in the middle of a conversation when Matt interrupted us: "Tell me what you guys think about this idea. 'Superkick Party!' Our new brand. It's perfect. Whenever we wrestle, instead of a big fight feel, we create a party atmosphere! We talk about being the hosts of Superkick Parties! You guys have seen it—when we're having a really good match, everyone in the audience is partying!"

Jay piped in. "Yeah, I love it. And I've already thought of your first T-shirt design. You can parody *Mario Party!*" *Mario Party* was a popular Nintendo video game featuring all the characters from the Mario franchise.

Right there in the restaurant we started designing a T-shirt which featured Matt as Mario, me as Luigi, and a whole cast of other wrestlers we knew. For the rest of that weekend, the entire locker room kept joking about throwing a Superkick Party. We knew that if something got over with the other wrestlers in the locker room, it'd probably win over the fans as well.

Meanwhile, our red and blue Superkick shirts were selling out at the shows and had become the hottest shirt on our website, which also had stickers, signed 8×10 photos, and posters, among other items. Every time I went over to Matt and Dana's apartment, I had to move boxes of merchandise out of the way just so I could play with my niece, Kourtney. It was a small consequence of a self-run business.

In early 2013, Matt received an email from Ryan Barkan.

He and Colt Cabana had an idea, and they wanted to do business with us. "Hey guys, I'm opening up an online shop for wrestlers to sell their T-shirts. We'll print only what is purchased and ship it. We won't hold inventory. We'll do everything, and we'll give you a royalty and pay you monthly." He also provided a link for a website that he asked us not to share until it was ready to launch. The website URL was ProWrestlingTees .com. In June, we were one of five wrestling acts to open a pro wrestling tees store. It started with Colt Cabana, us, Kevin Steen, and Chris Daniels. The stores were easy to navigate. You'd click a T-shirt design, scroll to find your size and then click to purchase. Every time a purchase came in, we'd be sent an email alerting us. It wasn't an immediate success, as we'd be lucky to get a single sale in a day. A few weeks after the website launched, we finally received the artwork for the "Superkick Party" T-shirt that parodied the Nintendo game. Matt tweeted out the image, and an uproar commenced. People were demanding we print it on a T-shirt. So instead of sending the artwork to One Hour Tees, ordering the shirts and waiting for them to be shipped to us, we now had the option to put it up instantly on Pro Wrestling Tees, or PWT, and survey any possible interest from the fans right away. Within hours of looking at the artwork for the first time, Matt was already announcing on Twitter that we had a brand-new shirt for sale. As our emails became flooded with sale notifications, we realized we had stumbled upon a gold mine. The "Superkick Party" shirt became one of the most popular shirts in independent wrestling. If there was a wrestling show, there was a good chance at least one person in the crowd was wearing this shirt. Many times, there were several. This was the first shirt we saw out in the wild, on nonwrestling weekends. This generation of wrestling fans wanted things right away, and Pro Wrestling Tees was the way to get it to them.

Pro Wrestling Tees was the start of our creativity with merchandise. We were able to express ourselves as artists, trying new and daring things with T-shirt designs, because if they didn't sell, we weren't going to be stuck with a bunch of inventory. The risk and gamble of creating a bad T-shirt design was gone. As our PWT store grew in popularity, other wrestlers flocked to sign up. Within a couple months, hundreds of other wrestlers now had their own PWT shops.

Not including our wrestling money, we now had two other streams of income coming in, between TheYoungBucks.net and PWT.

In July 2013, Matt received a text message from Hunter Johnston about doing a single show for ROH. After what they did to us the last time, we really didn't want to. But Hunter told us that ROH was now a different place, referring to Jim Cornette no longer being with the company. Jim apparently had another outburst at a November 3, 2012, ROH TV taping, which led to him finally leaving. I talked Matt into doing the show, convincing him to think of it as a pure business decision. "Right now, we're working everywhere and creating an element of surprise. 'Where might the Young Bucks turn up next!'" I said. In case you haven't noticed, I can be a little persuasive.

On August 3, we returned to ROH in Toronto, and our new popularity was palpable. The crowd went crazy for us. Instead of playing it safe, and wrestling handcuffed like our prior ROH run, we went out and threw a Superkick Party.

We got another message from Hunter a week later asking if we wanted to wrestle in New York on August 17. ROH had a show at Hammerstein Ballroom and apparently still had some tickets to sell. He wanted to put us against Rocky Romero and Alex Koslov, the Forever Hooligans, whom we'd known from years prior working around the Southern California independent scene. They were now primarily working in the junior tag

team division in Japan for New Japan Pro-Wrestling. The junior division is where the smaller wrestlers had their matches. Though Matt was again hesitant to do another ROH show, I told him it made sense from a business perspective. Really, and I kept annoying him until he said yes.

The Superkick Party comes to Manhattan! was tweeted from the ROH Twitter account. We rolled our eyes, because the year before, people in ROH were telling us not to use Superkicks during our matches at all, and here they were now being advertised to throw a Superkick Party. Cary called me the next day. "The moment you guys were advertised, ROH sold three hundred–plus more tickets!" We realized we were slowly becoming a minor box office draw.

The roof practically came off Hammerstein Ballroom, and everywhere legions of fans were chanting, "Young Bucks! Young Bucks!" We reveled in it as we strolled down the aisle, our gear even more outrageous, with tops covered in fringe to match. We were booked as the heels in the match, but the roaring audience in Manhattan wasn't going to boo us no matter what we did. We knew that.

We entered the ring throwing Superkicks to imaginary people, and the ring was filled with colorful streamers thrown out by the fans as a sign of respect. From across the ring, we could see Rocky and Alex were panicking, in real life. They were supposed to be the good guys that night. Alex pulled referee Todd Sinclair over and whispered into his ear, but never broke eye contact with Matt and me. Todd quickly came to us to report to us what was on Alex's mind. So only we could hear him, Todd whispered, "Alex says to turn the crowd!" He wanted us to figure out a way to make the crowd boo us and instead cheer

for them. Matt looked at Todd and said, "Well, tell Alex we said to suck it," and then used his hands to point at his nether regions (in wrestling, this is known as a "crotch chop"). Alex, reading Matt's lips, was flabbergasted. Todd replied, "Well, okay then."

We liked Alex and Rocky, but we were done listening to people at that point in our careers. We were gaining momentum, and we weren't about to slow down, even when it meant breaking wrestling traditions like getting cheers when you're supposed to play a heel. We tore the house down that night, and Alex and Rocky gave us a hard time afterward, but they too realized we were at the brink of some type of movement, far bigger than being a heel or a babyface.

Between our T-shirt stores, our winning tag team titles in both Chikara and DGUSA, and now the return matches at ROH, we had created a ton of buzz for ourselves. But the biggest impact of all came on August 31 at PWG's *Battle of Los Angeles* show at American Legion Post #308 in Reseda. At this point, Matt and I had become full-blown lunatics in the ring, coming out with our energy level turned up to maximum, mimicking all our favorite wrestlers and cramming as many Superkicks and high spots into our matches as possible. We did crotch chops and would use the nWo hand gesture, made famous by the New World Order. We were basically doing everything we were ever told not to do.

Adam Cole, the once-quiet, polite kid we met two years prior, had since come out of his shell and become one of the brightest stars on the independent scene. He was currently the PWG Heavyweight Champion and one of our closest friends in the business. He was articulate and confident. He carried himself like a movie star but looked more like a rock star. There was also Kevin Steen, one of the biggest babyfaces at PWG, and the most popular independent wrestler in the world at this

time. Kevin was the opposite of traditional wrestling. He wore a T-shirt and shorts to the ring, and he was overweight. But he, like us, only marched to the beat of his own drum. He always saw the trends and evolved with the times. "We're the biggest names here," he told us one day. "We need to form a group together and call ourselves the Mount Rushmore of Wrestling." The four of us were a match made in heaven. Matt, always the designer, was already creating a T-shirt in his head the moment the words left Kevin's mouth. That night our supergroup was formed, the internet was buzzing.

Amidst all of the buzz, I opened Facebook and had a message from our old friend Kazuchika Okada, whom I used to play rounds of Gator Golf with. Okada left TNA and returned to NJPW on January 4, 2012, and became a huge star in NJPW shortly after, winning the most coveted prize in the company, the IWGP Heavyweight Championship Title. We were so happy for his success. As I read his message, I was reminded of all the amazing memories we had shared over the years. "Do you and Matt want to come to Japan?" his message said.

Of course we wanted to! I remember telling Matt for about a year that the next step in our career would be going to wrestle for New Japan Pro-Wrestling, the biggest wrestling company in Asia. I knew we needed to make it there, and that would help our careers progress to the next level. NJPW was a giant platform, drawing in thousands of fans to each event. If you wrestled for NJPW, it legitimized you as a wrestler. We'd wrestled great matches through the years, but most of our best stuff happened only in front of a couple hundred people in high school gyms and bars. This was our chance to prove that we could regularly perform at arena shows, in front of thousands. Most important, working for NJPW meant a steady paycheck, which could provide security for our families. We didn't have a

clear long-term plan at the time besides trying to make as much money as possible, as often as possible.

But before we'd make our NJPW debut, Ellen was ready to burst. Our daughter's due date of September 15, 2013, had arrived. Upon getting to the hospital in a calm but nervous manner, we realized that this baby girl seemed way too big. She was estimated to be eight pounds, so we already knew this would be tough for Ellen, who's all but five foot two inches and had pleaded to try and have this baby naturally. After about eight brutal hours of labor, and realizing this baby wasn't coming out naturally, the doctor informed us we would have to have a cesarean section. At this point, Ellen was ready for anything because she was in so much pain. This whole day had felt like a dream, but when the doctors rushed me into the changing room and informed me to put on scrubs, it had suddenly felt real. *This was happening.*

I told Ellen beforehand that I didn't think I'd cry seeing our firstborn. But all of the stress leading to this day changed all of that, and I was an emotional mess. As soon as I heard my daughter, Alison, cry for the first time, I bawled my eyes out. It'd been so long since I had cried, maybe when I was a small child, it felt like my body was doing something for the first time. Ellen was still dazed from the pain-numbing shot she had received, but she started crying, too. Then she said to me, "I told you that you'd cry," which made me cry even more. We were so happy baby Alison Jean Massie was healthy and happy.

Alison weighed even more than what was projected, at one ounce shy of ten pounds. The first thing the doctor said when she saw Alison was, "Oh my God, this baby is huge!" I snuck my phone into the room and recorded the whole scene on my iPhone. I've watched it many times since, but Ellen refuses to watch it because of how scary everything was for her.

Life changed for me that day. I no longer was only responsible for myself. I now had to make sure a fragile little human, who looked like me, stayed alive. I had to feed her, clothe her, burp her, and rock her to sleep, all with very little experience. I was a paranoid mess, and I'd wake in the middle of most nights just to make sure she was breathing. I slept and ate when needed, but everything else in the day was devoted to making sure Alison was happy and healthy.

What if I am never able to provide a good enough life for this little girl? I thought. I shushed the negative voice in my head; I had a tour ahead of me. Though leaving my four-week-old behind was the most difficult thing I'd ever done, I kissed her forehead good-bye and prayed that I'd return safely to her. Could this trip to Japan help me provide the life I wanted for my daughter?

Bullet Club

MATT

Tiger Hattori, the older Japanese man with the ponytail whom we met briefly on the shuttle drive into Universal Studios back in 2010, was now calling me on the phone. "Matt? Okada says you guys are good workers. He say you also good boys. We need new junior heavyweight tag team. Do you want to come to Japan?" He offered us $1,800 each per week, and we accepted on the condition that we could sell our merchandise, which was becoming a lucrative business for us. Eighteen hundred dollars a week, guaranteed, sounded amazing.

And just like that, we sent over our information, made a quick visit to the consulate, and by late October, we were heading back to Japan. We hadn't been to Japan in about four years, but now we were booked on a four-week-long tour with the biggest Japanese promotion in the country, New Japan Pro-Wrestling. Over the course of four weeks, I would be missing Kourtney's second birthday, Halloween, and Dana's and my

fifth-year wedding anniversary. That didn't sit well with me, but I had no choice.

Before leaving, I carved Mickey Mouse into a pumpkin for Kourtney while spooky music played and we pretended it was Halloween. Then, we threw Kourtney her second birthday party at Chuck E. Cheese a couple of weeks early, with the entire family present. Among the screaming kids, and smell of pizza and socks, me and Nick both held our little girls tight and looked at each other, knowing we were about to miss precious time with them. In a way, it was nice to have someone there that could relate to me. Fatherhood would definitely bring us even closer.

A couple of weeks prior to our NJPW debut, we were announced to take part in the Super Junior Tag Team Tournament. But the biggest part of the announcement was that we would be representing a new outlaw stable called Bullet Club. Bullet Club was a collection of non-Japanese heel wrestlers who broke the rules and spat in the face of tradition. One of NJPW's monikers is "the King of Sports"—they, along with their audience, take wrestling very seriously. So, up until that point in Japan, it was very rare to see matches with heel spots, like outside interference, and cheating. Because of this, Bullet Club was a very controversial group, and genuinely hated by the Japanese public. In May 2013, Karl Anderson, Fergal Devitt, Tama Tonga, and Bad Luck Fale made the group official as they all "Too Sweeted," in the ring. This is wrestling's version of high-fiving or fist-bumping, wherein you press your thumb, middle finger, and ring finger together, while your index finger and pinkie stick up, and you touch fingertips with someone else's. Karl Anderson later coined this action as "Too Sweeting" someone. Prior to that, it was done in the 1990s with the nWo, but it didn't have a name. It's been a staple of wrestling culture for years. Alongside Karl stood Fergal Devitt, a

sculpted Irish wrestler who came up through the NJPW dojo with Karl. Tama Tonga, a Tongan American, and adopted son of old WWE and WCW wrestler Haku, also stood tall with the group. Last was Fale, a huge Tongan New Zealander and former rugby union player. The group of guys would terrorize the referees, ring announcers, and backstage interviewers. They didn't listen to authority and did whatever they wanted. Basically, they acted exactly how we did. It was a match made in heaven.

I kissed Dana and Kourtney good-bye, and I told Dana that this would be the last time I'd miss any important family events, but of course that wasn't true. Soon, Nick and I were back on an airplane heading back to the land of the rising sun.

We entered Kōrakuen Hall, a building we hadn't been in for quite some time, wearing black T-shirts with a pretty ugly Bullet Club logo on it. *This shirt sucks*, I remembered thinking, putting it on as our entire group of guys took a now-famous group shot on a stairway backstage. A shot that would be seen all over the internet, in magazines, and on television. Standing with us were Karl Anderson, Fergal Devitt, and Fale. We'd just met Fergal and Fale that day, and now here we were entering the ring together. Karl Anderson waved a Bullet Club flag while Fergal rode down the aisle on big Fale's neck. Nick and I threw up the Too Sweet hand sign, something we'd been doing for a long time anyway, so it was fitting that it was accepted in Bullet Club.

"The Bullet Club's newest members: Nick Buck, Matt Buck. The Young Bucks. We are Bullet Club, we do what we want," Fergal said on the microphone to a golf clap from the Tokyo audience. The crowd had no idea who we were, and apparently neither did Fergal, who called us by the wrong name. Karl Anderson would hassle poor Fergal for the rest of the tour. "Matt Buck and Nick Buck! You didn't even know their names!

What an awful promo, Ferg!" It'd been a long time since we'd
been in Japan, and it was for a completely different company, so
we weren't shocked that the audience wasn't familiar with us.

That evening, we wrestled our buddies Brian Kendrick
and Trent Beretta and aimed to steal the show. We planned a
match filled with huge high spots and spectacular false finishes,
or high-impact moves that would normally be used to end a
match. In our efforts, we ended up doing a bit too much and
were criticized backstage afterward. The motivated mind-set
we'd been using for the past few years on the independent scene
of saving nothing and doing everything didn't work here. "Big
impact, but too much!" said Gedo, the booker of NJPW and
veteran wrestler. Gedo liked to book shows that slowly built to
a climax at the end of the night, whereas we wrestled one of the
first matches on the show like it was the main event. But truth
be told, we only had one way of wrestling at that time, and it
was *balls to the wall*. This was going to be an adjustment.

Karl Anderson said a lot of the boys were watching the
match and shaking their heads when we had Brian Kendrick
kick out of our tandem tombstone piledriver. For the rest of the
tour, when we weren't in regular tag team matches for the tour-
nament, we traveled to small towns and did six-man tag team
matches most nights with Karl Anderson. We got a stronger
sense of the style of NJPW, and the roster soon took notice.
Truth was, the NJPW style was much easier than what we were
used to. At an NJPW house show, if you're on the first half of
a card, your match isn't going to be given more than twelve
minutes. Not only that, the showrunners wanted you to pre-
serve your body and only do a couple of high spots each. Often,
after the matches I'd feel like I cheated the fans, and Fergal
would remind me otherwise. "Matt, we all play our roles in
these matches. Simple and easy. You'll get your chance at the
big shows," he told me.

...nd new me, wearing my "World ...mpion" T-shirt. My mom still ...it to this day. (1985)

For my third birthday, I wanted a particular type of birthday cake! (March 13, 1988)

The very first day I met Nick. Oh, and check out the Hulk Hogan LJN figure in my hand! (With DJ, July 28, 1989)

On a weekend getaway to the Nevada & California state line. We were together always, one tight-knit family. (1991)

Nick, Matt, and Malachi. The Massie Bro's standing in front of the house where many eerie unexplained things happened. (Rancho Cucamonga, California, 1997)

I was thrilled to have a baby brother to play with. (Me and Nick, 1990, Rancho Cucamonga, California)

People these days don't realize I'm four years older than Nick, but it was very apparent back in the day (1999)

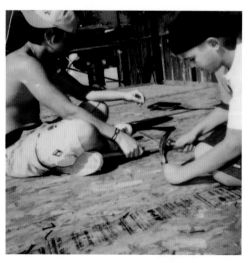

Me and Nick literally building our future out back all those years ago. (March 13, 2001)

My dad and I finishing up construction on our first wrestling ring. (March 13, 2001)

"Slick Nick" at age thirteen. (Rancho Cucamonga, California, 2002)

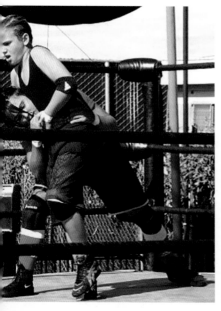

ck Nick versus Mr. BYWA
m the Anaheim Marketplace
naheim, California, 2002).
oto courtesy of Michael Machnik.

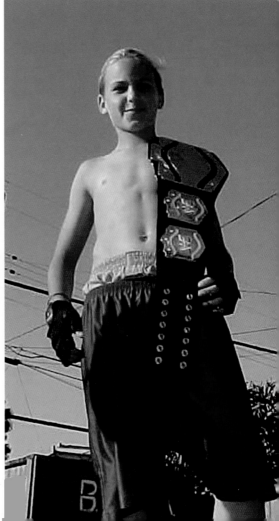

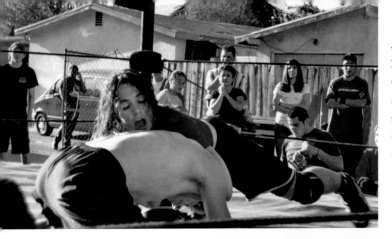

Applying a front face lock on Tarantula at a BYWA show. (Rancho Cucamonga, California, 2002)

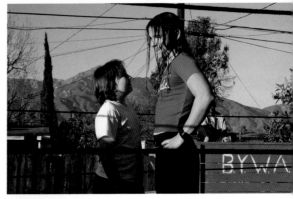

Mr. BYWA taking on Comedian Killer (Malachi) in our first wrestling ring in Rancho Cucamonga. (2003)
Photo courtesy of Michael Machnik.

In our second wrestling ring we built in Hesperia, Slick Ni takes on Tarantula. (2003)
Photo courtesy of Michael Machnik.

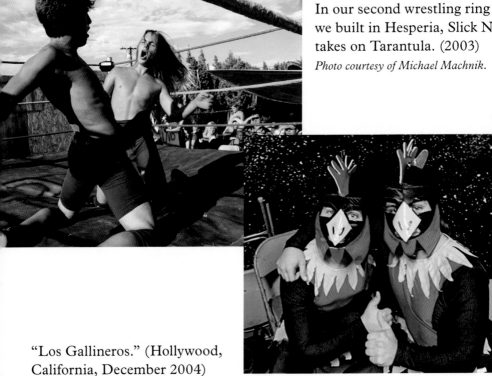

"Los Gallineros." (Hollywood, California, December 2004)

High Risk Wrestling's *Highway 2 Hell* in July 2004. Dana walking me down the aisle.

Photo courtesy of Michael Machnik.

[Ch]ris Kanyon and Shannon [M]oore came to High Risk [Wr]estling as our special [gu]ests. We learned so much [fro]m Kanyon. (October [20]04)

One of the very first photographs of the "Young Bucks Pose." (2005)

Photo courtesy of Michael Machnik.

[Ni]ck has never been [afr]aid to jump off of high [thi]ngs. (December 2004, [He]speria, California)

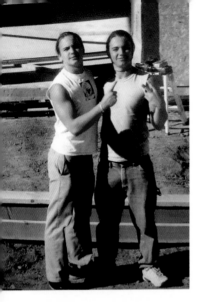

Me with Sonny Samson, Diablo, Christoph[er] Daniels, Tarantula, and Steven Andrews after an HRW show. (July 2006, Victorville California)

Working on a house with our dad. Massie Construction was in full swing. (2005)

The first time we met and worked with Marty Jannetty. We'd go on to learn so muc[h] from him. (August 2007)

I remember the days shiny pleather shorts was the only way to dress in the ring. (2007)

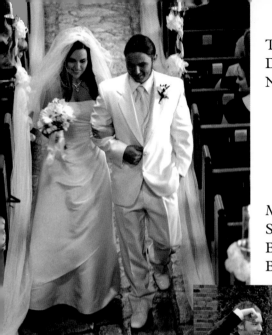

The day I married my soulmate, Dana. (Upland, California, November 1, 2008)

Me with my groomsmen Scott Kruse, Nick, Brandon Bogle, Malachi and Dustin Bogle. (November 1, 2008)

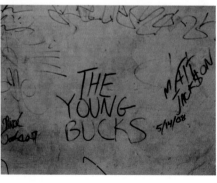

'G Tag Team Champions. (2009)

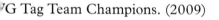

The wall that all of the foreign wrestlers signed backstage at Kōrakuen Hall. (Tokyo, Japan, May 14, 2008)

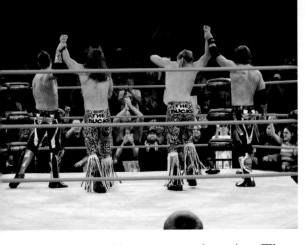

After our TNA tryout match against The Motor City Machine Guns, the audience chanted "Sign the Bucks!" (December 2009, Orlando, Florida)
Photo courtesy of Lee South Photography.

Introducing Max and Jeremy Buck, Generation Me. Cool name, huh?!
Photo courtesy of Lee South Photography.

Dana taking the term family business seriously, running the gimmick table at an independent wrestling show and looking after Kourtney. (2012)

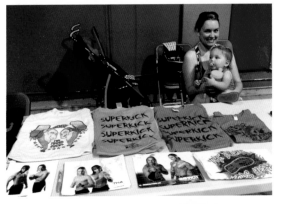

We were quite the trio with Kevin Steen (Owens). (2013)

In 2013, Us, Kevin Steen (Owens), and Adam Cole were "the Mount Rushmore of Wrestling."

...e number of hours we clocked ...behind a gimmick table before ...estling shows is endless. (2014)

Holding multiple tag team titles. The tides were turning. (2014)

...s with Bullet Club friends Karl ...nderson, Luke Gallows, and Tama ...nga backstage at Kōrakuen Hall. ...anuary 5, 2014, Tokyo, Japan)

For a long time, Bullet Club ruled Japan. We were the lighthearted jokeste in a gang full of hea hitters. (2014)

The first time we were able to fly our families with us out to Tokyo, to share the Japanese culture with them and attend *Wrestle Kingdom 9*.

Kourtney was showered with gifts anytime we went to Japan. Here she is holding the IWGP Junior Heavyweight Tag Team Title. (2015)

Some of our best six-man ta team matches happened wh we teamed with AJ Styles.

always tried to go on adventures
with Kenny Omega on our days off in
Japan. (Osaka, Japan, 2015)

In Japan, when we weren't wrestling, we'd find a Round One facility, and shoot hoops (Us, Kenny Omega, Chase Owens, and Hangman Adam Page).

When we ruled the world! Current PWG, ROH, and IWGP Junior Heavyweight Tag Team Champions. (November 1, 2016)

Cary Silkin always believed in us, even when others did not. Grateful for him. (2016)

Dana helped build the Young Bucks merch empire out of a tiny two bedroom apartment into what it is today. (April 2016)

A final curtain call, as we say goodbye to our Bullet Club comrades. (January 24, 2016, Duluth, Georgia)

Me and Nick at Tokyo Dome for *Wrestle Kingdom 11*, prior to bell time. (January 2017)

Kazuchika Okada, always the prankster, would find Nick's gear and wear it around at EVERY show. (January 2017)

Group shot with Matt and Jeff Hardy, after our insane Ladder War, at ROH's *Supercard of Honor.* (April 1, 2017, Lakeland, Florida)

e night before the BCInvasion," we had a iily dinner at my place. ptember 2017)

We had no clue the "#BCInvasion" would stir up so much controversy. (September 2017, Ontario, California)

Frankie Kazarian, Christopher Daniels, and AJ Styles are three dudes we've traveled the world with. (2017)

The last time we stood inside American Legion Post #308 in Reseda, California. The building where we became wrestling stars. (April 20, 2018)

Meeting Tony Khan for the first time in London. We had no idea our lives were about to dramatically change. (Summer of 2018)

Our final bow to the Hammerstein audience. (New York City, December 20

Photo courtesy of Scott L Ringside Photography.

Roaming the streets of Japan with the "BTE Boys" (Us, Marty Scurll, Hangman Adam Page, and Cody Rhodes). (May 2018)

The night before *All In*, we took a moment to appreciate the occasion. (September 2018)

was a HUGE deal when we got r very own Funko Pop Vinyls.

he day we went "All In" with dy Rhodes. Nothing has ever en the same since. eptember 1, 2018) *to courtesy of James Musselwhite/Portrait Wrestler*

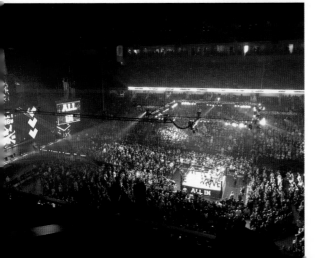

Over 10,000 screaming fans at Sears Centre for the largest independent wrestling show in history, *All In*. (September 1, 2018)

With two friends and people who became very important to our brand: wrestling journalist Dave Meltzer and Masa Anchan aka "F Ass Masa." (2018)

The original "Massie Six." Our Mom, us, DJ, Dad and Malachi.

After our final *Wrestle Kingdom* match at Tokyo Dome with our children. (PICTURED LEFT TO RIGHT: Zachary, Gregory, Alison, and Kourtney.) (January 4, 2019)

Our first ever T-shirt design. What do ya think?

At home, the crowds we'd performed in front of had learned our act over the years, so Japan was like a fresh canvas on which to paint. We were unafraid to try out strange ideas because, at the time, most of these house show matches weren't even filmed, so the only people who would see them were the ones in the building. Years later, NJPW would adopt a streaming service called NJPWWorld.com, where the subscribers could watch live and taped matches, but that technology was still some time off.

By the end of the tour, we had a star-making match in the main event in Tokyo at Kōrakuen Hall. It was the Young Bucks versus Rocky Romero and Alex Koslov in the finals of the tag team tournament. In wrestling, utilizing bigger stars to help the smaller stars is called a rub. Gedo had a plan to utilize one of Rocky and Alex's allies, Okada, and his hope was Okada's stardom could help rub off on us. It did.

This was the "big match" opportunity that Fergal was talking about. We'd been in Japan nearly a month, so we'd picked up the style in-ring of slowing things down when needed. In Japan, tournaments are taken very seriously, so after every near fall of this match, the fans would buzz and chatter. After a referee bump, big Fale came into the ring to interfere in the match, but to the approval of the fans, Okada stepped into the ring and delivered his trademark dropkick, which literally caused the building to shake. Right then I realized firsthand just how big of a star Okada had become. Eventually, we came in and stole the win anyway, which caused hysteria in the auditorium. The people were legitimately livid that the bad guys won. We stood in the ring, proudly holding these massive medal trophies that were nearly the same size as us, while a chorus of boos rained down on us. It was the reaction we'd aimed for, so they might as well have been cheering. *Job well done,* I thought to myself, as we posed for pictures inside the ring.

We'd also became comfortable with our newfound place in the Bullet Club group. While the other guys in the group were the serious heavy hitters, we were the arrogant, light-hearted newbies who could take a beating but make it look fun. Our styles meshed so well, and our backstage interviews were unpredictable and funny. We thought of ourselves as a band whose members enjoyed each other's company as much as we did performing. That is rare in both music *and* wrestling.

A few days later in Osaka at an event called *Power Struggle*, we would win the IWGP, or International Wrestling Grand Prix Junior Heavyweight Tag Team Titles for the first time in front of a large crowd of 6,400 people. These titles were the biggest prize for a junior heavyweight tag team like us. NJPW was giving us a huge push right out of the gate, and our stock was growing. After the match, Tiger Hattori pulled us aside and told us to make New Japan our number one priority. He offered us a minimum of fifteen weeks per year in Japan. We were excited for the opportunity, but also mindful of being away from our families for so long. I worried about Dana and Kourtney, but I also knew that this was my future. We agreed on a hand-shake deal, one that would end up lasting around six years. "We will see you in January at Tokyo Dome," Tiger enthusiastically said following our chat.

For months we'd heard the rumor that we'd be wrestling at the big annual *Wrestle Kingdom* show, but our deal with Tiger was our first confirmation. *Wrestle Kingdom* was NJPW's biggest event, which occurred every January 4 in the Tokyo Dome. Tokyo Dome is a large stadium with a dome-shaped roof that looks like an egg, where baseball games, concerts, and other events happen almost daily. I remember staring at the giant stadium while standing out on the stairway at Kōrakuen Hall after a Dragon Gate match, dreaming about one day wrestling in that building. Now, it was about to come true.

We'd completed the four-week tour, and upon flying home from Japan, I held my girls and unzipped my bag to reveal my new championship title, which I placed on Kourtney's shoulder. Dana was still working her full-time job as a leasing consultant, so Kourtney was with one of our parents during the day whenever I was gone. The times we were all together as a family were so important. The days I would arrive back home, the three of us would celebrate by going out to dinner at Chili's or Outback Steakhouse. I'd always be so jet-lagged and road beaten, but I'd overcaffeinate and do my best to be present, no matter how tired I was. Things were finally starting to pick up financially, but the entire family was split up most times. It devastated Dana. I'd hold her in my arms while she cried the night before I was set to leave town again. It equally hurt missing benchmark moments in Kourtney's young life. Every time I came home, she looked like she'd grown up a little more, or found a new interest, and I was always trying to play catch-up. I remembered reading old wrestler's books and they wrote about how their constant absence affected their children's lives negatively. It worried me that I was repeating history. So, I made it a huge priority to make up for the lost time when I was around. We would meet Dana on her lunch break every day and hold picnics in the park while Kourtney played in the grass.

We celebrated New Year's, welcoming in 2014 with our families, but on January 2 we were already back on a plane to Japan. We landed at Tokyo Narita Airport and walked over to the NJPW bus, where all the talent was gathering. As I stepped onto a full bus, I spotted Tama Tonga, who stood up and gave me a huge hug. "Welcome to the family!" he said. I also saw a massive, tattooed, bald wrestler who looked like he could be part of a motorcycle gang sitting alone and whom I recognized. He used to wrestle in WWE as a character named Festus, later changed to Luke Gallows. He was the newest member of Bullet

Club, coming aboard the month after we did. We had several mutual friends, so I felt like I already knew him.

"Hey man, mind if I sit with you?" I asked.

"No way. Come on in, buddy!" He introduced himself as Drew, but from that day foreword I referred to him as Gallows, because that was what everyone called him. We were stuck in Tokyo traffic for two hours, but we passed the time by laughing hysterically, barely pausing for a moment. We had one major thing in common, too: we hustled our merchandise. We compared business practices and traded ideas. We talked shop. By the time we arrived in front of the Tokyo Dome Hotel, I told him, "I feel like we're best friends now."

As we got off the bus, a chubby Japanese man with an entourage of people stood in the hotel lobby. The chubby man was Masa—or, as he liked to call himself, "Fat Masa"—a lifelong wrestling superfan. Masa had been around the scene since the early 1980s and had befriended all the great wrestlers. He would arrange business deals with them, and they would pose for pictures or sell their used gear to him or to other collectors. He was also known as a sponsor, meaning he enjoyed taking foreign wrestlers out to eat as an attempt to show Japanese hospitality. That night, we negotiated a deal with Masa to come up to our room and take photos of us in our ring gear with our newly won IWGP Junior Heavyweight Tag Team Titles. We'd heard some of the collectors did this but that it was frowned upon by the NJPW office and the boys. Still barely getting by, we couldn't pass up on money, so we awkwardly posed in our hotel room in full gear while Masa and his friends switched in and out for poses. When the room cleared out, Nick and I stood there in our tights and looked at each other with embarrassed smiles. "Let's never do that again," I said. We would do it maybe a hundred more times.

On the afternoon of January 4, 2014, we walked into the

Tokyo Dome with our Bullet Club comrades for the first time, and I was transfixed by the size and scale around me. It was the biggest stage I'd ever seen, with massive lights and video screens and the entire setup feeling like a rock concert. I don't think I'd ever been in a room that big in my life. Just two weekends before we were wrestling in a bar, so you can imagine my astonishment when I saw the stage. To think that this was only our second tour with NJPW and we were already doing an event like this made us confident that the company didn't take us lightly. In turn, we wanted to impress.

As we waited behind the stage, the butterflies fluttering in our bellies, the opening intro videos played on the screen, and Karl Anderson huddled us around him and delivered his motivational speech: "We went from wrestling in parking lots in SoCal together to now rocking the fucking Tokyo Dome. Go get 'em, boys!" The sound of pyro explosions went off in the building, absolutely startling me. The stagehands mimed to us to stick our fingers in our ears because more were going to blast. *Where the hell am I?* I thought, laughing to myself. I couldn't shake off this feeling of anxiety. I had to pee, I felt like I was going to throw up, and my legs felt heavy.

Nick and I said a prayer, and then listened as our new theme music with a solid beat and guitar riff blasted through the speakers. At first glance, it looked like it was going to take us an hour to get to the ring. We were surrounded by a sea of about thirty-five thousand people, the largest crowd we'd ever performed in front of. The lights were so bright, I couldn't even see past the first few rows of chairs. We strutted down the aisle, our tassels moved through the air, and our IWGP Junior Heavyweight Tag Team Belts were wrapped tight around our waists. Nick, in his full-blown obnoxious-heel role, got down on his back in the middle of the ramp and dry-humped the air to the dismay of the modest Japanese audience. His silly

antics helped settle my nerves. The stadium was so massive, with such a high rooftop, and there was so much air, we might as well have been outside. The match was a Four Corners Tag Match against Alex Koslov and Rocky Romero, Alex Shelley and his Japanese partner, Kushida (who was actually very similar to Chris Sabin), and Taichi and Taka Michinoku. Taichi was a Japanese comedy wrestler whose big high spot was pulling his breakaway pants off, revealing small trunks, and Taka was a small, high-flying Japanese wrestler, most famous for his time in WWE during the Attitude Era. I looked around at the others, trying my best to treat this like any other show, even though I was secretly losing my mind. *Act like you belong,* I reminded myself, something I've been saying every day before this and after. The in-ring action in the match itself was nothing special; we were given just eight minutes, so everything felt rushed, but it was still a great experience. We made the most of it, soaking up our short time in the famous stadium. Getting to perform at Tokyo Dome is a career milestone for any entertainer and would only help the strength of our brand, and having a Tokyo Dome bout under our belts gave us more credibility.

We flew home but came right back to Japan just a couple of weeks later, learning truly what a full-time schedule in wrestling meant. Dana and I couldn't keep asking our parents to watch Kourtney every day while she worked, so we put her into a preschool every day from 8 A.M. to 6 P.M. It was important to us that Kourtney would be properly educated but also in good hands, so we did research and found a local Montessori preschool that was highly sought out. It wasn't cheap and cost us just about what our monthly rent was. So even though both Dana and I were now bringing in steady money, we were still struggling to get by.

The first day I dropped Kourtney off for school was so hard

on me. Every parent talks about it, but you don't realize how difficult it is to leave your child alone with strangers, until you do it yourself. Dana and I returned to the car and looked back at Kourtney's empty car seat and we both cried. "She's only two, Matt. She should be with her mommy right now, bonding with me during this time," cried Dana. She was already hurting from me being gone so often, but now she was losing time with her daughter as well.

During the first week of the next tour, there was a rumor going around the locker room that Fergal would soon be leaving NJPW. He'd put in a ton of time touring Japan, and he was ready for a new challenge. Fergal would always sit next to Nick and me on the bus, and we'd watch bad wrestling matches and laugh until we were blue in the face. Everyone on the bus would be upset at our childish snickering and peer back at us with dirty looks. Fergal took us under his wing and looked out for us. As Nick and I would roam the aisles of convenience stores with empty baskets, he was always first to point out the healthiest and tastiest options. Or, when we'd stare confused at the food options at truck stops, he'd point out where chicken was on the menu. Late at night, after a show, on the dark bus while everyone else slept, he would come to us with helpful advice about our matches. Having someone eager to see us succeed meant a lot. It didn't feel right that he could leave us so soon.

After every show, the entire Bullet Club would go out with a sponsor for dinner, which usually lasted into early morning. In Japan, eating dinner out is like an event. You're served small portions of different foods, which usually come from the sea, for sometimes hours. At these sponsored dinners, the food and drinks were free, and also unlimited, so the guys drank and ate

endlessly. Nick and I were never the drinkers, nor did we really enjoy the Japanese cuisine, but we loved being with the gang. Oftentimes, after hours of drinking, for some reason, the host of the dinner would request that he and his friends be chopped in the bare chest by the Bullet Club. Hey, you asked for it . . .

"BANG!" Big Fale would slap the poor sponsor skin to skin with his hand as hard as he could, and it sounded like a gunshot going off in the middle of the restaurant, followed by screaming and thunderous laughter from the table. Usually a line would form, and each Bullet Club member would have his chance to up the ante. One by one, everybody would unload their best chop. But nobody had a heavier hand than Karl Anderson; the smack noise was ear piercing. By the ends of most nights, the rich men who wined and dined us would proudly show off the handprints on their chests like they were trophies. During one dinner, the sponsor pointed to Nick and me and made a special request. "Please Superkick me." Nick and I thought it was a joke.

"Bro, he really wants you guys to Superkick him," said Fale, who spoke fluent Japanese and understood the banter at the table. Nick and I looked at each other, communicating with our eyes. Smiling, we both stood in only our socks, per Japanese custom.

"Good brothers, ya gotta protect the business!" said a drunken, red-faced Gallows. He basically was saying to hit the sponsor hard. I whispered to Nick, "Don't kill him. Just give him a little peck on the cheek."

The eager Japanese man stood, clinching his teeth together, bracing for impact. The whole room counted: one, two, three . . .

BOOM! We connected with a beautiful, shoeless double Superkick and the poor guy nearly went through the wall. The

restaurant exploded in laughter. We helped the wobbly man back up to his feet.

"Arigato!" he shouted once he shook off the cobwebs. Anderson recorded the moment on his cell phone and would randomly show everyone in the locker room. We'd go into a room, hear belly laughing, and see Anderson pointing at his cell phone with another person on the roster, both in tears from laughing. One time in particular, we came in and saw Anderson showing the clip to head booker Gedo. *What is he doing! We're going to get in trouble,* I thought to myself.

Boom! I heard the sound of our feet smashing the sponsor in the face.

"HA HA HA!" Gedo laughed hysterically, then ripped the phone out of Anderson's hands and showed even more people in the locker room. Several sponsors after this would request the Superkick, but Nick and I didn't want to push the limits too far. We were lucky nobody was hurt.

Throughout the entire tour we wrestled Alex Shelley and Kushida, who were known as the Time Splitters, and developed an incredible body of work with them. Our styles and tag team combinations blended so naturally that it felt like wrestling the Motor City Machine Guns back in TNA. Shelley was a wrestling genius, and most of the stuff we did came from his imagination. On the final night of the tour in Osaka, on February 11, 2014, we had a chance to finally showcase what we could do during a big tag team match. In the final stretch of the match, I went to do a backhand spring and placed my right hand down on the mat awkwardly. I heard a crack and knew something was wrong. My hand stopped working almost completely, but I kept going, favoring it and holding it close to my body. The finish was our tandem tombstone piledriver, where I'd hold someone up while Nick would spring through the air

and push down on their body to maximize impact. The move was named "the IndyTaker," a play on words with the Undertaker, and also a nickname Nick was given by Chuck Taylor for sticking up for the locker room whenever he felt a promoter was taking advantage of or mistreating us. I did the move, essentially with one hand, and as the referee counted, I thought, *Dana is going to kill me.*

Hours later, I sat in front of a computer screen where the doctor showed me X-rays of my hand. I didn't understand what he was saying, but the picture spoke for itself: there were two clean breaks, both in the palm of my hand. When I called Dana in the middle of the night to tell her the news, she tried to stay calm but was clearly upset. I think she knew I was freaking out and wanted to play it cool. Up until that point, I'd never been hurt in a match. Since we relied on my paychecks from wrestling to pay the bills, this injury posed a serious consequence. It couldn't have happened at a worse time, either, as Nick and I were starting to gain some real traction. At the hospital, Nick and I sat in the lobby emailing promoters who had us on their upcoming cards and letting them know the news.

The next day, I flew home and went straight to the hospital to get another X-ray.

"The breaks are clean. We can do surgery, which might make recovery a bit longer, or just put you in a cast and we can keep checking progress every month." The doctor said.

Wanting to minimize recovery, I opted for a cast. The cast was placed on my dominant hand, covering every finger except my index finger and thumb and reaching the bottom of my elbow.

"I'd say three to four months recovery. Definitely no wrestling," the doctor warned, which of course went in one ear and out the other. A few days later I was on an airplane with Nick, heading to Australia. I didn't wrestle that particular weekend,

but a few weeks later I decided it was time to get back into the ring. ROH had a big weekend of shows in Milwaukee and Chicago, and the plan was to give us the ROH Tag Team Titles. We already held the tag titles in both PWG and NJPW, so we knew that holding a third set would be a massive achievement for us. Mostly, I really just wanted to take a badass picture of us draped in all of that gold.

The first night, I didn't do much except get through the match. The second night would be the real test, wrestling for the ROH Tag Team Titles against Kyle O'Reilly and his new tag team partner, Bobby Fish, a team named ReDRagon. Bobby, a world-class wrestler, was also a trained kickboxer and a legitimate tough guy who looked ten years younger than his age. He and Kyle's style of Mixed Martial Arts strikes and holds were gaining them buzz as one of the most unique teams in wrestling. I felt bad that I wasn't 100 percent for this match, but I was going to give it my all, although my hand still pulsed in pain through the cast at the slightest touch. Even when I would run the ropes, it felt like an electric shock went straight through my hand. We ended up having a great match by using my cast as the focal point of the story, creating a very dramatic plot. Kyle and Bobby worked over my injured limb, and I sold it well, helping me gain sympathy from the die-hard Chicago crowd.

I came home and draped another belt on Kourtney's shoulder. At first, I felt helpless having the use of only one hand, but I soon learned to prepare meals, drive, and even change Kourtney's diapers. I wasn't going to let that become an impediment to the momentous wave I was riding. I continued training at the gym, and naturally the cast would loosen on my hand, making

it pretty much useless. I would end up wearing four different ones. I was so determined, I told Gedo I wouldn't miss a single tour in Japan. When I showed up in Japan ready to work with the cast, the Japanese wrestlers told others how much respect I had earned from them. To me, it wasn't a matter of being tough; it was about paying my bills and taking advantage of all we had built so far.

Additionally, the Bullet Club was white-hot, and for the first time ever NJPW was becoming trendy to watch not just in Japan but all over the world. We saw firsthand how popular our faction had become when we were in the U.K. and a fan spotted a personal Bullet Club shirt of mine in my merch bag, still plastic wrapped, straight from Japan. "I'll give you eighty pounds for that T-shirt," he said. Every fan after him asked for a Bullet Club shirt as well.

On April 6, 2014, at NJPW's *Invasion Attack*, the rumors of Fergal Devitt leaving NJPW proved true. He gave a postshow, teary-eyed locker room speech in which he said good-bye and thanked us for being a big part of his recent success. I had met him only a few months prior, but this felt painful. And as is only routine in the wrestling business, we went from seeing him more than our families to hardly ever again.

With Fergal leaving, Gedo had a new idea for Bullet Club. We needed a big name to fill the empty void in the group, and that name would be AJ Styles. Backstage at Ryōgoku Kokugi-kan (also known as Ryōgoku Sumo Hall), a famous indoor sporting arena in Sumida, Tokyo, where sumo matches take place, a shaggy-haired AJ Styles stood wearing jeans and a leather jacket. "So freakin' good to see you boys!" he said to me and Nick. A few months prior, he had shockingly left TNA after twelve years in the company. Moments later, AJ entered the ring and attacked IWGP Heavyweight Champion Okada,

laying him out and challenging him to a title match. He then revealed that he was also part of Bullet Club. The Japanese audience was surprised; many fans didn't even know who AJ Styles was. Japanese wrestling fans are very loyal and mostly watch NJPW exclusively, especially at that time.

Knowing AJ from back in TNA, we introduced him to the others and welcomed him into our group like a new family member. We stood together and took a new updated group photo to post online. The wrestling world buzzed. AJ Styles was a huge name, and he brought over attention from thousands of his fans around the world. Any doubts we had with Fergal leaving were quickly put to rest. Internationally, having a guy like AJ helped legitimize NJPW and shine an even bigger spotlight on Bullet Club. We sat in an Italian restaurant near Tokyo Dome City that night and shared a pizza and big bowl of Caesar salad to celebrate the big debut. "I'm gonna tag along with you boys for now on, if it's okay?" he asked us. It was okay, and he did.

But AJ, the huge name that he was, usually came in only for the big shows in the major cities, so he wasn't on the bus, touring from town to town like the rest of us. Nick and I would fire up the laptop and watch bad wrestling together, as we rode hundreds of miles through the Japanese countryside, looking at the empty seat next to us where Fergal once sat. Someone once told us to never get too attached to others in the wrestling business, because everybody comes and goes. But luckily for us, we heard we were about to have a reunion with someone who would love to occupy that seat.

A couple of months later, we boarded the NJPW bus, which was parked out in front of the Tokyo Dome Hotel. It was day one of another four-week-long tour. I anxiously looked for someone I hadn't seen in a while. I looked for an old pal who

would be a special guest on this tour. I kept gazing down the rows of seats until I saw that curly-haired friend I'd only seen briefly one other time since that snowstorm in New York City in 2009. "Hey Bucks! It's been a while!" shouted an excited Kenny Omega.

Bloodstained Sneaker

NICK

We had tried our best to stay in touch with Kenny over the years, but reconnecting with him was like rediscovering a piece of our family. We learned that Kenny had become a full-time resident of Japan after moving there in 2010, even becoming fluent in Japanese. Kenny's popularity launched DDT, the company he worked for, into mainstream pop culture. He was often invited on television game shows or to be the spokesperson for fitness products and video games. He, along with his sometimes tag team partner, sometimes foe Kota Ibushi, had a one-on-one match that sold out Nippon Budōkan Hall in Chiyoda, Tokyo, which seats more than fourteen thousand people. In Japan, Kenny was royalty.

Needless to say, Matt, Kenny, and I didn't leave each other's sides that entire month in Japan. Kenny knew all the best restaurants and took great care of us. He would order our food on our behalf and teach us how to ride the subway around town.

During one particularly long bus ride late in the night, to kill time, we put together a list of the best wrestlers in the world from every wrestling company. We were all clearly still massive wrestling fans who idolized the greats.

"Okay, there are good wrestlers and there are great wrestlers," Kenny said, "but this list can only have the elite wrestlers." To Kenny, the word *elite* meant the absolute best of the best. That word indicated you were special, and had a god-given talent unlike anyone else in your field. So, we started listing off our favorites; our elite wrestlers. Hulk Hogan, Bret Hart, Chris Jericho, AJ Styles, Mick Foley, Owen Hart, Dynamite Kid, Eddie Guerrero, Shawn Michaels, Kurt Angle, Matt and Jeff Hardy, and Edge were among the names commonly listed. And of course, we always put ourselves on the list. On this night, we got all the wrestlers who were awake on the bus to participate and submit their own lists of elite wrestlers. The conversation began and at times turned into a friendly debate. Certain wrestlers would be mentioned, and after arguing their placement on the list, the majority would vote. During the tour, whenever a wrestler or a good match was mentioned, we'd question the value. "Okay, that was great," we'd say, "but was it elite?" Soon enough *elite* became part of our everyday lingo. After a delicious meal, we would all sit back and loosen our belts. "Now that meal was elite," we'd say, laughing out loud. We'd go out into the frigid cold, and mumble, "This weather is not elite," as our teeth chattered together. It was our inside joke.

Ryan Barkan had connected with Matt and Rocky Romero, who had become Tiger Hattori's right-hand man, about getting a deal done to make Pro Wrestling Tees the U.S. distributor for NJPW T-shirts. The NJPW product was getting hot, and there was a demand for merchandise, especially Bullet Club shirts. On June 23, 2014, NJPW officially opened up its own shop on

Pro Wrestling Tees, finally making Bullet Club shirts available for purchase in America. During the first twenty-four hours, it sold more T-shirts than any other T-shirt in Pro Wrestling Tees' short existence. The T-shirt's popularity would continue to climb, establishing Pro Wrestling Tees as the only practical place to shop for Bullet Club merchandise. What was it about this shirt that made it so popular? Was it the design itself? Or was it what the design represented? I'm not sure anyone knew exactly why the shirt or Bullet Club itself was catching such fire, but it was. Everybody was taking pictures and posting them online of them throwing up the Too Sweet hand signal. We might've been bad guys in Japan, but everywhere else, we were looked at as a cool, rebel, outlaw gang.

Outside of our casual discussions to pass the time, the business around us was changing. Because of the success of former independent wrestlers now hitting it big in WWE, more of them were getting signed to WWE. CM Punk, a former ROH champion and a tattooed, straight-edge expert on the microphone, was the first major independent star to go to WWE and ended up being one of their hottest properties. Bryan Danielson—now Daniel Bryan—whose roots come from the independents, was now getting bigger reactions than anyone else on the roster. Instead of hiring only professional and college athletes along with muscle-bound wrestlers, like they had for years, WWE started to look elsewhere to streamline scouting talent. The independent wrestling world was going through a shakeup. The billion-dollar wrestling company WWE promised independent wrestlers guaranteed salaries and opportunities to become global stars, so even the most unlikely wrestlers would be swayed to jump onboard. In 2013, one of the faces of independent wrestling, Rami (El Generico), signed with WWE. Rami practically invented "doing-it-yourself," and independent wrestling ran through his blood, so nobody ever pictured him going

to the big corporate entity. Many small independent companies around the world relied on El Generico on a monthly basis to come in and draw a small crowd for them. His move proved that all bets were off, and that WWE would be knocking on everyone's door, and most likely getting an answer. Then, to top it off, in the summer of 2014, Kevin Steen told us he was heading to WWE, too. We'd been spending most of our time in Japan at this point, but any time we were at home, we were usually on an independent show with Kevin. This one stung. *Don't get too attached. Wrestlers come and go,* I tried to remind myself. Still, it felt like all my friends were being taken out on the battlefield. Our affiliation with Kevin helped us seem like bigger stars, effectively giving us a rub in the process.

As Kevin wrapped up his independent dates, we had to tie a loose end in Reseda at PWG. July 26, 2014 would be Kevin's final PWG event, and he wanted to call the action from the announcers' table during our big main-event match. Nick and I had been in a long-standing feud with Joey Ryan and his female tag team partner, Candice LeRae. Candice, a five-foot, two-inch blonde, weighing probably one hundred pounds and change, had the heart of a lion, and ignited the imaginations of every audience member she performed in front of. While many men were afraid to work with Candice and sell for her because they were fearful of looking weak, Matt and I welcomed it. We saw her as a way to tell new stories.

This night's main event was deemed a Guerrilla Warfare Match, which meant there were no rules. The show ran late, so we didn't even enter the ring until after midnight. I remember making our entrance and feeling steam come off of the fans, who had all sweat through their shirts. The ring canvas stunk and felt hot, as if the summer sun were beaming down on it all day. We had a heck of a brawl and used all sorts of weapons like trash cans, thumbtacks, wooden tables, and steel

chairs. The Reseda crowd ate up every move we performed and cheered loudest when they heard the crack of a weapon meeting one of our skulls. The biggest moment in the match came when Candice crawled back into the ring a bloody mess after taking a tombstone piledriver on the floor. Days prior, Matt had superglued several thumbtacks onto the bottom of an old Nike high-top sneaker and hid it underneath the ring before the show. Matt had put the weapon of a shoe on and was aiming to take out Joey Ryan once and for all, with one of the craziest Superkicks ever performed. The heroic, bloody Candice crawled toward Joey and shielded him from the danger. Not sympathetic to a girl intervening in the situation, our evil characters took no mercy. In a moment I'll forever regret, Matt looked toward Candice, then delivered the hardest Superkick I'd ever seen to the top of her head. A golf-ball-sized bump with little tiny puncture holes from the thumbtacks formed on her head. Kevin Steen, who has been involved in extremely violent matches, said, "This is too much," while commentating the match. Kevin rarely broke character, but he did here. Candice would eventually overcome the odds and slam Matt onto a pile of thumbtacks, pinning him in the middle of the ring. The explosion of the crowd when referee Rick Knox counted to three was so loud and emotional that I realized we had done something special. What's more, the impact of the match was felt all over the world. Pictures of the gory scene spread online everywhere, while a best-selling T-shirt of her bloody face arrived on her PWT page just a couple days later.

The match itself, now being deemed a cult classic, was highly controversial and ignited online debates. *Was it too violent? Should men be wrestling women?* Matt took a lot of heat for the Superkick with the thumbtack shoe from not only fans but people close to him. Our mom, disturbed by the violence, called and chewed him out; and Dana was livid, and asked

Matt to never do anything like that again. Matt regretted hitting Candice as hard as he did and apologized to her profusely for months. I think the video clip still haunts him. I do not look forward to the day I have to explain this moment to my children, when they inevitably stumble upon it on YouTube. Nevertheless, we started to pick up on the patterns of our career. Every time we did something controversial, our popularity blew up (this time it wasn't for something we were particularly proud of). Speaking of controversy: about a year later, on August 8, 2015, at an Insane Wrestling League show in Baldwin Park, California, we'd make headlines again, involved in a segment where we delivered a double Superkick to a nine-year-old boy. The video would go viral online, was covered by TMZ, and would be replayed over and over again on MTV's television show *Ridiculousness*. The child's father was in on the bit, and the kick was rehearsed, but the video clip sparked another massive debate online. Veteran wrestlers cried we were exposing the business by involving a child. Once more, as the chatter got louder, our brand awareness became stronger.

The independent wrestling scene was blowing up as well. WWE, becoming aware of the boom, wanted to capitalize and decided to create their own version of an independent company. NXT, once just their developmental brand, was now shaping up to become a hip place where stars from Japan and the independents would land. And at NXT, the style of wrestling was more athletic, harder hitting, and acrobatic, like what you'd see on the independent circuit. In a short time, NXT was loaded with talent like the Japanese sensation Kenta, ROH alumni Claudio Castagnoli, El Generico (now known as Sami Zayn), Fergal Devitt (now named Finn Balor), and their newest addition, Kevin Steen, who was about to be renamed Kevin Owens. All these new signings shined a spotlight on the old companies

they used to work for, which made them hotter. Pro Wrestling Guerrilla, Ring of Honor, and New Japan Pro-Wrestling were all being mentioned by name on WWE television shows. For the fans, seeing how good these wrestlers were almost worked as an infomercial for independent wrestling. And at the number of signings and the frequency they were happening, suddenly things seemed extremely unpredictable. Who was going to go to NXT next?

Of course, always cashing in on whatever was topical in wrestling, Matt and I continued to say things online or in interviews to keep people in suspense. One day, I would outright tweet a picture of WWE tag team titles, just to mess with people. The next, I would reply to WWE wrestler Twitter accounts, challenging them to a match. It was the beauty of our gimmick. We could do or say anything. Nothing was off-limits. Other wrestlers asked us if we were fearful of making people in the WWE office or locker room mad, but we truly did not care. By this point, we had decided we probably would never work there. We were making the most money we'd ever made in wrestling, and we couldn't keep enough merchandise on our gimmick tables or in Matt's apartment. We had made our choice: we were going to be the unafraid loudmouths who did and said whatever we wanted, and worry about what came next, later down the road.

But we also realized this had become more than just trying to make a living. We took great pleasure in being our own bosses and earning our own money. We took pride in the fact that we didn't have a machine behind us. We enjoyed the art of the hustle. There was nothing more gratifying than coming up with an idea, then putting that idea on a T-shirt and going from town to town and selling out of merchandise. We'd arrive at a given town, set up shop, sell merchandise, steal the show, quickly and swiftly make our way back to the table, and get rid

of the remaining inventory. Rinse and repeat. We made conversation with the fans. We remembered their names. We gave them an experience.

When we were home, Matt was fulfilling merch orders. When we were on the road, Dana was in and out of the post office dropping off orders. "Thank you for your support," she would handwrite on each packing slip. If this were a movie, this would be the part when you hear production music and see a conveyor belt of never-ending Young Bucks merchandise, mixed with a montage of airplanes and wrestling moves.

That summer, in between Japan tours, we were booked for a big event in Fishkill, New York, for an independent wrestling company called Northeast Wrestling, where we'd be wrestling two of our all-time favorite wrestlers: Matt and Jeff Hardy, aka the Hardy Boyz. In terms of box office sales, no other tag team in history had been more profitable than Matt and Jeff. Beyond that, though, they're considered the all-time great tag team by most wrestlers in the business. Clearly, they were highly influential to me and Matt as teens. For years I would fall asleep and dream I was in the ring with the Hardys. And now it was actually happening. Luckily, fans equaled our excitement, and we sold a couple thousand tickets for the event. It was one of the largest non-WWE crowds of the year for a wrestling organization, even more proof that we were becoming a ticket-selling draw.

Many of the event's wrestlers were part of a meet-and-greet prior to the show. We made it a point to go introduce ourselves to someone we had a run-in with a couple years prior, someone who was responsible for our career shift. "Hey, my name is Matt, and this is my brother Nick. We didn't get to say hi last time we were at a show together," Matt said, sticking out his hand to Booker T.

Booker smiled ear to ear and shook both of our hands.

"Man, that whole thing got out of hand," he said. "I'm sorry it went down like that. Thank you for coming and saying hello." For a long time, the whole no-handshake thing felt like it was ruining my life. It felt good to finally put it to rest.

We went backstage and sat and talked over the match with Matt and Jeff, who seemed just as excited as we were. They were eager to give the people their money's worth, and on that night, we sure did. The audience, while mostly pro-Hardys, was also filled with Young Bucks fans. Our fanbase was growing, as hundreds of men in their twenties and thirties were wearing Bullet Club T-shirts and throwing up Too Sweet hand signals, while some teenage girls held handmade Young Bucks signs. Typically, in major cities, the "smart fans," or diehard fans, loved us, but our popularity was now reaching even smaller towns like Fishkill, to the more casual wrestling fans. To us, that was very telling about how far we'd come. This match would only add more fuel to the fire. It was inspiring being in the ring with two brothers who were stars of their stature yet still willing to work just as hard as us. It was like getting a glimpse of ourselves in the future.

Back in Japan, Kenny Omega and NJPW held a press conference announcing that Kenny was set to leave his old company, DDT, and start full time with NJPW. If it meant we'd be able to hang out with Kenny more, then we were all about it. "Guys. I'm joining Bullet Club, and I'm not happy about it," he said to us. "We're elite wrestlers. We should be wrestling each other, not be on the same team. Besides, with AJ, I feel like I'm going to get lost in the shuffle." AJ Styles had received a massive push right out of the gate, defeating Okada for the IWGP Heavyweight Championship, which in turned helped Bullet Club become even bigger. But AJ was being put in a top spot, so in Kenny's mind there wasn't room for him at the top. We reassured him that this would be a good thing, and that his

involvement with Bullet Club would only help. On November 8, 2014, at NJPW *Power Struggle*, Kenny Omega joined Bullet Club by becoming "the Cleaner." As was tradition, we stood together as one and took an updated group photo.

Another tradition was every member of Bullet Club wearing Bullet Club T-shirts and hoodies everywhere we went. We'd ride on the bus together from town to town wearing that same logo, and I felt like a kid again, playing basketball with my city league squad. We were a team. We cheered in the back while members of the club's matches played on the television screen. Often, we'd come down to ringside during each other's matches and encourage one another, despite being told not to. Although AJ was clearly the most pushed, and Gedo's favorite wrestler amongst the group, neither he nor any of us looked to him as a leader. That was the beauty of our group: there were no egos.

If anyone was our spokesperson, it was Karl Anderson, who had been in NJPW the longest and who everyone came to for most things. He usually grabbed the microphone and cut a show-closing promo after our main-event matches. Fale, the gentle, quiet giant, acted like our muscle and always made sure everyone within the group behaved themselves. And the crazy one? Well, nobody was crazier than Tama Tonga. He'd get stone-faced and speak passionately about the business, except that *passionately*, in this sense, refers to his habit of screaming in one's face. Gallows was the class clown and always the life of the party. Whether it was on the bus, in the locker room, or at dinner, if Gallows was around, the entire room was belly laughing.

Matt, Kenny, and I were like the Three Musketeers, exploring the cities together and playing arcades and basketball in our free time. Kenny, clearly the most familiar with the culture and locations, proudly led us both on foot and through

the subway. I was usually the most energetic and fun of the three of us, always joking and clowning around, never one to turn down a new adventure. Matt was quiet and reserved, usually observing every situation we were in. He was the adult, or father, of our trio. We were three of the only members of the gang who didn't drink, so we'd sit together at these all-night marathon dinners while everyone else got plastered and laugh at the ridiculousness of it all. Bullet Club had a 24/7 group text chat that at least one person would answer at all hours of the night. The chat was probably like any chat you've ever been a part of, in many ways. It was filled with screenshots of stupid things other wrestlers tweeted, or silly selfie photos we'd take from home when we were bored. The moment a Bullet Club member had a new baby born, the chat would be the first place to see the newborn. We talked business openly in the chat, debating how to expand on our ever-growing popularity. We were together even when we were apart. The partying, the traveling, the bonding, all of our time together outside of the ring paid off when we were in front of a camera.

Matt and I introduced the group to the wonderful world of merchandise. We taught the others how to come up with good T-shirt designs and which artists were best to use. We let them in on our secrets about selling used wrestling gear to the collectors. Additionally, we lectured the guys on the importance of marketing yourself and keeping the conversation about yourself alive online. It may sound simple now, but we explained to them how mandatory it was to use hashtags in your tweets. We never studied business or marketing in school, but we'd picked up a lot of these things throughout the previous couple of years.

Matt and I were gone from home so much that time began to blend together. Months would pass in what seemed like a blink of an eye. My daughter Alison was growing up so fast, and most of my fathering was taking place through FaceTime

on my phone. While it was rewarding to see her smiling face, nothing could replace time spent together in person. On the road, Matt and I struggled with this more than anything, but we always had each other to lean on. Still, I'd have days when I'd need to get out of the hotel alone, feeling myself sinking into a depression. I'd go shoot hoops at the local arcade near Tokyo Dome City to clear my head. Or I'd go to the convenience store and load up on candy and ice cream, and search for an American movie on television. Matt, in his bouts of depression, would sometimes trap himself in his room for twelve hours and write in his journal. At times, Matt was so hard on himself, he'd feel guilty for having a good time without his family when we'd go do something fun, like go to Universal Studios in Osaka. Most of the time, when we needed to get out (and I mean when we'd force each other to try and embrace the outside world), we'd go eat at an Italian-style diner called Saizeriya, where we would order chicken wings and hamburger beef. Afterward, we'd go shopping at a discount chain shop called Don Quijote that had anything and everything you need. As we rode up the Tokyo Dome Hotel's glass elevator, which went up forty-three floors, we'd stare out at the entire city. We were there so much, I'd sometimes wonder if we'd ever actually gone home. Did I even have a home? Had I been in Japan this entire time, and fantasized about having a family back home? It messed with my psyche. We loved Japan, and were surrounded by people we loved, but it was still a foreign place and oftentimes we'd both get very homesick. It can mess with your mind when you're constantly in a room or on a train around people who don't speak your language. There's a loneliness to it. To entertain ourselves during longer tours, Kenny, Matt, and I began to make short six-second videos on a new video application called Vine. The idea of trying to tell a story in six seconds was both challenging and rewarding. In one video, Kenny and I sang

the famous song "Do You Want to Build a Snowman?" from Disney's animated film *Frozen* to Matt, only to find out that Matt had already built his own snowman, frustrating Kenny and me. In another Vine video, Matt brought his phone into the ring and filmed a point-of-view video of himself clotheslining someone. These videos became pretty popular online, and fans encouraged us to make more. We didn't realize these silly videos would eventually morph into a weekly web series that would define our careers.

On the wrestling side, our junior tag team matches had become so popular on the NJPW shows that Gedo had no choice but to push our matches further up the card. Historically, junior tag team matches would either be a preshow match or the first match on the main show, but now we were often the fifth or sixth match on the card. Most fans were saying our matches were better than the heavyweight tag team matches, which *wasn't* supposed to be the case. The heavyweight tag team matches consisted of the more popular, pushed wrestlers, and the matches were always given more time, so our matches had no reason to be better. But I agreed with the fans: they were.

"Do you think it'd be possible if did a front flip during the IndyTaker?" I asked Matt one day. Instead of springing off the ropes and jumping straight down to assist Matt with the piledriver, I wondered if adding a full front flip before would be possible.

Matt looked at me like I was crazy. "I'm sure it's possible, but we'd have to practice it," he said. "There's so much room for error, too." He put his headphones back into his ears, easily dismissing my question as he geared up for another long bus ride somewhere in the middle of Japan. Each day after, I would pitch this idea to our friends, just to see what they thought. I put the idea in my back pocket and almost forgot about it. A short while later, on August 30, 2014, we found ourselves

back at American Legion Post #308 in Reseda for night two of *Battle of Los Angeles*.

"Hey, that move you mentioned to us before. Let's do it tonight," said a bold Frankie Kazarian. We were booked to wrestle Frankie and Christopher Daniels, two guys we'd really hit it off with around this time. Two guys we'd also bonded with over surviving TNA. We were thinking of a spectacular finish for our match, and the competition that night was stiff. How could our match stand out?

"Go ahead. Pick me up, Matt. Let's try this. If not now, then when?" Frankie asked. Matt and I were anxious, but Frankie's persistence was convincing. As Matt held Frankie up, feet in the air, I bit my lip and then sprung off the top rope, tucking my head to do a front flip, and then grabbing Frankie's thighs and helping Matt plant him right on his head. The wrestlers filling the ring stopped what they were doing and made an audible gasp.

"Holy shit!" said Ricochet, the one-time skinny kid with an afro now turned confident wrestler. "You guys gonna do that tonight?"

"I think so!" I answered.

Later that night, in front of the jam-packed Reseda crowd, Matt picked up Frankie. To the crowd it appeared as if we were going to do our usual IndyTaker move, but I did the front flip and the place exploded. It almost took a few seconds for it to register completely for the fans to realize exactly what had happened. After the impact of the move, the fans broke into conversation, trying to describe to each other what had just happened. Wrestling is an art form where most moves are a copy of another move from the past. It is not common to see something that has literally never happened, right before your eyes. It'd be like someone pulling out an iPhone in the 1990s. Nobody would know exactly what they were looking at.

The next day, as I drove back to Reseda for the third and final night of *Battle of Los Angeles*, Matt scrolled his phone, looking at pictures of our new move taken by fans. The new move received a big reaction online, and as usual there was lots of chatter. A fan tweeted that the most popular professional wrestling journalist, Dave Meltzer, would give the move a five-star rating. Dave famously rated wrestling matches, and the best matches would receive five stars. Matt's eyes opened big. I could tell he had something to tell me.

"Oh my God. I've got it!" he said. "Let's call the move the Five Star Driver."

"Rob Van Dam already does the Five Star Frog Splash," I replied.

"That's right. Okay," he said. The car went silent for a few moments. "Okay! What about 'the Meltzer Driver!'" he yelled.

"That's it!" I said, speeding the car forward as the dust from the freeway kicked up behind and our future shone bright ahead.

The Elite Is Born

MATT

As 2014 ended, we were regarded around the world by many wrestlers, fans, and critics as the greatest tag team in professional wrestling. "They are the next big thing. They are the most exciting tag team in the world," Matt Hardy said about us in a video he uploaded in the summer of 2014 from his personal YouTube account. Our body of work at ROH, PWG, and other independents was fully recognized, but most notable was our work in NJPW. We'd developed quite the rivalry with the Forever Hooligans, the Time Splitters, and ReDRagon. And due to our producing consistent matches, we secured our very first fan-voted Wrestling Observer Newsletter Tag Team of the Year Award, which is the highest award in the business for a tag team (we'd win it four more consecutive years). Our newest move, the Meltzer Driver, had gone viral, and every audience we performed in front of wanted to see it live and in person. Suddenly, interested fans wanted to know more about this Dave Meltzer

journalist, and he soon became a popular caricature within our brand. Whenever Young Bucks was mentioned, the name Dave Meltzer would follow. We joked on Twitter, affectionately calling him our uncle Dave. Fans criticized us for pandering to Dave in order to score better match ratings, but instead of denying that, we'd lean into it, blowing Dave a kiss while he sat front-row at PWG events. We were getting bookings all over the world—packing suitcases full of merchandise everywhere we traveled to and leaving with them completely empty. Since bookings were on a request basis, we had to pick and choose where to go next, just as long as NJPW was our number one priority. This was proving easy since, for the first time in our lives, Nick and I were making close to six digits. There were only a handful of wrestlers in the industry who made that type of money, and almost all of them worked for WWE. While several others were being poached and planted into WWE's developmental company, NXT, at an alarming rate, our success gave us further indication that we didn't need to go there. In fact, back on June 23, 2014, their senior director of talent development, Canyon Ceman, contacted us about doing a tryout for WWE in Orlando, which we respectfully declined. This move earned us immediate heat in the WWE office, and word about us declining the tryout ended up on the internet. *Wrestlers simply don't turn down offers from WWE,* common knowledge said. *It's every wrestler's dream to one day work there.* But it no longer was for us. We'd also already worked for a large company, one not even close to the size of WWE, and saw how micromanaged things were and how impossible it was to be creatively satisfied. The whole handshake thing didn't exactly bring back fond memories of being there either. We enjoyed working for ourselves, and after all these years we finally had a good, lucrative thing going. We didn't want to ruin that.

There were other practical reasons behind our decision, too:

if you signed a deal with NXT, you'd have to uproot your family and move to Orlando, where the NXT Performance Center is located. The Performance Center is a high-tech gymnasium filled with coaches and specialists to help prepare wrestlers for the WWE main roster shows, *Raw* and *Smackdown*. New signees are required to spend most of their time there throughout the week. Moving to Florida was a deal breaker beyond anything else. We were family men, and it was important that our kids could spend time with their grandparents and cousins in California. Dana and I also had plans for baby number two, who was on the way, and we didn't want to be in the middle of a move during her pregnancy. In the eyes of our devoted fans, while everyone else was leaving in droves for NXT, turning down the tryout offer only made our brand cooler. They saw us as even more unpredictable.

Despite how much we were currently in demand around the world, and how well our merchandise was moving, we were still working everywhere without a guarantee. My hand, which ended up taking four or five months to heal, was a reminder to me just how vulnerable we were. A maelstrom of thoughts entered my mind: *What if I get hurt? What if Nick gets hurt? What if Bullet Club goes cold? What if it shuts down?* Years ago, I would've celebrated the success and tried to enjoy the moment. But now, with both my injury and my being a father, my philosophy took on a different form. These worries kept me up late at night. Nick and I both knew how fast the wrestling business moved, so it was imperative that we stayed healthy and on top. Nobody was going to outperform us, because it was a matter of survival.

On June 3, 2015, Dana and I went to the hospital for her planned C-section surgery. In much less dramatic fashion than the birth of Kourtney, we welcomed our son, Zachary, into the world. I worried I could never love another child the way I loved Kourtney, but the moment I looked at Zachary's face and saw

his piercing green eyes and matching dimples in his cheeks, I was head over heels. As Dana held Zachary in her arms for the first time, three-year-old Kourtney came into the room, wearing an "I'm a big sister" sticker and smiling from ear to ear.

"Hi Zachary. I'm your big sister!" she said proudly. I held my entire family in my arms. It felt so complete, and for a moment all the other things in life became mere background noise. When a new life is brought into the world right before your eyes, you have a moment of clarity. *This is all I need,* I thought.

Zachary's birth was also exciting in that he was the first boy born out of seven grandchildren, so my dad was through the roof and rewarded me with a crisp $100 bill. "I promised the first one to give me a grandbaby boy gets a hundred bucks!" he told me, though I couldn't remember him making such a promise. Either way, it pleased me to see him so happy.

In the wrestling world, ROH and NJPW had continued to use us regularly, and working for both companies simultaneously helped open the door for a working relationship between the two. Soon, Japanese wrestlers would make special appearances at ROH shows, while ROH wrestlers like ReDRagon became regulars on the NJPW tours. On most ROH shows, we would represent Bullet Club by teaming up with AJ Styles in some unforgettable six-man tag team matches. We shared an undeniable amount of chemistry; he even joked that the *J* in "AJ" stood for "Jackson." AJ had always been one of the all-time greats in the ring, but it wasn't until the Bullet Club that he truly found his personality. Many people, including me, credit Bullet Club with pulling him out of his shell.

During a weekend on the road for ROH, we were approached by ROH General Manager Greg Gilleland. For months, ROH had been trying to offer us a U.S. domestic exclusive contract. We always avoided it, thinking they'd never come close to what we were already making on our own. Also,

the idea of working for only one wrestling company in America sounded scary.

"What's it going to take to get you guys?" Greg said, not wasting any time.

Humoring him, I replied, "Well, for starters, we would need to keep working for NJPW whenever they need us. And also, when we're home, we'd like to continue wrestling at PWG. It's a deal breaker otherwise." Greg understood the NJPW stipulation but seemed surprised about the PWG part. "And we won't close our Pro Wrestling Tees shop or TheYoungBucks.net," I said. Between both stores we made nearly half our yearly income.

"Also, we'd need the exact amount of money we made last year from wrestling but guaranteed," Nick said.

After telling him what we made the year before, Greg had a quick answer back. "Okay. I think we can come close to all of that." Greg also reassured us that we could try it out for about a year, and if it wasn't for us, there'd be no harm done.

Nick and I spoke later that night about how signing that type of deal couldn't be a bad thing. "We wouldn't have to do so many shows anymore," Nick said. "We could just focus mainly on NJPW, ROH, and an occasional PWG show." When we weren't in Japan six months out of the year, we were doing three shows every weekend in three different cities, burning the candle at both ends. With this potential ROH contract, the limited schedule and more time at home sounded great, but I couldn't help thinking of the strangeness of not appearing in independent shows across the world, and not hawking our merchandise at intermissions. It's what we'd built our brand on. Would we be looked upon as sellouts when we'd built a reputation on being the underground, hustling, do-it-yourself types? Nick had another baby on the way—another Massie boy

(we were just pumping them out now)—and I was juggling being a father for two kids and a husband to Dana while living out of a suitcase. We knew it was time for a change.

In October 2015, we signed at the time the largest contract in ROH history, putting us just under six digits guaranteed, complete with all the deal points that we'd asked for. For the first time in our careers, we wouldn't have to worry about where our next payday came from. I told Dana, who was home on maternity leave from her leasing consultant job, to never go back to work again. Can you imagine saying that to someone? I'm still humbled to have ever uttered those words. We celebrated that night, in a booth for a party of four at Red Robin. Zachary slept in his detachable car seat, while Kourtney, Dana, and I scarfed down cheeseburgers. *I'm finally, really doing it,* I thought to myself, looking proudly at my family, who was eating food purchased solely from my wrestling.

The worries of getting hurt during a match and not being able to provide were now over. So many wrestlers talk about their favorite moments, and they usually involve winning a championship belt. Forget that! This was the moment I felt like I'd finally made it.

This didn't make Dana slow down, not in the least. "With my new free time," she said, "I'm going to treat our online store like a full-time job now. It's successful right now, but I want to make it huge." And so the family business expanded. We invested in more merchandise and designed an updated web store. We rebranded to YoungBucksMerch.com and instantly saw an increase in sales. Where Pro Wrestling Tees dominated with the T-shirts, we began offering more unique items like tank tops, shorts, socks, hoodies, matching tasseled shirts, children's T-shirts, and customized autographs. Later, we'd get sublimation all-over-print T-shirts and leggings to match our

outrageous wrestling gear. This type of printing allows you to cover every inch of the fabric with designs and patterns as opposed to traditional printers, who typically only cover a block. I recall so many nights of putting the kids to bed and staying up until the early morning with Dana, folding hundreds of Young Bucks T-shirts on our dining room table. I could no longer hustle at independent shows, snatching $20 bills out of customers' hands, but I could still get my fix from the privacy of my own home. There was something romantic about working together with Dana every day and building an empire out of our home. Our creative minds never stopped, and often in the middle of the night one of us would elbow the other awake and pitch a new idea. Working together strengthened our marriage and our respect for one another.

Upon returning to Japan for the following tour, we noticed a change in the dynamic of Bullet Club. AJ Styles, Karl Anderson, and Luke Gallows, who'd spent much time together during the long summer tour, had become extremely tight. They were together at our expense and excluded us from many activities. The Bullet Club group text chat had gone silent. We didn't know what was going on, but we knew something was up.

At the time, NJPW didn't have many wrestlers locked into full-time contracts. Most of us worked on a per-tour contract, which meant NJPW had us exclusively only during that particular tour. Me, Nick, Luke Gallows, Kenny Omega, and AJ Styles, among several others, technically worked for NJPW on a handshake deal. Karl Anderson, Tama Tonga, and Fale, who all came up through the dojo system, were the only members of Bullet Club signed to guaranteed contracts, but we didn't know the details of their agreements. Nick, Kenny, and I wondered if

some of the guys were thinking about making a move. Why else would they be acting funny? By the end of the tour, our suspicions were proved right when we finally got it out of Karl. We'd known him the longest of anyone, and he just couldn't keep it a secret any longer. He, AJ Styles, and Luke Gallows were all in serious talks about going over to TNA Wrestling.

"Listen. I know it sounds crazy," Karl said, "but they're offering great money, and I've been coming to Japan for eight years. I think it might be time to come home." As he spoke, I couldn't help but feel betrayed in a way. Nick and I flew home, wondering what this meant for the future of Bullet Club.

On December 18, 2015, we traveled to Philadelphia to ECW Arena, a place in which we'd had a catalog of memorable matches, to participate at ROH's Final Battle. In the middle of stretching in the ring, AJ approached me and Nick and asked if we had a moment to speak in private.

"Are you guys currently under a deal?" he whispered.

"We just signed with ROH a couple of months ago," I said.

"Dang it! I was going to see if you guys might want to come with me," he replied, disappointed.

"To TNA?" I asked.

"Yeah, maybe. Or even possibly the other place," he said.

"Wait, what?" Nick asked, raising his voice. AJ insisted he'd tell us everything later, but for the rest of the night, Nick and I could hardly focus on wrestling. We felt like a bomb was just dropped on us.

Late that night, Nick and I met AJ, Chris Daniels, and Frankie Kazarian in one of their hotel rooms. As we were some of AJ's closest friends, he needed our advice.

"I was on the phone with Triple H earlier today, and he wants me to come work for him," AJ said, right out of the gate. Before any of us could say anything, he continued, "However, I've been promised the world by TNA. And with TNA, there

wouldn't be any surprises. I've worked for them for years. I think I can trust them."

"You trust them? They're the last people you should trust!" shouted Chris, who'd experienced bad times there firsthand with AJ. As AJ talked further about the pros of signing with TNA, I interrupted him, saying something I never imagined myself saying: "If WWE offers you a spot in the Rumble, you have to take it. You'll be a made man overnight." WWE holds an annual pay-per-view event called *The Royal Rumble*, built around a battle royal match where a new contestant enters the ring every minute or ninety seconds. Debuting in a moment like that could be monumental.

"Going there is the only thing you haven't done," Nick agreed. "What a way to end your career." As much as it pained us to even think about losing AJ, we were looking out for his well-being. Kazarian kept telling AJ his name could live forever in history, that he'd be able to take care of his family after making such a move. The more the four of us hammered it into his brain, the more he defended the idea of going to TNA instead. By the end of the conversation, it didn't feel like we had gotten through, so we were all convinced he was going back to TNA.

A couple of weeks later, I used all the miles I'd saved from years of traveling to fly Dana, Kourtney, and Zachary to Japan. Nick did the same for Ellen, Alison, and their new baby boy, Gregory. *Wrestle Kingdom* was the one time a year that everyone was encouraged to bring family and friends, and it meant the world to me that my family would be able to watch me perform in front of so many people. I also took great pleasure in being able to show my family the wonderful Japanese culture. For years, I'd told Dana stories about what Japan was like, so it was exciting to watch her experience it for herself. Little, curious four-year-old Kourtney and her six-month-old,

chubby-cheeked brother, Zachary, grabbed the attention of everyone wherever we went. Our fans particularly were fascinated with Kourtney. One morning, Kourtney and I held hands and walked through the lobby of the Tokyo Dome Hotel. I was stopped by fans who wanted to take a picture. Before I knew it, there was a large line queued up to take photos with me. In between a photograph, I looked over to Kourtney, whose hand I was still holding. With her other hand, she held up a "Too Sweet" sign and smiled for a photograph with a fan. Within a minute she had a line of a dozen of fans waiting to take a picture with her. It was one of the funniest things I'd ever seen. By the end of the trip, our hotel room was filled with stuffed animals, games, and candy, all gifts for the kids from fans.

On January 3rd, 2016, all of the wrestlers were loaded on the NJPW bus headed to a press conference for *Wrestle Kingdom 10* at Tokyo Dome, our third time doing a show at the massive stadium. As we got off the bus, Karl Anderson got close to me and said, "We need to talk. We're making a move."

"To Dixieland?" I whispered. It was a reference to former TNA Wrestling owner Dixie Carter.

"No. The other place."

I was startled. "What? When?"

"Immediately. We're giving notice today. They want AJ, and they want us, too," he said.

I found Nick and Kenny and told them what was going on. We got through the press conference, and as the flashes from the cameras went off, I stood there holding a smile, but I couldn't help but worry about my future. Afterward, we all gathered in a back room to rehearse our matches for the big show the next day. As we began planning, we noticed Anderson and Gallows speaking to Gedo and Tiger Hattori within earshot, right next to the ring. It was impossible not to eavesdrop.

"I appreciate everything you guys have done for me for eight years," Anderson said. "I was nothing. You guys took me in. Thank you so much. But I have to go. It is time. I'm so sorry." Gallows echoed everything Anderson was saying.

Rocky Romero, who was also eavesdropping with me, said, "This is insane." He wasn't wrong. Toward the end of the conversation, they'd nearly forgotten to mention AJ was leaving too. "Oh. And AJ is coming with us, too," Anderson said. "He wants to talk to you guys as well." We looked at Gedo, and it was like a dagger had gone through his heart. AJ was the number one foreign wrestler in NJPW and Gedo's ace in the hole. Not only was he losing a top heavyweight tag team, but AJ, too? Sometime after our group conversation with AJ in Philadelphia, AJ had decided to call Triple H back, and during the conversation, Triple H asked if any other Bullet Club members were available. Before long, Anderson and Gallows had offers on the table as well. On top of all of this, later we'd find out that one of NJPW's top Japanese wrestlers, Shinsuke Nakamura, had also given Gedo notice a couple days prior that he was leaving to go to the WWE. I could only imagine what was going through Gedo's head. It was a mass exodus.

As soon as Gedo shook hands with Anderson and Gallows, thus ending their conversation, he interrupted Kenny, who was calling tomorrow's match with Japanese wrestler Kushida. I knew exactly what was happening. A few minutes later, Kenny came up to Nick and me beaming with joy. "I'm moving on up," he said, as he pointed upward with his thumb. We knew that meant he was moving up to the heavyweight division and getting a push. Because of the talent leaving, there was about to be a major shift on the card. Kenny was always going to be a major player; this was just going to expedite the process.

The next day at *Wrestle Kingdom* was a blur. Everybody's heads were spinning because of the news. In the two prior

Dome shows we participated in, Gedo was really hands-on with helping to produce our matches, and the referees were on us about making our time cues. This year, though, it felt like everybody was in panic mode, and *Wrestle Kingdom* was the last problem to worry about. Despite all of the chaos, after the match, we walked over to the family section and hugged all of our loved ones. I gave Dana a big kiss, and she told me how proud she was.

The next day's follow-up show, *New Year's Dash*, at Kōrakuen Hall would act like a story line reboot. AJ was leaving imminently, but Anderson and Gallows had agreed to come in for one final tour in February. The idea was to do a story where, following a Bullet Club tag team match, AJ would climb to the corner turnbuckle to pose and Kenny would quickly snatch AJ from behind, putting him on his neck and delivering his One Winged Angel finishing move, in which he grabs you by your neck and drops you neck first in between his legs. The crowd was stunned when he pulled it off. Nick and I then ran into the ring with the other members of Bullet Club, all of us acting confused. It was pandemonium, and the audience didn't know what was going on. Gallows and Anderson picked AJ up to his feet, as if they were trying to help him up, as Nick and I questioned Kenny for doing what he did. Then, we turned to AJ and delivered a vicious double Superkick to make the turn official. All of the Bullet Club members smiled, looking toward Kenny. He was now *the guy*.

We all exited the ring and started heading toward the stairway to the locker room. Kenny stood close to Nick and whispered under his breath, "Ask Matt if we should go back into the ring." I overheard, and before Nick even said anything, I shouted, "Yes!" The three of us slid into the ring where AJ still lay. The rest of Bullet Club had gone backstage.

"Should I give him Styles Clash and you guys do a double

Superkick to him?" Kenny asked. Styles Clash was AJ's finishing move, where he holds his opponent upside down and drops him on his face. It would be like adding insult to injury from a story line perspective, but it was also something we hadn't discussed with AJ beforehand.

"Yes!" I excitedly shouted again.

Wham! Kenny planted AJ on his face with his own move to a chorus of boos. Kenny, knowing the importance of photographs in Japan, told us to strike a pose. One great picture could end up on the cover or in the pages of the weekly wrestling magazine. Nick and I threw up our Young Bucks pose, while Kenny used AJ's trademark pose in mocking fashion.

The three of us stood tall. Yes, we had gone into business for ourselves without asking anyone for permission, including Gedo. But we knew, given the talent departures, we were in a situation where we needed to act quickly to survive. It was time for a new era of Bullet Club, and we didn't want to be considered the leftovers of the former.

As soon as I left the ring and arrived backstage, I tweeted a fan photo of the three of us posing, with a caption that read, The Elite of Bullet Club. At that moment, "the Elite" was officially added to the annals of wrestling history.

Being the Elite

NICK

JANUARY 23, 2016

Anderson, Gallows, and AJ were advertised for what would be
their final ROH appearances. The entire building was covered
in Bullet Club shirts, and rumors were running rampant about
where the three would turn up next, which only created more
buzz. We knew where they were headed eventually, but AJ had
kept quiet, even from us, about exactly what he was doing next.
Would he enter *The Royal Rumble*?

After a Bullet Club tag team main event, we went off script
when AJ entered the ring. Even though we had kicked him out
of the group a couple of weeks prior in Japan, we all huddled
up and shared one last group Too Sweet. During the huddle,
I spoke from the heart to some of my best friends at the time.

"This has been the most fun time of my life," I said. "We
changed the business forever! Thank you for the memories and
good luck to you guys." I looked at Matt, Gallows, Anderson,

and AJ, who were all crying. Tears hit the sweat-stained canvas. We were a brotherhood coming to an end, and I experienced the same feeling in my gut when we moved from our childhood home. A sinking feeling of inexplicit change.

"Okay guys. I've gotta go. I love you guys," AJ said as he went to exit the ring.

Matt stopped him, gave him one last hug, and whispered into his ear, "What number did you draw?"

"How'd you freakin' know!" AJ replied. Matt was referring to his hunch that AJ would indeed be debuting at *Royal Rumble* just twenty-four hours later in Orlando. It may seem obvious now, but at the time there was only speculation. Matt was right. AJ would end up drawing number three in *Royal Rumble* and would go on to have a very successful WWE career.

A few months prior, on October 9, 2015, our healthy boy, Gregory, was born, weighing in at nearly nine pounds. My father-in-law, Gregory, never had a son through which to pass on his name to another generation, so I thought he would appreciate it if we named our son after him. Being better prepared this time around, Ellen's second C-section surgery wasn't as difficult as the first, and within minutes of delivery she was holding little baby Gregory Nicholas Massie in her arms. I was so blessed to be there in person.

Back in Japan, the Elite was catching on. Kenny was in the midst of a giant push, and anywhere he was seen, so were we. If he had a big match, we were ringside. If he had an important interview, we stood and spoke with him. Strangely, the other members of Bullet Club had a loyalty to the three guys who sort of just left us all high and dry, so we felt a weird animosity within the group. It felt like a lot of the boys had heat with us

over our trying to take things into a new fresh direction. We needed to differentiate ourselves from past versions of Bullet Club, so we decided to divide ourselves from the others, making the Elite a small subgroup within Bullet Club.

We'd also seen Bullet Club's popularity grow astronomically, and we felt we were never properly compensated for all of those thousands of Bullet Club T-shirt sales. At the end of the quarter, we'd get handed a check for only a couple hundred bucks. While we were grateful for what NJPW had done for us, we wanted to look out for ourselves. So, we decided to create a new, simple T-shirt design: a black shirt with white letters in a box that simply read "The Elite." We would split the profit evenly three ways. Instead of wearing Bullet Club T-shirts out to the ring and in public, we'd wear our own brand instead. Within a couple of months, we'd made more money from the Elite design than all of the Bullet Club T-shirts combined. NJPW, seeing the growing popularity of the Elite, offered to buy the rights to the logo to sell on their own for a couple hundred dollars, and a 2.5 percent royalty each. Luckily, we had the foresight to decline the offer.

After Kenny won the IWGP Intercontinental Championship Title in controversial fashion with our help, he announced that he'd be hosting a press conference. In Japan, press conferences are traditional and taken very seriously. Many fans speculated that Kenny would apologize for the unsportsmanlike conduct in what resulted in his championship victory.

On February 16, 2016, we started a YouTube channel and posted our first video, titled, "Press Conference." Fans clicked the video and got something they weren't expecting. What begins like a typical apology speech quickly turns into a hilarious

sketch: Kenny, from out of nowhere, reveals he has a microphone, and switches from apologizing to passionately singing "Raise Your Glass" by Pink, which is fittingly changed to "Raise Your Belt." Every time the word *belt* is sung, Kenny raises his newly won title into the air. Matt and I eventually join in on the chorus, and we all sing until we're red in the face and until we lose our voices in a tiny karaoke room near Tokyo Dome City.

Needless to say, the video was an immediate hit, and fans pressured us to make additional videos. Any time the three of us were together, our downtime took on the feeling of a writing room, where we'd pitch new ideas for future sketches and bits. Any time we had a day off from a tour, we'd shoot a video from my iPhone, edit it, and post it to our channel. It fulfilled us creatively and gave our fans new digestible content, which, in turn, created more brand awareness for the Elite. It was also a fun way to pass the time. We realized that not only could we create buzz from our in-ring performances, but we could also help spread the word through these wacky videos.

One day, we decided to challenge a popular, charismatic wrestling stable in WWE, called New Day, to a match. We knew the possibilities of such a match were most likely impossible, but we thought if we could get them to banter back and forth with us, the fans would be entertained. To add gasoline to the fire, we made a video on our YouTube channel teasing whether or not we'd enter an NJPW ring wearing New Day merchandise, driving people to watch the show on NJPWWorld.com, the now two-year-old streaming service that could be watched in most countries. Without asking permission, we all entered the ring wearing light blue New Day shirts, surprising fans watching the show back at home, and pushing the boundaries of what wrestlers did with rival companies. We were never penalized, but we heard people in the office weren't thrilled about

this choice. Whatever the case, it worked, spurring headlines all over the internet and creating more conversation about the Elite.

A couple of months later, I pitched the idea of creating additional content for our growing YouTube channel. Since our lives were on the road, I wanted to document it and make short videos. People really only knew us as the people that they saw in the ring and, until recently, the over-the-top characters we played during the comedic pieces we'd been putting out. They didn't know the real us, or the daily struggles we went through. They didn't know the tedious travel, the sights we saw, and the things we liked to do. They didn't know us as people. When I was a kid, I enjoyed wrestling documentaries that'd take you behind the scenes, exposing you to the real-life people who played the characters. I was interested in making miniature documentaries like those. Matt and Kenny didn't love the idea, telling me that people enjoyed the sketch comedy stuff the most and that we couldn't stray from it, not now at least. I decided to start filming anyway and put something together to show the guys. At the end of a typical insane week on the road, filled with long flights, bus rides, and impromptu fan meet-and-greets, we drove home from the airport and recapped the last several days. It was mainly us complaining about how tired we were and plugging upcoming events. After we shot the video log, or vlog, Matt and I discussed possible names for the video. *On the Road with the Elite* and *Hitting the Street with the Elite* were two possibilities we came up with. But then, a light bulb went off.

"I've got it!" I said. "*Being the Elite*. It's short and sweet and describes exactly what the video will be about: us." Matt agreed right away.

On May 5, 2016, I posted the video, though it wasn't a surefire hit. Our subscriber number didn't jump overnight or anything, but the people who did watch loved it and begged

for more. We debated making this new documentary a weekly series. Our good friend Colt Cabana, whose ultrasuccessful podcast dropped almost every week for nearly nine years, had advice for us: "If you guys are serious about making weekly content, you have to stick to it, and do it every single week. The most important thing is producing good content, consistently." Eight years earlier, Matt and I had tried a similar thing, documenting our life on the road and putting it on YouTube. We called the series *Young Buck TV*, or *YBTV* for short, but we never had the exposure or following to drive interest from fans. I think we killed the series after eight episodes. If we were going to take another swing at it, I figured now would be the time.

On the second episode of *Being the Elite*, we took fans behind the curtain and showed the aftermath of a major Bullet Club angle, where the group got a new member and wreaked havoc on the ROH roster. The ROH and NJPW relationship was becoming increasingly stronger, and joint shows with big story line development were becoming more common at the events. In the town of Chicago Ridge, at one of these joint shows, Matt and I helped write, produce, and direct a violent angle culminating in Adam Cole joining Bullet Club. We had a heavy hand in many PWG stories beforehand, but this was one of our first times doing so at ROH. It was our idea to get Adam into Bullet Club, and we knew he'd be a perfect fit from our short time together in the PWG stable, the Mount Rushmore of Wrestling. It also happened to be Adam's lifelong dream to one day work for WWE, so if we could help get him red-hot before he headed there, we were going to do it. It also meant we'd get to be around Adam more and have the opportunity to work together. Our chemistry was fantastic together, so we knew we would produce some unforgettable content. The angle was outrageous and stole the wrestling newsfeed. After Adam

joined Bullet Club, together we laid out a group of wrestlers, referees, and security guards. We then spray-painted on the barricades, took over the announcer duties, and even Super-kicked our own father when he tried to intervene. In the closing shot, we knocked out a cameraman, and got down on our bellies and postured into the camera. It faded to black after we obnoxiously gave Adam a big kiss on his cheeks, while Tama Tonga sprayed a bottle of black spray paint toward a $50,000 camera. It was a chaotic mess, but video provided the right medium for these antics.

In the same episode of *Being the Elite*, another Adam quietly joined Bullet Club. This was Adam Page, a quiet, six-foot, shaggy-haired, full-time schoolteacher and part-time wrestler from North Carolina. NJPW wanted a younger wrestler to come to Japan and be the fall guy for Bullet Club multitag matches, which basically meant he could be the one who eats the pins, or gets pinned, to protect the higher-positioned Bullet Club members. Weeks before, Hunter Johnston, who continued to book for ROH, called Matt and asked for his input. Out of the four or five guys suggested to join Bullet Club, we all agreed that Adam Page was young and moldable, so he'd work best. So the night after Cole joined Bullet Club, we went to Dearborn, Michigan, for another ROH/NJPW joint show: it was here where Adam Page, now referred to as the Hangman, would join Bullet Club.

Every time we were at the airport, I'd pull my phone out and ask Matt to talk about whichever city we were headed to next. We were candid about how sore and jet-lagged we were, and how much we missed our families. We were open about pretty much everything. All the subjects that we thought might be boring and tedious seemed to resonate with our small group of viewers. Fans only knew the energetic Young Bucks who

came screaming through the curtain, wearing bright neon costumes, but they didn't know the real us. *Being the Elite* humanized us and made us more relatable to them.

Slowly but steadily, our subscriber count started to grow, and after just a few episodes we were up to eight thousand subscribers. This motivated us to keep going and to give fans an even deeper look. We introduced our family, talked about our favorite restaurants, and hobbies. We showed footage from our meet-and-greets. During one episode, in controversial fashion, we filmed ourselves underneath the wrestling ring before we did a spot in one of Kenny's matches. During this time, we saw an increase in merchandise sales, crediting it to fans feeling like they were supporting a good cause. Capitalizing on our new self-earned exposure, we snuck in commercials for our newest merchandise. And in almost every shot, there were product placement ads built in, as we were never without Young Bucks T-shirts on our backs. After months of episodes, we noticed our meet-and-greet lines at ROH shows had doubled in some towns, and even tripled in others. Person after person would thank us for continuing to make *Being the Elite* and would quote lines from their favorite episodes. For the first time, we felt a deeper connection with our fans. Now they understood us. Now they truly knew what we were like on a personal level.

Historically, wrestlers were supposed to treats fans . . . like fans. We were taught to lie to them and work them into believing we were larger-than-life superstars, on a different level than them. "Perception is reality" is the common motto most wrestlers live by. For the last few years we'd been telling people on Twitter that we were arrogant millennial wrestlers who didn't care about what anyone else thought. And for a while it worked. But it was time to tell people the truth: we were just a couple of regular guys, just like everyone else. We were fans of wrestling who worked hard and stayed true to ourselves. We had our own

personal struggles that we had to overcome. The reality of our lives gave fans something bigger to root for.

Around the same time *Being the Elite* debuted, WWE wrestler Cody Rhodes, son of legendary wrestler Dusty Rhodes, left WWE for greener pastures. He had been unhappy for quite some time—he was never given much of a chance and was stuck with an oddball gimmick that he tried his best to make work. His leaving WWE was a huge deal because many wrestlers didn't have the courage to do so, not to mention that wrestlers were usually going *to* the WWE, not the other way around. Leaving the WWE is compared to "swimming off of the island," and truth be told, the few people who swam ended up drowning or being eaten by a shark. A few days prior to news breaking about Cody leaving WWE, we got a call from our old friend Kevin Steen, who had befriended Cody. "Can you please look after him?" asked Kevin. "He's a good dude." Any friend of Kevin's was a friend of ours, so we promised we would do just that.

Just as many of our stories begin at American Legion Post #308 in Reseda, California, at PWG, so does this one: On a hot summer night on September 2, 2016, night one of *Battle of Los Angeles*, we spotted a tall, slender, brown-haired man wearing a suit and tie and standing in the hallway of the cramped backstage area. It was sweltering in the sweatbox of a building, so I remembered thinking, *Why the hell is this guy in a suit?* As I suffocated on the thick air, wearing nothing but a tank top and a pair of basketball shorts, we briefly exchanged words. He was a charming fellow, but he had the strange habit of smiling after every other word. *Who smiles this much?* I thought while he asked advice about what he should do in his match the following day. I had only ever seen him maybe wrestle once, and it was a *WrestleMania* match against Rey Mysterio Jr. It had been ages since Matt and I had watched television wrestling.

Meeting him didn't seem significant, though we figured he seemed nice enough. We didn't have much in common. He was a tie-wearing, second-generation wrestler who'd spent years in WWE, and we were just a couple of casual dudes from Southern California who worked the independent scene.

A little while after this initial meeting, the ROH office picked our brains about whether or not booking Cody was a good idea. I remembered back to our conversation with Kevin and decided it was time to make good on our promise. Despite our less-than-exciting meeting, we vouched for Cody, and soon enough he was booked for a couple of shows for ROH. It was then we started to see more of each other, him always with that smiling face. We'd join in small chitchat and started to realize how quick-witted and hilarious he was. He would look at you intently, paying close attention to you, making you feel as if you were the only person alive. He was never not on as a performer, always holding court in every locker room he was in, telling old war stories from his career at WWE.

On December 3, 2016, Matt and I announced that we had signed a new two-year deal with ROH. The deals were equal to what some of the guys on the main roster at WWE were getting, but we'd be working less than half the dates. They were, again, the most lucrative contracts in company history, and not since WCW had a non-WWE wrestler signed such a large deal. We had proven to ourselves and to every wrestler that you could make a good living in wrestling without having to go to the WWE, and it established ROH as more than just another wrestling company. It made ROH a destination. And in Japan, where we were still free to work, we were having the time of our lives, being a part of some of the biggest matches and stories in the company. We were riding a high that seemed never-ending.

Around this time, to our surprise, we were told by Gedo that Cody Rhodes would be joining Bullet Club and making his

NJPW debut on January 4, 2017, at the next *Wrestle Kingdom* event at Tokyo Dome. At first, I couldn't imagine it. A rich guy in Bullet Club? The son of one of the most respected wrestlers in history, the legendary Dusty Rhodes? We were the outlaws, and all cut from the same cloth: A group of gritty wrestlers who either started in Japan or on the independent scene. Cody seemed like more of a guy Bullet Club would feud with, not team with. But as soon as I saw a video that NJPW produced of Cody smoking a cigar in a room filled with smoke, I knew he had something different about him. He oozed charisma and spoke with confidence. He could fit in Bullet Club in a different way from the others. He could be the slick member of the group who outsmarted his opponents instead of destroying them. He could act as the more serious character, to contrast with some of our silliness. Cody also had the gift of gab and knew how to pull emotion out of fans during his interviews. He made you believe every word he was saying.

After Cody joined, he, Adam Cole, Adam Page, and we spent more time in the States representing Bullet Club at ROH, while Kenny held it down in Japan with the others. It was like two different wings of Bullet Club, dominating both of its regions. In an effort to shine the spotlight on all the stateside members of Bullet Club, we included them on *Being the Elite*, introducing them to our growing audience. Our cult following fell in love with Cody, whose comedic timing was dead-on. If we introduced a new person on our show, our audience accepted that they were cool. They trusted us. Our audience loved seeing how we all interacted and spent time together both backstage and outside of the ring. Wherever we were hanging out or traveling, there was a good chance one of us had our iPhone out, filming the hilarious dialogue between friends or the latest adventure we were going on.

Our knack for booking angles at ROH continued, as we

brokered a deal with new free agents Matt and Jeff Hardy, who were coming off of a red-hot run at TNA Wrestling, now known as Impact Wrestling. Since wrestling them a couple of years back, we had stayed in touch and become good friends. Matt especially had reinvented himself, with a new strange gimmick called "Broken Matt." Essentially, his body was taken over by an old soul that affected his mannerisms, moves, and even accent. He and Jeff filmed campy videos that went viral, and their new alter ego characters became the hottest acts in wrestling. Over the course of a few years with the growing popularity of NXT and NJPW, the wrestling business had become a place with very few characters; Matt and Jeff's ostentatious personas stood out like a sore thumb. We pitched an idea to booker Hunter Johnston and Joe Koff, ROH's chief operating officer, to have the Hardys in for several shows to work with us. It would also involve us visiting the "Hardy Compound" and filming our own version of the "Final Deletion," a cinematic fight scene that Matt had produced with Impact Wrestling that was a smash hit. But as soon as we got clearance from all sides, we received an unfortunate call from Matt Hardy: "Listen. Please keep this between us, but we're going back to WWE. We got a great deal, and an offer to return at *Wrestle-Mania*. We've got to go make a wrong a right. I never liked the way we left that place." Our angle, which was originally going to take six months to a year to run through, would now have to be done much quicker. We were going to have to get right to the good stuff. We came up with a game plan together, in which our story would conclude in a ladder match the night before *WrestleMania* at ROH's *Supercard of Honor*. Prior to that, the Hardys would surprise us on March 4, at ROH's *Manhattan Mayhem*, challenge us to a match for the ROH Tag Team Titles, and beat us clean in the ring, becoming the new champions. The moment the lights were restored after being turned

off, like they often are in the magical world of wrestling, and the New York City audience saw Matt and Jeff standing in the ring unannounced, will forever live on as one of the loudest moments I've ever experienced on this earth. I just went back and watched it upon writing this, and the crowd reaction still gets me emotional. Matt and Jeff, the most unlikely ROH Tag Team Champions because they simply had no history there, stood there with the belts while the wrestling world tweeted and Instagrammed the iconic moment.

Then we set up our ultimate dream match: a ladder match against the Hardys, where the winner would have to climb a ladder and pull the ROH Tag Team Titles down to win. The match was responsible for setting a new all-time record attendance for ROH, as 3,500 people would pack the Lakeland Center, in Lakeland, Florida. It was another unprecedented accomplishment that we helped set—tag team wrestling hadn't been the main event or the main draw at big shows for years. We were making it possible.

Hours before the fans had been let into the building, Matt Hardy approached Matt and me as we practiced climbing and jumping off ladders in the ring.

"I just got a call from Vince," he said, referring to Vince McMahon. "[Vince] said, 'Listen. I know these Young Buck kids are good, but please tell them to take care of you guys. We need you tomorrow.'" Unbeknownst to everyone else besides the Hardys' family members, we knew that Matt and Jeff were set to make their WWE return the next night at *WrestleMania*, after about seven years of absence. Their safety was a lot of responsibility. The best part was that their *WrestleMania* match was *also* going to be a ladder match. So, they'd be doing back-to-back ladder matches. That just doesn't happen in wrestling. If you've done two ladders in a year, *that's* excessive. Obviously, ladder matches are one of the most dangerous matches in the

business, so we knew we had to take care of our friends, so they'd be ready for their massive comeback the following night. After the match, we stood in a ring filled with broken table debris and crippled ladders. All 3,500 fans stood on their feet and clapped. We'd just had a stellar ladder match, filled with dramatic moments and huge stunts. Afterward, Matt and Jeff stood in one piece, thankfully, grabbed a microphone and professed that we were the greatest tag team they've ever shared a ring with. It was the greatest moment of my career up to that point. Ellen, Gregory, and Alison watched from the crowd, along with my parents and Matt's entire family, all of whom made the cross-country flight for this important event. They knew how big this night was for us. I paused at the scene and remembered watching the Hardys wrestle their legendary ladder matches, from my parents' living room, and now we had just done one of our own. It'd be like watching Jordan play for the Bulls, and then getting to play a one-on-one pickup game with him. The next night, we sat at a restaurant and huddled behind an iPhone as we watched Matt and Jeff take their walk down the aisle at *WrestleMania*. The little secret we had held on to was finally out. I was happy for them, but sad our time working together was over.

By May, Bullet Club was about to get a villain, English wrestler Marty Scurll. An attractive, average-sized guy with great style and a massive personality, Marty had been largely responsible for the recent boom in the UK's wrestling scene. We'd run into him for years on the independents, but it wasn't until he adopted the Villain persona that his career started to blow up. Marty traded in doing wrestling holds for adding more flavor

to his character, leaning on his showmanship, entering the ring wearing a plague mask while spooky entrance music played. In wrestling, it's just as important to have a great villain as it is to have a hero, but Marty became so good at being bad, people began to cheer for him over the good guys. Much like famous wrestler Stone Cold Steve Austin, who's best known for tormenting his boss, Marty was an antihero. The fans couldn't help but cheer for a guy who would snap his opponent's fingers in the ring, and then choke them out with a Chicken Wing submission. It was like rooting for the gangsters in a mob movie.

Marty joining Bullet Club would coincide with Adam Cole's ROH contract expiring, so we put our heads together to come up with a unique way to have Cole's character exit the club and introduce Marty as his replacement. For the first time on *Being the Elite*, we played out a slow burn story line culminating in Adam getting kicked out of Bullet Club and being replaced by Marty at an ROH and NJPW joint show at Hammerstein Ballroom in New York City, called *War of the Worlds*. The story involved Kenny and Adam butting heads, and Kenny hiring Marty to kick Adam out. Loyal *Being the Elite* fans were treated to subtle hints about what was coming and were rewarded with a massive payoff when Marty laid out Adam and joined Bullet Club. The regular viewers of the show definitely saw something coming via the clues, while the rest of the world was completely caught off guard. The episode garnered over 500,000 views, making it our first blockbuster episode and the show can't-miss material from then on. We didn't ask ROH or NJPW permission to do any of this; we figured that if it was good, we wouldn't hear any complaints. With the success of this episode, we learned that not only could *Being the Elite* be a fun vlog and look behind the curtain, but it could also successfully serve as a place to supplement our ongoing story

lines at ROH and NJPW. Marty would become a permanent character on our show, and his quick wit and creative mind would make him a fan favorite.

Back at *WrestleMania*, the very show in which the Hardys made their return, two important people sat in the audience surveying something common taking place among the fans. Those two people were T-shirt buyers from Hot Topic, a retail chain store found in most malls in North America and that specializes in counterculture-related clothing and accessories. They both noticed that the most worn T-shirts at the WWE event were not WWE merchandise but were Bullet Club, Young Bucks, and Kenny Omega T-shirts. Black T-shirts with white font were littered all over the stadium, signifying a disruptive change that had occurred within the mainstream. Following the show, the Hot Topic buyers reached out to Ryan Barkan of Pro Wrestling Tees and asked how they could get our T-shirts into some of their stores. After making a deal with us and NJPW to license our likeness, Hot Topic ordered 2,700 Young Bucks T-shirts, 1,900 Kenny Omega T-shirts, and 7,000 Bullet Club T-shirts to sell in select stores. Once the T-shirts hit the shelves in June 2017, droves of our fans swarmed the stores and bought everything, and I mean *everything*. "Sold Out" signs popped up all over social media. Fans who lucked into getting a T-shirt bragged to their friends, while those who missed out grieved about their disappointment. Of course, all the chatter made the product even hotter. The sales were so remarkable that Hot Topic decided to stock our merchandise in all their stores. In the next three months, it reordered another staggering 25,000 Bullet Club T-shirts, 18,000 Kenny Omega T-shirts, and 22,000 Young Bucks T-shirts. Although the deal certainly didn't make us rich, it was the first time an independent wrestler had ever had merchandise in a major retail store. It also exposed our brand to a much larger audience. With the

success of our T-shirts, Hot Topic decided to also carry Marty Scurll and Cody Rhodes T-shirts, and would eventually carry several other wrestlers' designs as well, giving independent wrestlers a massive opportunity to sell their merchandise to a mass audience.

Meanwhile, the story lines on *Being the Elite* were becoming outlandish (blame this on all the fun we were having!). The once-documentary series was transitioning into a strange combination of science fiction and mystery. Our characters on the show, who had basically become parodies of our real selves, were being handed cease-and-desist letters from an evil character known as the Stooge, who was presumably an office executive from WWE and who ordered us to stop using their intellectual property. At the time, Matt and I used the "Suck It!" catchphrase and hand gestures that WWE's D-Generation X had popularized, and we were looking for a way to shed it from our brand. We wanted to reinvent ourselves, and this was our way out.

As part of our story, the Stooge upped the ante when he kidnapped one of our own, Hangman Adam Page, tied him up and tortured him, and forced him to watch WWE programming (yes, it was getting really meta). Hangman would eventually escape, culminating in the gang saying we'd had enough and that it was time to invade WWE, seek revenge, and take back what belonged to us.

Matt and I had talked about parodying a famous D-Generation X bit done in the late 1990s, where they rode on a tank and attempted to invade *WCW Monday Nitro*, which was WWE's direct competition at the time. We knew WWE was in town for *Raw* at Ontario, California's Citizens Bank Arena, which was only a few miles away from the home where our original backyard wrestling ring was built, and it was time to strike on our idea. Cody and his wife, former ring announcer

Brandi Rhodes—who had also begun to appear regularly on *Being the Elite*—Adam Page, and Marty all agreed to participate. We rented a Hummer limousine that we would ride along to the arena in, then posted a call-to-action message on our social media imploring our fans to meet at the Hot Topic store inside the Ontario Mills Mall, only a few blocks away from the arena. (The same Hot Topic we bought our Generation Me gear from all those years ago.) We figured it would be smart to cultivate a small group of fans, fill them in on what we wanted to shoot, and then go to the arena parking lot and get the couple of shots we needed. I'll admit, we were sort of winging it as we went. While on our way to the mall, I got a FaceTime call from our brother-in-law, who'd beaten us there. "Um. Guys. There's a lot of people here," he said. He turned his phone camera around to reveal a line of people that seemed to go on forever. "Oh. The cops are here, too," he said. He wasn't lying. I could see several police officers standing next to the line, probably wondering what all the commotion was. There must've been over three hundred people there waiting to meet us. Everyone in the car burst out in laughter. I realized that this thing we were doing was more than just wrestling. It was a movement.

We got to the mall and noticed a frenzy upon turning the corner. Hundreds of fans wearing Bullet Club merchandise were screaming and taking photos as cops were trying to calm the large crowd. Hot Topic was overflowing with people. We used the megaphone we brought to try and direct traffic. The Hot Topic employees were flabbergasted but extremely accommodating, and politely asked us to please give them a heads-up next time we decided to do something like this. We took photos, met the fans, and asked them to follow us outside where the Hummer limousine was parked. Several police officers followed as well. We figured we could do some movie magic and

pretend the mall parking lot was in fact the arena parking lot where *Raw* would be hosted just a few hours later. Each of us stood atop the limousine and made rally speeches, tossed out free merchandise, and fired up the crowd. Everyone on social media was following along, and "#BCInvasion" was trending on Twitter. We then drove the Hummer limousine to the arena, where many of the fans met us for a couple of key shots that we needed. Cody, having worked for WWE for so long, led our driver to where we should park. While we roamed around the arena parking lot for our final shots, our old friend and ROH Scrub Room partner Jimmy Jacobs, who was now part of the WWE writing team, burst through the doors and gave us a giant hug. We posed for a group picture using his phone.

"Don't you dare post that, Jimmy! You'll get in huge trouble!" I said to my old friend. "Never!" he replied, laughing. Five minutes later, after we wrapped our shots, we got back into the Hummer limousine and I scrolled through Twitter. I stopped as soon as I saw that Jimmy had posted the group shot we had just taken, and even included #BCInvasion in his tweet.

This guy's got a death wish, I thought. The day had been so chaotic and fun that we sat in blissful silence for a moment to take it all in.

Cody finally broke the silence. "You guys realize we're officially at war with them now, right? This won't go unpunished." We thought he might've been exaggerating a little. After all, we just made an innocent video for our YouTube series. Then again, he did know the company better than any of us.

That night, I posted a *Being the Elite* episode entitled "Bullet Club Invades Raw" that I edited on my phone during the drive home. It would become our biggest episode to date, garnering close to 900,000 views. We were hotter than ever, and this video particularly resonated with our audience.

The next morning, Matt's phone vibrated and lit up with

alarming frequency. It was an email from WWE's senior director of intellectual property claiming unauthorized use of WWE intellectual property. WWE claimed they owned the Too Sweet hand gesture and that we must discontinue use of the hand gesture in the ring and stop selling merchandise using it. It was a cease-and-desist letter, just like the one on our show. Except this one was real.

Going All In

MATT

I was sitting at the dining table of the new home I had just proudly purchased in April of that year. It was a big house (but not too big), in a quiet gated community, surrounded by mostly older neighbors. The backyard was about an acre of mostly dirt, but there was an old, beat-up swimming pool with tons of potential. As a kid I fantasized about one day having a pool of my own, while my brothers and I judged each other's cannon-balls and dives at the community swimming pool. Now this house, *my dream house,* was 100 percent paid for from wrestling. For years, our credit was so bad, it looked like we'd never get cleared for a home loan. But we were finally able to clear away that debt and come out on top. Financially, my life was the best it had ever been.

Dana ran the YoungBucksMerch.com empire out of her new office in our home. Five-year-old Kourtney was ahead of every kid in her kindergarten class, and two-year-old Zachary

was a happy toddler. Most days, the house was filled with danc-
ing, singing, and laughter. Being a father brought me more joy
than anything in my life, including wrestling. Nothing about
being a father was easy, but it proved a welcome distraction
from the world of business and physical strain.

As I sat at the table and sipped coffee, one thing still worried
me: the cease-and-desist letter we had been sent by the WWE.
The letter cited the most ridiculous things as evidence: links to
8×10 photographs of me and Nick on YoungBucksMerch.com
where we're doing the Too Sweet hand gesture, or to T-shirt
designs we hadn't even created that contained the same pose.
The letter claimed we could be held liable for $150,000 in dam-
ages plus other fees. *We asked for this,* I thought, chuckling. *We
poked the bear.* As I sat there feeling confounded, Dana was on
the phone with a lawyer, who'd examined the letter as well.
"Nobody can own a hand gesture," the lawyer told her. "This is
baseless. They're trying to shake you out for everything you've
got. And I've got a feeling these guys are petty, so they're just
going to keep stacking paperwork in front of you." He told us
they basically had no case but asked if we'd be willing to spend
thousands of dollars in court to fight this. I liked doing the Too
Sweet, but I didn't like it *that* much.

My brain kicked into hyperdrive mode, which by now
meant I was going to get creative. I leaked the news online and
contacted Ryan Barkan to get started on a "Cease and Desist"
T-shirt to be added to our Pro Wrestling Tees shop the mo-
ment the news got out.

"It's just a hand gesture," I said to Nick. "We don't need
it. Let's get rid of it and make it part of the story." The news
broke online, and thus the debating began. People sided with
us. Others sided with the WWE. Within twenty-four hours—
whichever way the conversation went—the T-shirt was our

most sold shirt on Pro Wrestling Tees ever. Within a few weeks, it was selling out across the board at every Hot Topic store as well. To add more fuel to the fire (literally), our next *Being the Elite* episode was titled "Hand Gesture," in which Nick and I burned the last remaining merchandise that featured the Too Sweet hand gesture, symbolizing a new era for us.

In large part due to the "us versus them" narrative that was more present than ever, ROH's attendance was up across the board, and nearly every person in the building showed up to the shows wearing our merchandise. After every live event, we would do an off-the-cuff send-off to close the show. Me, Nick, Cody, Hangman Page, and Marty would all enter the ring with a microphone, and deliver an unscripted, not filmed good-bye speech, thanking everyone for coming to the event. It would sometimes last over thirty minutes. We'd finally do one last curtain call, like the actors do after a Broadway show, taking one big bow, to the applause of the audience. Every fan stuck around even after the show was over and clung to every last word we said. It felt like we were the Rolling Stones, and the audience was singing along to every song. We were dubbed the "*Being the Elite* guys," and every bit of content we put out was consumed by our loyal fans. If we had a new bit on a Monday, by Friday there were fan-made signs in the crowd referencing the bit.

During one episode, we introduced the audience to a young former Army National Guard solider named Flip Gordon; we had seen big potential in him and made him a recurring character. He played a sympathetic underdog masterfully, and our fans fell in love with him right away. And the other characters soared as well: Marty's story line was that he was following his true dreams of becoming a pop star, so after every show Marty would sing a famous 1990s pop song and invite the entire

audience to join him. Nobody had the heart to tell Marty that he in fact was a terrible singer. No matter how ridiculous, every bit got over. We just couldn't miss.

After a recent streak of consecutive sellouts for ROH, Cody reached out to Nick and me about an idea he had brewing. We all had momentum, and he could feel it. "I think we should consider running an arena show. I really do think we could fill up ten thousand seats," he said earnestly. In May of that year, Dave Meltzer had replied to a fan on Twitter who asked if ROH could sell out a building with ten thousand seats. Dave replied, "Not anytime soon." Cody then replied to Dave, saying he'd take him on that bet: all he'd need was us on the card with him. This bet clearly was something Cody was serious about, and he couldn't get it out of his head. At the time, independent wrestling was the hottest it had been in its tenure, as record-breaking crowds came out to shows all over the world. Even so, nobody was drawing ten thousand people to a wrestling show, so the idea sounded pretty naïve. Even WWE rarely drew in that many people to an event. But there was a strange feeling of invincibility in us at the time. If ever there was a time to try something like this, it would be now. We told Cody that we were willing to give anything a shot and committed to doing the show with him. By the end of 2017, we were talking about where and when we were going to do it and who would be on the show. We knew we wanted NJPW's involvement, so we discussed available dates with Rocky Romero, who had the upcoming 2018 schedule. We kept coming back to September 1st, which would be during Labor Day weekend. Our initial thoughts were to do the show at the site of the infamous invasion, Ontario, California. Dana, who's a great people person, took the initiative and reached out to Citizens Bank Arena to ask about availability and pricing. They were slammed. So, she contacted the Honda Center in Anaheim, California, where

the NHL team the Anaheim Ducks play. They, too, were over-booked. Our second market of choice was Chicago. Every time we came through the Windy City, the crowds were large and roaring. Also, we figured it was in the middle of the country, so we wouldn't be asking anybody to fly too far to the event. It was then that ROH General Manager Greg Gilleland and ROH Chief Operating Officer Joe Koff approached us about being involved in the show. "We've got a production team who knows how to shoot wrestling, and contracted wrestlers at your disposal," Greg told us. It made sense to us to work with people we trusted. Not to mention, technically, per our contracts, we'd be in breach if we wrestled stateside on a non-ROH, -NJPW, or -PWG show. They insisted it'd be our show and that they were only looking to help. We shook hands and made a deal.

"How do you guys feel about Sears Centre?" said ROH Vice President of Operations Gary Juster. Gary had been in the business for years, most notably working for WCW. He was one of the most respected guys in the office. Truthfully, I didn't even know what Sears Centre was.

"Can it fit ten thousand people?" Cody responded, obsessed with that number.

"Yes. And . . . it's a great building in a nice location . . . and it's available September 1."

"I think we found our building!" I said.

We created a group text chat with Cody that went twenty-four hours a day, seven days a week, spitballing idea after idea. For talent, we insisted that, besides the obvious players like Bullet Club, we needed to get Okada on the show. He was on another level at the time, and his name being attached to this made it cool.

"I think I can convince Stephen to do something," Cody said. He was talking about Stephen Amell, a Canadian actor staring in the CW's *Green Arrow*. Cody had worked and become

friends with Stephen briefly back during his WWE run when Stephen came on as a guest. Needless to say, big ideas always were suggested.

What about Punk? I suggested in the chat. CM Punk had been away from wrestling for years, and Chicago was his hometown. Getting him on the show would make getting ten thousand people a sure thing.

"He'd be great, but we don't need him. The draw is us. The draw is this movement we've created," Cody said.

After a few days of ponderance, our chat lit up again. My sister Teil just came up with a wonderful idea. We're self-financing this show and going all in on making it happen. We should name it "All In," said Cody. It clicked instantaneously. We started coming up with marketing ideas, such as having talent announce they were coming to the event by saying they were "All In." We opened up a Twitter account and sat on it until the time was ready to strike.

I began reaching out to some of our corporate friends for sponsorships. Hot Topic, who obviously loved us, took several calls with me, insisting they wanted to be involved somehow in the show. Cracker Barrel Old Country Store, which was one of our favorite places to eat on the road, began reaching out to me after the free promotion we gave them on social media, leading them to offer to help with this big idea of ours. I contacted TGI Fridays, a restaurant we jokingly dubbed "our favorite Japanese cuisine," after eating countless meals there in Japan, and they too wanted to come on board. I pitched nonmonetary ideas, like them simply plugging our show on their social media channels, providing catering for the boys at the show, and opening up local restaurants for possible meet-and-greet events during the weekend festivities, among other ideas. Dana, seeing that I was overwhelmed on these phone calls, stepped in and started helping me make these pitches. Soon, there wouldn't be a

phone call she wasn't on. She loved the action. She and I eventually came to an agreement with these three brands, and in exchange for their help, we put their logos on our ring skirt and did in-store visits to help drive customers to their businesses.

In Japan, Kenny Omega was having an unbelievable string of matches that were critically acclaimed. He won the *G1 Climax* tournament in the summer of 2016, becoming the first non-Japanese wrestler to do so. His historic night was captured on the cover of the magazines and covered by news outlets all over Japan. By June of the following year, we would stand ringside while he defeated Okada for the IWGP Heavyweight Championship Title, which many people, including Dave Meltzer, called the greatest match ever. At the time, Dave broke his own five-star scale, awarding the match six and one-quarter stars. In my opinion, Kenny had already been the best wrestler in the world for a long time, but now other people were starting to say the same. Finally, on November 5, at NJPW *Power Struggle*, legendary WWE wrestler Chris Jericho shocked the world by appearing on-screen, sparking a feud with Kenny. Chris Jericho, considered by many as the all-time greatest wrestler, showing up on a non-WWE event caused a massive shift in the industry. More eyeballs than ever were tuning in to NJPW. When Chris Jericho and Kenny Omega eventually wrestled in Tokyo Dome at *Wrestle Kingdom 12*, on January 4, 2018, business went up drastically. According to *Wrestling Observer Newsletter*, NJPWWorld.com saw a 100,000-subscriber increase, which most people credit to this match.

On January 10, 2018, one person after another, including Stephen Amell, who Cody convinced to participate, tweeted they were All In, on September 1st. We were vague, and left out the location of the show, hoping fans would stay tuned in. The interest was high, and fans were hungry for more, even though the show wouldn't be for another eight months. There

were also critics. So many fans and journalists doubted we'd ever be able to sell ten thousand tickets. "They could only do this with CM Punk" was most commonly said among those who doubted. The ones closest to me always encouraged me, even when I had doubts of my own. "Have more faith in what you guys have built. You're going to sell out," said Dana. My parents would constantly echo her sentiments.

Every week, we'd announce a new talent, building anticipation. Finally, on March 5 on an episode of *Being the Elite*, we announced the location of *All In*. I don't have the stats, but I'm pretty sure that the airlines saw an increase in flights to Chicago directly after the announcement.

As anticipation and excitement built for the next thing in our careers, we had to say good-bye to an important part of our past. We were given the unfortunate news that American Legion Post #308 in Reseda, the very building in which we'd molded ourselves into wrestling stars, had been sold by its owner and would be demolished by its new owner. On April 20, 2018, at *PWG All Star Weekend*, we would wrestle our final match within those walls, before giving an emotional farewell speech. Not usually the sentimental or emotional types as far as wrestling goes, we really struggled with the thought of shows no longer being held in that venue. I guess we just assumed it'd be around forever, for generations of wrestlers to enjoy. It wasn't just a building, it felt like we were losing a part of ourselves. As we drove away from the parking lot one final time, stopping through Taco Bell to keep tradition, we felt like we'd lost a family member.

On May 18, we held a press conference at the Pro Wrestling Tees store in Chicago to promote the tickets on sale for *All In*.

That evening, we would put ten thousand tickets up for sale to the general public. "I think we'll sell six thousand tomorrow," I'd said to Marty the night before.

On the way to an ROH show we were wrestling at later that evening, we split up the group into two Ubers—with me and Dana in one, and Cody, Nick, Flip Gordon, and Adam Page in the other. On the drive over, the ticket on-sale began, and I noticed the amount of traffic online was tremendous. "I'm in a virtual waiting room," I said to Dana, who'd pretty much worked every day with us, every step of the way, since the concept of *All In* started. "Imagine if we sold out today. How crazy would that be?" I joked, putting away my phone. Several minutes later, I checked back on Twitter and my mentions were going wild. Fans were claiming a sellout, but it seemed too good to be true. I finally accessed the front of the ticket line and clicked the "Best Available Seat" option. "No Seats Available" came back on my screen. I looked at Dana with big eyes and said, "I think we sold this thing out."

We got out of our Ubers and ran toward each other. "Guys, I'm pretty sure we're sold out!" I yelled at Nick and Cody, who doubted me just as I had doubted myself minutes before.

"Let's not get too excited until we hear from Gary," Cody said. Gary Juster was working firsthand with Sears Centre's ticketing team. At that moment, Gary approached us, grinning ear to ear. "Gone. They're all gone," he said. "The whole allotment. Congratulations!"

Cody, Nick, and I hugged each other, and chills shot down my spine. "Oh my God, we did it," I whispered to them, my eyes tearing as we huddled up. Cody was in complete shock and couldn't even speak. Nick, on cloud nine, kept shouting, "Hell yeah!" Dana grabbed me and held me tight, saying into my ear, "Congratulations, baby!"

We had sold ten thousand seats in less than thirty minutes.

It was the first non-WWE professional wrestling card in the United States to sell ten thousand tickets since 1999, when WCW did it. But we—an independent wrestling troupe—did it in twenty-nine minutes. This was a full-blown movement. If ever there was a moment we realized this movement was becoming bigger than us, this was it.

Following the huge sales at Hot Topic, we were contacted by one of the store's biggest vendors, Funko, who wished to go into business with us. Funko is a company that manufactures licensed pop culture collectibles; their most popular items are little bobblehead-looking vinyl figures of famous pop culture people and characters. We cut a licensing deal with them to create Young Bucks, Cody Rhodes, and Kenny Omega Funko Pop figures. In June 2018, continuing our hot streak of events, the first of two Young Bucks Funko Pop figurine variations dropped in Hot Topic stores, making us the very first non-WWE wrestlers to achieve such a thing. It was yet another feather in our cap. The figurines were created doing our trademark Young Bucks pose, and had our likenesses: Us wearing our gear, with tassels and familiar color schemes. Nick with his trademark headband, and me with my signature sideburns. Watching Zachary and Kourtney play with a toy of me and their uncle Nick was a moment I never thought I would experience. It brought me back to the days of my childhood, when me and DJ would sit and play "Barbies and Hulk" on the carpet. I would go out of my way to take the kids to the mall and have them spot my toy on the shelves of Hot Topic. "There you are, Daddy!" screamed little Zachary.

With all the success we'd had in the previous two years, our ROH contracts were set to expire on January 1, 2019, but this time we knew we were in the driver's seat. We still had several months left on our deals, but it was time to start planning next steps. We took a meeting with Greg Gilleland and Joe Koff, an-

ticipating a massive offer in order to keep us around. We really had no intention of leaving, so long as the offer was right. Also, we felt like we'd proven ourselves from a creative standpoint, being the minds behind the hottest ROH angles of the past couple of years and helping supplement ROH story lines every week on *Being the Elite*, making their stars shine even brighter. So, along with a financial offer, we fantasized about possibly being offered a creative position in the company.

The initial offer came, and it disappointed us, to say the least. For a small company like ROH, it was still good money, but it wasn't close to what we expected. We weren't on the same page; we weren't even reading the same book. When Nick and I mentioned the idea of helping with the creative process, we were quickly shut down as well. "We couldn't have our talent making the creative. We've seen what happens when companies go down that route," we were told. Historically in wrestling, whenever the wrestlers were in charge, because of selfish reasons, they'd usually only book themselves as the main stars, which would become troublesome. More often than not, when the talent booked the shows, it didn't do good business. Still, we said that we felt like we had more than proven ourselves to be capable, and we were upset that they didn't have more faith in us. It really hurt our feelings.

For the very first time since we had been with ROH, we imagined a life without them and thought that maybe it was time to look elsewhere. We were happy, but we knew this was the year to cash in on all our hard work. If we didn't get paid here, *now*, our time might pass and we'd regret it the rest of our careers.

We briefly considered going back to the independents, where we hadn't regularly been for the past few years. Most of the indie's biggest stars had been signed away, so there'd be a massive demand for us. "Imagine the amount of merchandise

we would move on the indies!" Nick said. He wasn't wrong. Still, I was thinking bigger. "Should we at least talk to WWE, and see what our street value is?" I asked him. But even the mention of that seemed weird. We'd basically built an entire career on not working there, at the same time giving hope to wrestlers all over the world to carve their own paths. We worried about looking like sellouts. Also, the notion of WWE ruining the brand and legacy we had worked so hard to create concerned us. And obviously, there was the elephant in the room: the fact that a year ago they had threatened legal action against us with that whole cease-and-desist thing. But business was business, and it wouldn't hurt to at least have a conversation. Besides, it could help goad negotiations elsewhere.

"Hey Matt. It's so nice to finally talk to you," WWE's executive vice president of talent and live events and Hall of Fame wrestler Triple H was on the line. It was like the universe had read our minds. It seemed surreal that we even took the call. A few days prior, in a complete coincidence, a mutual friend had said Triple H had been wanting to talk to us. It was like his ears were burning when Nick and I had contemplated reaching out to WWE after ROH negotiations went badly.

"God, that guy is nice," I said to Dana after hanging up. We had spoken for close to an hour, and Dana was in the room for the entire phone call, likely observing my face light up whenever he said things that interested me, which was often.

"Yeah, he is," she said. "He said all of the right things."

Triple H talked about how we could benefit the tag team division by listing all the great possible matches. He complemented us on how big we'd made our brand without the machine but talked about how the WWE could make us into

global stars. He also inquired about Kenny, saying he'd want all three of us because it would make the biggest impact.

Online, the narrative was that Triple H and the Young Bucks were sworn enemies. It'd be like if the New York Yankees and the Boston Red Sox were having lunch together. By the end of the phone call, we had already planned for the next one. I couldn't help but feel a bit promiscuous. It was like I had just started a secret affair. To complicate things a bit more, Triple H wouldn't be the only person who wanted to speak to me discreetly.

My friend Tony Khan is the co-owner of the NFL Jacksonville Jaguars and Fulham football club in London. He'd like to talk to you if you have a free moment. I reached out to your brother but never heard back.

On July 3, 2018, a mutual friend wrote me this email, and I opened it poolside while watching my kids swim. I'd never heard of Tony Khan but was well aware of the Jaguars, and so I was open-minded. Tony's phone number was provided in the email, so I thought it'd be harmless to shoot out a text and introduce myself before jumping back into the pool. I wondered what someone involved in the NFL wanted to do with me.

A couple of hours later, I grabbed my phone and went to place a phone call to Tony Khan. "Ugh. It's your day off," Dana told me. "Do this some other time." She was always trying to protect my free time—our free time—and for that I'm thankful. But on this occasion, I told her that I had a hunch about this and that I needed follow up on it. "Okay, but I want to be on this call, too. Come to my office," Dana angrily suggested.

On the call, Tony told me and Dana to check our phones for texts he had just sent. It was a video of me and Nick making our entrance at an NJPW show in Long Beach, Too Sweeting a

fan wearing glasses, a leather jacket, and a Bullet Club T-shirt. "That's me," Tony said, referring to the fan. "We've technically already met. I've been watching you guys since the Dragon Gate days, and you're my favorite tag team in the world. And Kenny Omega is my favorite wrestler in the world. The Elite is the best thing in the wrestling business." Tony was clearly a passionate fan and seemed like a good dude, but I wondered where this conversation was going. He finally got to the point: "Okay. I've been fantasy-booking wrestling cards since I was a kid. My dream has always been to one day run my own wrestling company. I heard you guys will be free by the new year. I believe right now the market is ready for something new."

I looked at Dana and rolled my eyes. Being in the business as long as I have, I'd heard this story too many times: a new billionaire investor wants to get into the wrestling business. He has grand visions. A master plan. But then Tony went into detail about his relationship with several television bigwigs including the president of TNT and TBS, Kevin Reilly. TNT and TBS, both channels started by billionaire Ted Turner, had a rich history in wrestling, having hosted WCW television shows from the 1990s through 2001. The channel was now owned by WarnerMedia, the media conglomerate. Tony told us how he wanted to go right over to Kevin Reilly and make a pitch to put pro wrestling back on TNT, and how now was the perfect time to do it. I rolled my eyes back again like I was the Undertaker, but there was no denying Tony's try-or-die attitude. I told him we could continue the conversation another day.

After hanging up, I did what I did after every time I spoke to Triple H: I texted Nick and Kenny and told them about everything. They'd heard a story like this a million times, too, but Kenny particularly was curious. Like us, his NJPW contract was soon expiring, something the three of us purposely planned. We knew that no matter what, the Elite was most

valuable as a unit and that whatever happened next, we would go all in together.

The next day, the entire family celebrated the Fourth of July in Nick's backyard. As we swam and barbequed, the joyous sound of kids' laughter pervaded every square inch of his property from a total of nine grandchildren between my three siblings and me. Malachi had matched us with a boy and girl of his own, Paisley and Hezekiah, while DJ's three girls looked out for all the little ones.

In between splashing with the kids in the pool, I shared information about the phone call I'd had the day before with everyone, expressing my skepticism but also the rush of optimism I continued to feel. "You're wasting your time. I'd cut it off immediately," Nick said. This was the basis of our relationship. I'd try to be the positive one while Nick played the role of the realist who brought me back down to earth. As we passed around burgers and hot dogs, sitting in water-soaked towels around the backyard, the rest of the table agreed with Nick. Except one person. "I don't know, Matty. It feels like there's something to this," our mom said. "I've just got this feeling. I'd follow up on this. The Lord has always told me you'd be part of something special." She and I often shared a spiritual outlook, and I felt comforted that she, too, saw something unique in this arrangement. While everyone else moved on to the next topic, I bit into my hamburger, and let my imagination run wild. *What if there is something to this?* I thought to myself. I wasn't done talking to this Tony guy.

"Hypothetically, you start this wrestling company, what would you call it?" I said to Tony on the phone one afternoon while next to Dana on my back patio.

"It's gotta be three letters, like WCW or WWE," said Tony, who was a massive WCW fan back in the day. "My first idea is to call it World's Best Wrestling. WBW!"

I looked at Dana and mouthed, *No way*. I had a different idea. "With the success of the Elite brand, I think people would gravitate more toward this new project if Elite was in the name," I said to Tony.

"What about World's Elite Wrestling? WEW?" he countered. I didn't hate it, but I wasn't in love with it, either. We agreed to make it the working title for the interim. We'd soon learn that WEW was already taken, so we'd have to go back to the drawing board. In the meantime, I pitched to Nick and Kenny the idea of all of us being more than just wrestlers if we indeed went through with Tony's plan. Tony was a bit shocked. "I didn't think you guys would be interested in helping with the creative. That would be awesome!" he shouted. It made me feel so valued. Someone out there indeed appreciated our creativity. He then complimented Dana on everything she had done with the Young Bucks Merch brand and asked if she, too, would be interested in coming onboard to help with the marketing and merchandise. Dana was a bit taken aback, not realizing this Young Bucks Merch thing she'd started just for fun would one day turn into a real job offer.

I still was unsure if any of this stuff I was discussing with Tony was real, or just a pipe dream. I didn't know the guy personally, and there was a lot riding on our next decision. Our careers and, most important, the welfare of our families was on the line. I continued talks with Triple H, who was as smooth as silk, getting me to agree to schedule our next calls before the current ones even ended. One day out of the blue, while on another long call, he made an offer to all three of us that made my head spin. It would start us at $500,000 each, guaranteed in the first year. I knew what wrestlers were being offered, and

this wasn't it. This was more than triple what most starting wrestlers got on the main roster. The offer would be the same for myself, Nick, and Kenny. Right then and there, we saw our street value. We realized no matter what, we were more valuable than what ROH was offering, so either way it was time to leave. Coming to grips with the fact that our ROH careers were ending was emotional for us. It'd been our home for so long. But things had definitely escalated, and we had to make the best decision for our families. I planned another phone call with Triple H, but this time Nick and Kenny wanted to be in the room with me. I couldn't help but think about the very real possibility of us all going to WWE. But I felt very conflicted. There was just something about the way Tony Khan spoke to me about his dreams. Where Triple H was charming, charismatic, and said all of the right words, talking to Tony felt like I was talking to myself. He was a dreamer, and he wanted to change the industry by supplying a new alternative. Tony had even somehow already convinced TNT to take a couple of meetings with him so he could make his pitch. The guy was a go-getter. Even though this plan seemed less safe for us, he had my undivided attention. So, on the same day the three of us would talk to Triple H, we decided to do back-to-back phone calls with Tony Khan. By then, I had convinced the guys to at least hear both men out.

The three of us gathered around the speakerphone in a tiny hotel room, and I introduced Kenny and Nick to Tony, who called us first. Tony went right into his fast-talking, long-winded pitch he'd given me a couple months earlier, which was likely the same pitch he gave to TNT. This conversation wasn't about money, although Tony had relayed to me in an earlier phone call that he'd take care of us and our families. This conversation was about creativity and collaboration. We discussed possible story lines and dream matches, and because the call

had taken a productively creative turn, we all lit up. Tony talked about wanting us to be more than just wrestlers in this company. He conveyed the importance of our health and keeping us on a light schedule. That was music to our ears, as our bodies were pretty banged up from years of abuse in the ring. After a long conversation, Tony became completely transparent with us. "Guys, I'm busy," he said. "If you guys told me right now to walk away, I'll walk away. No harm. I can't do this without you three. I need the Elite, or this project doesn't work." We thanked him for the conversation and then hung up the phone. I looked at Kenny and Nick, who were smiling. "That just felt right," Kenny said. I believe it felt right to all of us, but the choice wasn't yet clear. We still had to talk to Triple H.

"There's a lot of potential stories with the Bullet Club thing, obviously," Triple H said on the call, referring to our old comrades AJ Styles, Karl Anderson, Luke Gallows, and Finn Balor, who were all achieving success in the company. Triple H offered to fly to Japan, or to fly us to WWE headquarters in Stamford, to sit with us and collaborate on ideas with Vince McMahon. We brought up the issue of the schedule, which was our biggest concern with WWE. Being family men, Nick and I weren't interested in being gone all of the time. We'd missed enough time with our families as it was. We were already burned out from years of traveling the globe and heard horror stories about the WWE schedule being even worse. Kenny also wasn't interested in living out of a suitcase and beating up his body any more than he needed to. His last two years of big matches in Japan had really taken a toll on his physical and mental health. He'd confide in us that fans' expectations, along with his own, were going to eventually kill him if he didn't leave NJPW in time. He needed to move on to something less taxing, not something even more so. But Triple H had an answer for everything and genuinely knew

how to put us at ease. He said they'd be willing to adjust by giving us special perks like first-class seats on airplanes and a more limited schedule. We thanked him for his time and hung up the phone. He seemed honest and extremely interested in acquiring us, no matter what it took.

The call went as perfect as a call could go, which really didn't make things any easier on us. We sat in the room and began weighing our options, occasionally laughing at the ridiculousness of it all. No matter what, Kenny knew his days in Japan were coming to an end. On top of everything, he felt completely disrespected by NJPW, having come off of two of the biggest box office years in company history and being offered much less money than he expected. So the decision was between two things: Go do what everyone else predictably does and work for the established powerhouse WWE as strictly wrestlers (and make more money than we could've dreamed of). Or, take a gamble on this new unknown project, where we could be more than just wrestlers and remain true to ourselves and our brand. In a moment I'll never forget, Kenny and Nick both gave me a knowing look. Deep down, we were rebels. We were disrupters. We were unpredictable. We never wanted to do what everyone else did. Right then and there, the three of us committed ourselves to this new project. I sent Tony a text message that simply read, We're in.

Tony continued taking meetings with TNT, speaking ardently to a room full of executives about his vision for a still-unknown wrestling show without a single wrestler currently under a contract. He figured we could start a wrestling company in the new year, book a couple of massive pay-per-view events, and by the fall have a show ready for weekly television. It all sounded crazy and impossible, but Tony had a way to convince you that anything was possible. While Tony was doing his thing, it was time to get our team together. We hopped into

a van with Christopher Daniels, Scorpio Sky, and Frankie Kazarian, who were now calling themselves SoCal Uncensored, or SCU for short. We'd put them on *Being the Elite* as a heel group that trashed every town they went to, and much like everything else we did on the show, it caught on. Next to Kenny, they were our closest friends in the business, and we couldn't keep tight-lipped about our new project. Both Frankie's and Chris's ROH contracts were up the exact same day as ours, and Sky was working on a per-night agreement. "We'll follow you guys to the ends of the earth," said Chris.

Next, I called Hangman Adam Page and told him everything. Page had really started to come into his own after spending a lot of time in Japan and working on becoming a more solid wrestler. I knew you could build a company around a young, hungry wrestler like him. Page had made such a huge impression on me the past year, turning in such amazing performances no matter if we were wrestling or just filming a silly bit. His commitment to everything he did made him so valuable, and I knew he'd be possibly the biggest star of any of us one day. Unbelievably, his contract was also expiring the exact day as ours. I learned that he, too, was also speaking to Triple H, and his anxiety about his future was through the roof. "If this is real, you know I'm with you guys," he said.

Next was Cody Rhodes, who we'd recently bonded with working on the *All In* show. Between planning for the show and our future, we were all stressed-out messes. Cody, whom I knew the least of everyone else in the group, shared that his ROH deal was also up around the same time as ours and agreed that whatever we did we'd be more powerful as a unit. He was a bit more skeptical than everyone else, seemingly changing his mind every day about what he was going to do next. One day he was staying with ROH, while the next he was considering a WWE return. Then, we'd get a message out of the blue saying

he was coming with us no matter what. This upcoming change was difficult to deal with for everyone. I'd seen the work Cody had done since his WWE departure, and I knew that whatever he touched turned to gold. He was a hype man, and one of the best promoters I'd ever worked with. He was the wildcard, the one missing piece to the puzzle.

I set up a meeting in London to finally talk in person with Tony Khan. Nick and I hopped into a black Escalade where a young, thin guy with short, black hair, and thick glasses, and wearing a Young Bucks bomber jacket, met us with hugs. "It's so nice to finally meet you guys!" he yelled like we'd known each other for years. He asked his driver to take us to Craven Cottage, Fulham Football Club's outdoor stadium, which his father owned. He figured it'd be fun to give us a tour of the place. I assumed he wanted to prove to us that he was the real deal. "You guys watch football?" asked Tony, referring to what we Americans call soccer. "Yeah!" I said (I didn't actually, though). He then gave us the grand tour, finally concluding at his dad's fancy office. As we roamed around the empty stadium, we all fantasized about one day running a wrestling event on the field and imagined where we'd put the stage and the ring. We talked about what part of the year would be best to run a show there. We debated how many people we could fit on the field and in the stands. Looking back, it was the first time we discussed the logistics of putting on a wrestling show, the first of many more to come.

A Road Never Traveled

NICK

As *All In* approached, *Being the Elite* was the main platform that told each match's story. We didn't have a live weekly cable show to hype the event, so we used the tools we did have. Every week, our loyal audience of 200,000 to 300,000 fans watched the show, anticipating the next match announcement or detail about the event. People were calling it "the Biggest Independent Wrestling Show Ever."

Since the show had sold out so quickly, fans begged us to find another way to watch it. With ROH's connections, we secured a deal to air it on pay-per-view in the United States, and on a platform called Fite TV, which would stream the show in multiple other countries. Joe Koff helped us make a deal to air our preshow, *All In: Zero Hour*, on WGN America to serve as an infomercial of sorts for the pay-per-view itself.

On the card, we had booked both young, unknown wres-

tlers and big players: Okada, for the hardcore fans. Actor Ste-
phen Amell to draw mainstream attention. And finally, Rey
Mysterio to appease the more casual wrestling fans. There was
a little for everyone. But mostly, people wanted to support us
and our crew, whom they'd fallen in love with. They wanted to
make this show a success because they felt personally involved
and invested in our lives and they knew how important this
was to us. We were transparent with them every step of the
way, sharing our successes and failures the past couple years
on *Being the Elite*, so there was an emotional attachment. Cody
was right. We didn't need a huge name on the show to draw a
huge crowd, or to create interest. We just needed each other.
We were the draw. Several wrestlers committed to doing the
show with us without even negotiating their booking fee. They
just simply wanted to be part of history. "I just want to be in
the building," said Jimmy Jacobs, who was now working the in-
dependent scene after his WWE writing career recently ended
suddenly after he posted the selfie he took with us during the
#BCInvasion.

One afternoon on a long bus ride between shows, Marty
came up with a great idea for the show involving Chris Jericho
making a surprise appearance. We'd spoken to Chris earlier
in the year about doing a spot on the show, but at the time it
seemed like he had a loyalty to Vince McMahon and WWE.
Months had passed, so we figured we'd contact Chris and
gauge his interest. Chris, always having his finger on the pulse
of wrestling, knew that being involved could be great for him.
I don't know what exactly changed his mind, but he finally
agreed to do the show.

Except there was one problem. Chris was also in a rock
band called Fozzy that was in the middle of a tour. He already
had a gig booked the evening of September 1 in Kansas City.

The only way Chris would be able to make both shows is if he did the spot and then got directly on a plane. A commercial flight wouldn't work, and we knew only one person who likely had a private jet we could use. We told Tony Khan how important it was to have a huge surprise on our show and called in our first major favor.

"I'd be happy to fly Chris on the jet," Tony said, to our relief. Chris was aware of Tony Khan, having already taken a couple of phone calls to listen to Tony pitch the new project he wanted to start in the new year. Tony knew that getting a major player like Chris Jericho would be beneficial long-term, especially when dealing with television networks.

Between announcements for the star-studded Starrcast convention that podcast host and entrepreneur Conrad Thompson had set up to piggyback our event, and *All In* match announcements, fans hung on to every word we put out on social media. The world buzzed, counting down the days to our show until the festivities finally began. As we arrived at the hotel hosting the four-day event, a Hyatt Regency in Schaumburg, Illinois, the crowd of fans reacted to us like we were their best friends whom they hadn't seen all summer. In recent years, we had definitely gotten over with the audience, but this was next level. As we walked the lobby, people screamed and clapped, thanking us for helping organize the weekend. Fans ran up to hug us and share a quick chat about how much this weekend meant to them. There was a sense of community in the air, like everyone knew each other, as chatter filled every room I walked into. Everyone seemed in high spirits, like we were all celebrating a holiday together, or the same feeling you get when you walk around Disneyland. More than half the fans were wearing Bullet Club and Elite merchandise, while many cosplayed as their favorite wrestler. I'd turn a corner and see a boyfriend

and girlfriend couple wearing spandex with tassels, dressed as us, and behind them would be a person wearing a plague mask, just like Marty. It felt like San Diego Comic-Con, but instead of Marvel superheroes, we were the attraction. We hosted a slew of meet-and-greets, and many of the fans had tears in their eyes as they told us how we helped get them back into being wrestling fans. They shared stories about how watching *Being the Elite* helped them with their mental health. Some told me that our videos gave them something to live for, and how our content gave them an escape from their everyday problems. We learned that we were changing people's lives firsthand, and that meant so much more to me than money or a championship title. Even the supporting characters who'd appeared semiregularly on *Being the Elite* had gigantic lines to meet them. Dana ran her own Young Bucks Merch booth, virtually selling out of every item on the first day. Our dad, who ended up supplying original soundtracks for the show, even got to host his own live concert at Starrcast, where hundreds of fans sang along to his original music. He'd sacrificed his dream of being a musician at a young age in order to be a father, so it felt good to pay him back for everything he'd done for us. Marty hosted live karaoke to a packed room of screaming fans.

The night before the show, we entered Sears Centre to check out how the load-in was going. My breath was expelled from me as soon as I saw the gigantic stage and LED screens. I'd only seen the concept art of the set on a computer screen beforehand, so seeing it in person was surreal. We sat in the stands staring at the entire setup, fantasizing about what the next day would bring us. In a way, I hadn't felt an anticipation like this since the arrival of my children Alison and Gregory. Much like watching the bump in Ellen's stomach grow month after month, I watched this show get bigger and bigger. The

next day, I'd finally get to meet this baby I'd helped create. Marty, Adam, Cody, Matt, and I sat in silence, reveling in the moment.

The next morning, on show day, Matt received a text message from Triple H wishing us luck and asking us to call him after the show, when we had a chance. Matt had been putting the conversation off, but it was probably the right time to outright decline the WWE offer. We'd made a commitment, and we weren't planning on going back on it.

THE ELITE! THE, THE ELITE! SUPERKICK PARTY!

My dad's introduction music for *Being the Elite* blasted through the speakers at Sears Centre as more than ten thousand fans sang along. As we arrived onstage, Dad cried as he held my mom in the VIP box, later telling us that this particular moment brought him back to the very beginning, when he first built us our wrestling ring, all those years ago. It had all paid off. These weren't just ten thousand wrestling fans. These were ten thousand of our people. I looked out, all the way to the top of the bleachers, and had a difficult time holding tears back. Despite all my experience being on stage and performing in front of sold-out shows around the world, nothing would've been able to prepare me for this. In a business that is sometimes built off of bloody, violent feuds, I felt nothing but unequivocal love.

Pro wrestling is notoriously known as a very selfish business, but on this night the locker room united as one big team. As each wrestler came back through the curtain, they were met with applause and high fives. Everyone who was part of the event wanted to make the show a success. We stood and cheered like fans as Stephen Amell dove and crashed through

a table. We held our breath when Hangman Adam Page tossed Joey Janela off the stage. Some of the wrestlers had tears in their eyes, much like many of the audience members, when Cody won the NWA World Championship, just like his father did so many years before.

Midway through the match, we snuck Chris Jericho into the back, where he'd hide out until his big surprise. He'd come to the ring during a blackout dressed in luchador Pentagon Jr.'s attire and mask, switch spots with him, and then surprise and attack Pentagon Jr.'s opponent, Kenny Omega, revealing it was him all along. Sears Centre exploded when Jericho appeared at a non-WWE event in the United States for the first time in more than twenty years. This moment would solidify this night as an unpredictable, can't-miss masterpiece.

After Marty Scurll and Okada absolutely tore the house down, our main event match was cut short. The prior match had gone way over time, and we were forced to trim a twenty-eight-minute match into an eight-minute one. So, Nick, me, and Kota Ibushi wrestled Rey Mysterio and highflying luchador wrestlers Fenix and Bandido in one of the shortest, fastest, high-impact main event matches in wrestling pay-per-view history. I was devastated, though, because I had to rush every movement I had planned for months, but once the bell rang and the match ended, all of those feelings of disappointment went away. We grabbed a microphone and called everyone we loved into the ring to join us. Our families entered the ring, along with the rest of the crew, as we spoke to the audience and thanked them for making this night possible. By the end, not a single person in that building left, even though the pay-per-view had ended nearly a half hour earlier. I wished we could've held that moment forever.

The next day, riding the high from the greatest night of our careers up until that point, we were led into the lounge of

a private jet airport in Chicago by Tony Khan, where we saw a dark-haired, older man with a stylish mustache sitting at a long table. One of the wealthiest people in the world, Shad Khan stood and greeted us with a huge smile. He was so warm and friendly. He'd stopped in Chicago in between business trips just to meet us. In the room were Tony, Matt, Dana, my parents, and DJ. Brandon Bogle (also known as Brandon Cutler) also sat in with us. He had left the wrestling business more than seven years before, but saw the exciting things happening in wrestling and decided to fly himself into Chicago to help out at *All In*. We sat for a couple of hours and got to know each other. Shad congratulated us on the success of our show, and right then and there we started planning on doing another show in Chicago a year later. Looking back now, I think this meeting was Tony's way of proving to us further how real this all was to him. By this point, we had a lot of confidence in Tony, but meeting his father certainly put us even more at ease.

We had a plan, but we still didn't have a name for this project. We thought of just calling it ELITE and giving each letter in the word a meaning. We even thought of just calling it Elite Wrestling, but Tony really preferred having three letters. Elite Wrestling Association, or EWA, was another suggestion. Nothing really clicked. Finally, one day during a long conversation in our group chat, Matt had an idea. What if you took the two brands, All In and the Elite, and merged them into one? All Elite Wrestling. AEW. Putting two vowels together seemed strange. But as the hours passed by, it started growing more on all of us. On September 5, All Elite Wrestling and AEW trademarks were filed.

In mid-September, Matt received another call from Triple H. We'd gotten so preoccupied for a while between running the show and planning with Tony, we hadn't really had a chance to let him know we were going to pass on the offer. Before Matt

could even tell him the news, Triple H made an offer that was even bigger for the three of us. It was a three-year deal worth millions, for each of us. On top of that, we were also given the option of signing, and if we weren't satisfied with how things were going, we'd be given a special clause in our contracts that would allow us to leave the company in three months, no questions asked. He also inquired about making a deal to put *All In* on the WWE Network. His dream was to put all of wrestling in one destination, to make the lives of fans easiest. It was crazy. We never once asked for more money or more perks. These things were just offered to us over time, the closer we got to the ends of our contracts. WWE seemed extremely interested in having us on their team—or were these attempts at stopping a movement before it really got started? Whenever our offer got better, we would chat among ourselves, wondering if maybe they knew about our little secret. Despite the enticing offer, at this point we never even gave it a second thought. We just had the most fun, rewarding time of our lives running our own show, and there was no going back. The days of us being just wrestlers were finished. Without being able to tell Triple H everything, which was difficult to do, we respectfully declined his last offer. I think he thought we were a sure thing, and that we were just playing hardball, so he was a bit surprised. He took it gracefully, though, and was nothing but pleasant afterward.

The next thing we did was sit down with Joe Koff and Greg Gilleland and let them know that we would not be re-signing with ROH after January 1. This wasn't easy. ROH was our home off and on for about ten years, and the last couple of years was the most fun we'd ever had. They gave us the creative freedom to book our own angles, to shoot whatever content we wanted for *Being the Elite*, and to pretty much do whatever we wanted in the ring. Not to mention how much they helped us with *All In*. Our leaving was a tough pill to swallow, for Joe

especially, who teared up we told him. He told us that this was the risk he took letting us do *All In*, but he didn't regret it. After we got a taste of what it was like, he believed we would need more. I don't think he was wrong.

To build speculation and drama, we started an angle on *Being the Elite*, where a timer was placed on the screen set to expire at midnight on December 31, 2018, the exact time most of our contracts would also be expiring. Fans buzzed, predicting and speculating what would happen the moment the timer went to zero. Most fans expected we would be announcing we were signing with WWE. Others held on to hope of us running another show in the future. Whatever we were doing, we were "sticking together," according to Cody's post–*All In* speech. In mid-October, we were finally convinced Cody was coming with us, although he would flip-flop a few more times until finally telling Joe and Greg he, too, would be leaving ROH. He knew our next move was important, and I think he struggled with it being the right one. Tony had an idea just what that first move should be. From the success of running Labor Day Weekend, he came up with the idea of running our first show on Memorial Day weekend, on May 25, somewhere on the west coast. He felt like the west coast was a largely untapped market, and we'd have from January to May to plan and execute the event. We all agreed that it was a great idea.

Although we'd strayed away from most things Bullet Club by this point, we were still affiliated with the club. We'd still travel to Japan representing the club, but truthfully, we had become pretty divided. It was as if there were two stables: Bullet Club Japan, and Bullet Club USA, and the latter version was by far the more popular of the two, which might've caused some animosity among the members. On October 30, me, Matt, Kenny, Cody, Adam Page, and Marty Scurll announced that we'd be leaving Bullet Club. Marty was in a tough spot,

being locked into a longer deal, and he would have to be left behind. Even knowing the impending change, he still went along with this. Leaving Bullet Club was more difficult than I thought. We had major history within the group, and our time in the faction really made us the stars we were today. All of this sudden change was taking a toll on my mental health. At times, I hoped we weren't making a huge mistake. We'd worked so hard for so many years to get to this place in our careers, and I didn't want to do anything to ruin any of this. I was so anxious about this next move, I developed insomnia, staring at the bright red numbers on the clock on my nightstand all hours of the night. *Should we just stay put? Or should we have just cashed in with WWE?* I'd agonize while I tossed and turned. My brain was elsewhere while the kids fought for my attention, as we all sat and played on the hardwood floor. But the fact I wasn't doing this alone put me at ease. My big brother and all my friends were by my side. When I felt like I was about to break down, someone would be there to make me feel better, reassuring me that we were doing the right thing.

On November 5, 2018, I received several text messages that read, The filing of the AEW trademarks are all over the internet! Everyone was panicked. A reporter had spotted the trademark filings, which were attached to Tony's name, and several news articles were written about it. We didn't want our big news getting out just yet, and certainly not like this. Our timer angle on *Being the Elite* needed a huge payoff, and this was spoiling it. We remained quiet, which built speculation even more.

In December, Kenny, Matt, and I scheduled a meeting with Rocky Romero, head booker Gedo, and two other NJPW executives. A couple months prior, we flat-out told Rocky we would be leaving ROH and hoped to continue working with NJPW in the new year. We mentioned that once we had more information, we would pass it along. Now was that time. Matt

and I told them we were not going to WWE, but instead we'd be working on a new project in the beginning of the year. They were the first ones we officially spoke to about AEW. Kenny let them know he, too, would be working on this project with us and would not be re-signing with NJPW. That seemed to deflate the room. We expressed our interest in collaborating together, hoping this wouldn't be the end of our relationships, and told them about how a relationship where we shared talent could be beneficial to everyone. We didn't even rule out the three of us continuing to come work in Japan on a limited basis. We promised we'd even include that in our new deals. We held up that promise.

Later that month, we stood in the ring at the end of *Final Battle 2018*, with Cody, Marty, Page, and SoCal Uncensored in New York City at Hammerstein Ballroom, a building we'd created so many wonderful memories in, and said good-bye. While speculation was growing wildly everywhere and nobody knew exactly what we were doing next, this good-bye marked the ends of most of our ROH careers. Prior to the event, almost all of us who stood in the ring had given notice to ROH, so rumors were already running rampant about a mass exodus. We were the last ones in the building that night, even staying as the ring crew tore down and swept the floor. In the middle of the room sat a big pile of colorful streamers the fans threw into the ring during our match entrance earlier. I kept my eye on it, as a staff member wearing a black T-shirt with "ROH CREW" on the back, grabbed the pile and placed it into a trash bin. We grabbed our roller bags and headed toward the exit. Looking back one final time at the scene, I tried to take it all in. *This part of my life is over*, I thought.

After Kenny gave notice to the NJPW office that he would not be re-signing, they made it clear that the Tokyo Dome match Kenny was main-eventing would be his last match with

the company, despite having time left on his deal. Prior to our arrival in Japan, which would signify our last performance with the company, we learned we were all being pulled off the annual *New Year's Dash* show, which happens every year the day after *Wrestle Kingdom*. This basically meant we wouldn't be able to properly say good-bye to the fans. We'd seen AJ, Anderson, and Gallows leave the company after giving only a twenty-four-hour heads-up, and still be afforded a proper send-off, so this stung.

On the flight to Japan, as I sat and looked out the window at the endless ocean, I thought of how this could possibly be the last time I'd see the country I had come to love. Japan had seen so many different versions of me. I reminisced about coming here ten years younger, when I was moneyless, hungry, single, and without kids. Then I thought about the eager guy who came back a few years later with a chip on his shoulder, ready to shove successes down the throats of anyone who doubted him. Finally, I thought of the successful performer I had become in part due to what this place awarded me. Most important, I thought of the best version of myself that this country saw: the mature husband and father. The provider. I was a bit of an emotional wreck, as I held Ellen's hand, squeezing tight. She'd been living the past several months with me, and knew the toll it'd taken on me, making tough decisions, and saying my good-byes to people I genuinely loved. Seeing Gregory and Alison watching their favorite Disney films onboard the plane made me feel better.

Just a few days earlier, Tony, Matt, Kenny, Cody, and I made the decision to not just announce that we were doing another show once the timer ran out on *Being the Elite*, but to finally, officially, announce All Elite Wrestling as well. I kept looking at the time, anxiously counting down the hours to our announcement. I'd walked around for months pretending

things were normal, hiding the biggest secret of my life, so I longed for what a relief it would feel like to tell the world the truth.

We'd meet the whole crew one last time on New Year's Eve at the TGI Fridays in Tokyo Dome City. We'd shared so many meals and memories there throughout the years it became the background set to countless *Being the Elite* scenes (I always thought of it as our "Max" from *Saved by the Bell*). We knew the next few days would get hectic, so we made it a priority to sit and be together. As I looked around the table at Cody, Kenny, Matt, Marty, and Page, I remember it feeling like it'd probably be a long time before we'd all be together again as a complete team. I felt bad that we were essentially leaving Marty behind. He didn't deserve it, as we'd all been on this ride together. I could tell he was a bit down about everything, and we did our best to reassure him that he would be fine. We all stood up and did a big cheesy group hug. It was like one final curtain call, but without an audience there to cheer for us. I then looked at the time on my phone, and my stomach turned. We were less than twenty-four hours away. It felt like an asteroid was about to hit the earth, and me and my friends were the only ones on the planet who knew about it.

Later that night, we shot a cinematic scene as the payoff to the long storyline of *Being the Elite*, with each of us walking down hotel hallways, escalators, and through the city, as the timer ticked down and dramatic music played. The streets of Tokyo were colorful and packed with people celebrating New Year's Eve, which offered a natural backdrop to an already special video. We'd all eventually meet in front of Tokyo Dome, with our phones in hand, as we counted down the final ten seconds of the timer and until the new year came. When the timer finally finished, we'd look to our phones. Mine, Matt's

and Cody's would read, "Double or Nothing," the name of our next show, confirming *All In* was definitely getting a sequel. But then, Page would dramatically flip his phone over, revealing the AEW logo. This news would mean not only were we not going to WWE like many believed, but we'd be indeed sticking together to do something that'd be called revolutionary.

The last time a competitive wrestling company existed was in 2001, when Vince McMahon bought WCW. And never before had the hottest wrestlers in the world decided to team together to help open a new wrestling organization. This was a first. For whatever reason, we just couldn't get the last shot of the scene right. Was it the frigid weather, or our nerves? We didn't quite know. Even after getting a good take, we all scratched our heads and wondered if it was any good at all. There was so much pressure to get this announcement right. We were seventeen hours ahead of Pacific Time in the United States, and our plan was to go live with the episode at midnight Pacific Time, or 5:00 P.M. New Year's Day in Japan. After finally wrapping our shot, out in the brisk Tokyo winter, I went back into my room and feverishly edited the most important episode we'd ever upload. It had to be perfect. As I edited, I thought about how far this little vlog I'd created had come. The first video I'd edited for our channel, one of Matt, Kenny, and me singing karaoke, was in this very hotel a couple years earlier; now, we were about to use that very channel to announce a new wrestling promotion. The weight of this announcement hit me as I watched the final frames back of Page turning his phone around to reveal the AEW logo. *We're about to change the wrestling world,* I thought to myself, my hands shaking. Finally satisfied, I uploaded the video and set it to private so nobody could see it until it was time. Tomorrow, all we'd have to do was press a single button. I went to bed contemplating how the

wrestling business, and my life, was going to change from the simple click of that button.

My eyes fixated on the clock as it got closer and closer to midnight back in the United States. Every twenty minutes, I'd pull out my phone to check the time, and I alternated between anxiousness and reflection. I couldn't help but think about our successes and the series of fortunate events that led to all of this. The butterfly effect of moments: *What if we had great success at TNA? What if we had properly introduced ourselves to Booker T? What if we were never invited to Japan to join Bullet Club? What if we never became close friends with Kenny? What if Dave Meltzer and Cody never made that bet? What if Matt didn't pick up the phone for Tony Khan?* Every moment in our careers played a role in us getting here.

But I also reflected on everything starting from the very beginning. I remembered Matt, Malachi, and me jumping off of the couches in the living room while wrestling played on the TV. I remembered hammering the final nails into the plywood with my dad, so our wrestling ring in the backyard would be complete on Matt's sixteenth birthday. I remembered the first time I walked through the curtain and heard the cheers of a crowd, and how I still have those same feelings to this day, all these years later.

Time felt like it was moving at a snail's pace, but midnight Pacific Time was approaching. We were only a few minutes away. I thought of the highs and lows that I'd lived through the past several years, how I had convinced Matt not to quit when we were both broke and how we hung on through the controversies when just the mention of our name caused a stir in a locker room.

It was almost time. So close now.

In a room at Tokyo Dome Hotel, I met with Matt, Dana, and two representatives of All Elite Wrestling, who were there for one thing: Our signatures. The representatives' lips moved, but I didn't hear any sounds coming out—just the ticking of a clock getting louder in my head. Behind them was a perfect view of Tokyo Dome, and for some reason I became fixated on it. I thought of the huge gamble we were taking, betting on ourselves, and putting our careers on the line. We were in our prime and every wrestler before us took the easier road, while we were taking the road never traveled.

The representatives talked some more. I still didn't hear anything. The only thing I saw was Tokyo Dome, the bright yellow lights that wrapped around it. I saw the green lit up "TOKYO DOME" sign that's front and center. It was all in clear focus, while the men sitting in front of me were fuzzy. I thought about how we had just turned down millions of dollars from an established company that had been around for decades, to chase the unimaginable dream of starting a wrestling company from scratch.

We were seconds away. I looked at Matt, who wore the same nervous face he always does when we're behind the curtain before a match. My sweaty hand clenched my phone as if it were a bomb, and I waited to press the button to make *Being the Elite* live for the world to see.

"It's 11:59 P.M. back home," I blurted out, interrupting the conversation about God knew what. Across from me, I saw Matt grab on to Dana's hand like they were both bracing for impact. I wondered how the other wrestlers in our crew felt, knowing they, too, were counting the seconds down from their own hotel rooms.

"Ten, nine, eight, . . ." I led the countdown with my brother. I again fixated on Tokyo Dome. I finally realized I was coming

to terms with the end of my Japan career. Then, for some reason my life was flashing before my eyes like in the movies before a character dies. Suddenly my mind was filled with images of all of my great life achievements and memorable moments.

". . . Seven, six, five, four, . . ." Ellen was walking down the aisle in her wedding dress. Alison's and Gregory's births played in sepia-like images.

"Four, three, . . ." Snapshots of me and Matt, huddling and praying countless times before every match.

"Two, one, . . ."

"Happy New Year, everyone!" Matt shouted aloud in the room, before kissing Dana. The representatives finally came into focus, and Tokyo Dome became a blur. I bit my lip and pressed the button to make the video live. All Elite Wrestling was born.

EPILOGUE

BY MATT JACKSON

The announcement of All Elite Wrestling shocked the entire professional wrestling industry. Fans were excited for a new alternative wrestling product, and unsigned wrestlers within the industry now had a new company from which to earn a living wage. The entire wrestling economy changed, as the threat of a new competing company helped secure wrestlers their jobs in rival promotions, with better pay. Me, Nick, Cody Rhodes, and Kenny Omega would be named executive vice presidents of talent, live events, and creative, working directly with founder, president, and CEO Tony Khan. Tony, making good on his huge, ambitious promises, landed a deal with WarnerMedia. On May 15, 2019, All Elite Wrestling announced a deal for a new weekly prime-time show airing live on TNT, every Wednesday night, beginning in October of that year. The show would later be named *AEW Dynamite*—a callback to the very name Tony used to call the fantasy wrestling company he wrote for

as a teenager. As retaliation, on August 20, our main competitor WWE announced its NXT brand would go head-to-head against us, every Wednesday night on USA Network, with a show of their own. Again, experts, column writers, and many fans predicted our early demise, stating that the much more experienced WWE would wipe the floor clean with us. As of this writing, in April 2020, I can proudly say that our show has had an overall television rating larger than theirs for twenty-two weeks, and has tied one other time with them. Not bad for a bunch of newcomers, eh?

All Elite Wrestling debuted with *Double or Nothing* at MGM Grand Garden Arena in Las Vegas, Nevada on May 25, 2019, before 10,953 rabid fans. The show sold out in four minutes and would go on to sell more than one hundred thousand pay-per-view buys, a number that shocked industry insiders. I'd never been more nervous for a show than this one. In life, and especially in wrestling, you've only got one shot at making a good first impression. And what an impression we made! After several awesome matches, to end the night, newly signed to All Elite Wrestling, Jon Moxley, formerly known as WWE's Dean Ambrose, showed up unexpectedly, truly making our events can't-miss. Then, on August 31 we returned to where it all began, Sears Centre Arena in Hoffman Estates, Illinois, almost exactly a year after *All In*, and ran *All Out* before 10,500 fans. Chris Jericho, our biggest signee who helped legitimize us as a *real* company, would become the first-ever AEW World Champion that night.

Most recently, before the global pandemic that would sideline us and our peers, Nick and I wrestled Hangman Adam Page and Kenny Omega on February 29, 2020, at Wintrust Arena in Chicago, in a match that is being deemed one of the all-time greats. Dave Meltzer broke his own five-star scale rating, awarding it six stars. He's quoted as saying, "It may have

been the best tag match ever in the United States . . . maybe ever. Period!" Between the aggression, physicality, and drama from the story we told between four men in a complicated friendship, this might be the best match we've ever had.

Off the mats, I may not be folding T-shirts in the middle of the night or fulfilling merchandise orders like I used to, but it still very much feels like I am running a family business. I work every day with Dana, now AEW's chief marketing and merchandising officer. She credits the early days of Young Bucks Merchandise for making her work ethic what it is today. I'll still elbow her in the middle of the night with a new T-shirt design idea, but instead of the design revolving around me and Nick it'll be for one of our many talented wrestlers. They are as much a part of our family as my own bloodline.

Speaking of which, our youngest, Zachary, who is now four years old, is a full-blown wrestling fanatic. My collection of wrestling figures that were being stored at my parents' house is now back under my roof, in good hands with him. We have daily wrestling matches on our family-sized Lovesac beanbag (our makeshift ring) that are constantly being shut down by Dana, much like how my mom did back in my backyard wrestling days. Kourtney, now eight years old, is the sweetest, most intelligent kid I've ever met. She's read more books in her short time on earth than I have, which probably includes this one. (Sorry for the curse words, sweetie!) One of my most rewarding moments in my life is sending her off to school every morning on the bus and watching her return that dimply smile back as she steps aboard and gives a final wave.

Just the other day, Nick welcomed his third happy and healthy baby into this world, Michael Owen Massie. He jokes that if Michael decides to get into the business, his wrestler name will be Michael Jackson. I visited him and his family the other day at his new giant home with a mile-long driveway. For

more than a decade, he would drive by this house and fantasize about one day being able to buy it. Guess what? He did. He, Ellen, Gregory, Alison, and little Michael are all doing well. The family looks complete.

Although being executives of a large company is quite new for both Nick and me, it's still business as usual. We've been working together successfully in perfect harmony for around sixteen years now, with very few disagreements. While we're inexperienced in working in television, we seem to be adjusting quickly. Nick credits the knowledge we use on a daily basis mostly to all the years we wrote, edited, and directed *Being the Elite* on a weekly basis. Speaking of *Being the Elite*, we now have around 430,000 subscribers and are approaching episode 200, which is a huge milestone for us.

Right now, along with the rest of the world, we are quarantined in our homes because of the COVID-19 pandemic. It seems like every day gets a little gloomier because of climbing death tolls. At times, living in my own little bubble here in my Southern California home, editing and completing revisions to this book, I forget what is going on out in the world. It's not until I go out for groceries and am confronted with the sight of every person wearing face masks and gloves, that I am brought back to reality. We haven't had an AEW event in front of a live crowd in more than a month, and there's no known return date in sight. I didn't realize how much I would miss the roar of a crowd, the touch of high-fiving with fans. While times are scary and confusing, the silver lining for me is the valuable time I've spent with my family. I feel like I'm making up for years of lost time on the road, bonding with all of them in critical ways. I pray that by the time this book finds you and you are reading this, all of this is just a distant memory, and despite the malaise it has caused, you too are able to find a silver lining.

In order to film new content during the current climate,

Nick and I rented a wrestling ring to put up in Nick's back-yard. Funny enough, this particular ring was the PWG ring, the last surviving object from American Legion Post #308 in Reseda, California. The very ring where we built our career. As we stand in the ring, everything comes full circle. From the backyard to Reseda to New York City to the Tokyo Dome to Sears Centre to live cable television, then right back to the backyard. Where it all began. Where we'll never leave no matter how big the stakes. Where we'll always be kids chasing that same stubborn dream.

ACKNOWLEDGMENTS

We never could have understood how difficult the task of writing a book about our lives would be. Especially when that book is being written at the exact same time we were opening up a brand new wrestling league. It's crazy to think that this entire book was typed on an iPhone, usually on an airplane between business trips, or during weekdays when our kids were in school. Reading through old journals, blowing the dust off of old photographs, conversing with family members, and researching our own careers online to make sure the facts were right, was an absolute labor of love. Thank you to our wives, Dana and Ellen, who dealt with us throughout this entire process. We could be irritable, and anxious at times during this project, but you were helpful and patient. Dana has probably read through this entire book more than anyone else, making sure it was just right. Most importantly, these two amazing women have stood by our side through some of the most challenging

times of our lives, and never stopped believing in us. Being a wrestler's wife is an impossible, thankless job, and they've done it for years. Thank you to our children, Kourtney, Zachary, Gregory, Alison, and the newest addition: Michael. You kids have had a unique childhood, enduring excited strangers approaching us at Disneyland, the mall, and grocery stores, and having to celebrate birthdays and dance recitals without us. Professional wrestler, executive vice president, action figure, author, and any other title pales in comparison to what it is like being your father. Watching you grow up has been the biggest joy of our lives. Thank you to our number one fans, Mom and Dad. You two were the first ones to believe in us, teaching us to never stop dreaming big. You may not have been able to afford to send us away to a fancy university but building us our very own wrestling ring in our backyard was the best college education we could've asked for. None of this would've happened without your support. Thank you to our in-laws: Dave and Sue, Gregory and Debbie, who always looked after us, and take care of our children like they are their own.

Thank you to DJ, our brother-in-law Paul, and their daughters Makayla, Rebecca, and Natalie. Thank you to Malachi, our sister-in-law Heather, and their children Paisley and Hezekiah. The entire family give us a sense of normalcy every time we get together, eat pizza, and play cornhole. There's hardly ever a time we don't see you guys wearing a Young Bucks T-shirt. Thanks to Dustin and Brandon Bogle, two of our best friends who've stuck with us for nearly twenty years. We'll never forget the day you two stumbled into our backyard. Thanks to our favorite wrestler in the world, Kenny Omega. In a business that could be consumed with political games, and backstabbing, you have been loyal, honest, and a true friend. The movement the Elite created doesn't happen without you. Long after wrestling is finished, we will still chat on a daily basis. Thank you to

Ryan Barkan, who never stops working and has helped us build our brand to what it is today. Thank you to Tony Khan for taking a chance on us with a massive endeavor. Thank you to the boys (and Candice LeRae) who we shared many miles and meals with: Christopher Daniels, Frankie Kazarian, Scorpio Sky, Adam Cole, Rocky Romero, Jay Lethal, Adam Page, PAC, Marty Scurll, Marty Jannetty, AJ Styles, Luke Gallows, Karl Anderson, Cody Rhodes, Kazuchika Okada, Matt and Jeff Hardy, Kevin Steen, Colt Cabana, Rami Sebei, Jimmy Jacobs, Alex Shelley, Chris Sabin, Brian Kendrick, Tommy Dreamer, Excalibur, Rick Knox, and everyone else we've worked with. Thank you to the ones who saw something in us even when we hadn't discovered what we could be. You made an investment and took a gamble on us: Super Dragon, Cima, Mike Quackenbush, Cary Silkin, Gedo, Tiger Hattori, and Joe Koff. You made the adventure getting here so worth it. Thank you for helping us put food on the table. I'd like to thank the entire staff at Dey Street Books for all of the help on this book. Matthew Daddona, thank you for reading, and re-reading this book, helping us tell our story to the world. Thank you to Rosy Tahan, Kell Wilson, Heidi Richter, Victor Hendrickson, Dave Palmer, and Paula Szafranski. We couldn't have done this project without you.

Most importantly, thank you to the fans. Every interaction we've had with you has truly made our lives happier. Whether it's slapping hands with you during an entrance, sharing a moment with you at a meet and greet, or reading a message from you online about how we've impacted your life in a positive way, we are forever grateful. Our careers would've ended a long time ago if it weren't for your love and encouragement. Thank you for supporting us. Thank you for buying this book.

ABOUT THE AUTHORS

Matt and Nick Jackson, the Young Bucks, a professional wrestling brothers tag team duo, are highly regarded in the industry by fans, critics, and other wrestlers as being one of the greatest tag teams of all time. Matt and Nick, starting as teenagers on the ground floor of their self-built wrestling ring in their backyard in Southern California, eventually traveled the world, perfecting their act, building their brand into an empire. Their success came from bucking the system of a traditional business-like pro wrestling, carving out a cult following of fans whose imaginations were captured through rebellion and excitement. Matt and Nick are multi-time tag team champions, voted Wrestling Observer Newsletter's Tag Team of the Year five times and named Wrestling Observer Newsletter's Tag Team of the Decade of the 2010s. Matt and Nick both live in California with their families.

Jackson, Matt, 1985-

Young Bucks.

PRESS

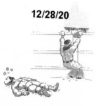
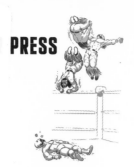
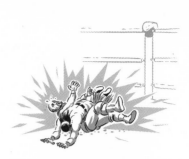

1 Perch yourself on top rope.

2 Do a forward moving backflip.

3 Land belly first on lying opponent.

450 SPLASH

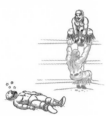

1 Stand perched on top rope.

2 Do a front flip, rotating all the way to your belly, landing on lying opponent.

MOONSAULT

1 Spring to top rope.

2 Do a backflip, landing belly first on lying opponent.

CROTCH CHOP

1 Stand tall as opponent approaches.

2 Put arms into the air like you just don't care.

3 Point to crotch and shout derogatory words.

TOO SWEET

1 Stand tall with your tag team partner, gaining perfect eye contact.

2 Touch thumb, ring finger, and middle finger together to form proper Too Sweet hand gesture.

3 Press fingertips together with tag team partner. Now, you're Too Sweet!